HISTORIC VIEWS OF
LONDON

Photographs from the collection of BEC Howarth-Loomes

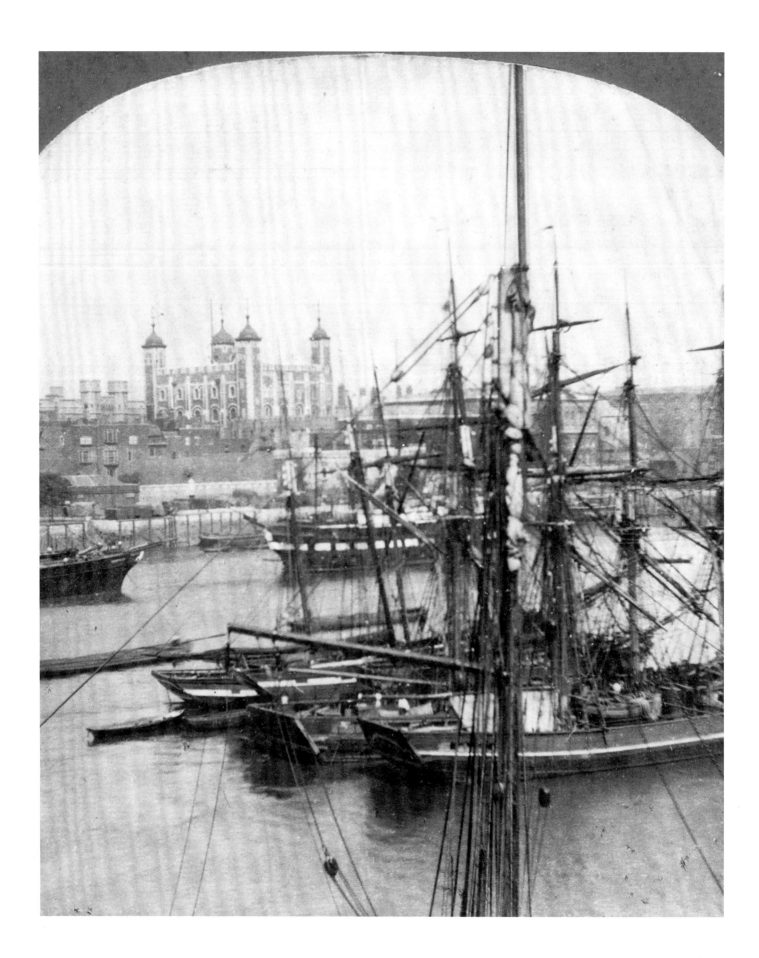

HISTORIC VIEWS OF
LONDON

Photographs from the collection of BEC Howarth-Loomes

ANN SAUNDERS

ENGLISH HERITAGE

Published by English Heritage, Isambard House, Kemble Drive, Swindon SN2 2GZ
www.english-heritage.org.uk

English Heritage is the Government's statutory advisor on all aspects of the historic environment.

© English Heritage 2008
Text © Ann Saunders

First published 2008
10 9 8 7 6 5 4 3 2 1

ISBN 978 190562 418 8
Product code 51348

British Library Cataloguing in Publication Data
A CIP catalogue record for this book is available from the British Library.

Edited and brought to publication by René Rodgers, English Heritage Publishing
Design by Doug Cheeseman
Printed by Deckers Druk, Antwerp

Frontispiece: The Tower of London seen through masts and rigging. [BB85/02111A-2]

» CONTENTS

» ACKNOWLEDGEMENTS

THIS BOOK IS BUILT AROUND THE LONDON ITEMS IN THE extraordinary photographic collection amassed by Bernard Howarth-Loomes and his wife, Alma, who has so generously encouraged the publication. The National Monuments Record (NMR), a part of English Heritage, decided that a book was needed and – trustingly – asked me to undertake it; to my editor, Dr Andrew Sargent, I owe many thanks.

The volume would not have been realised without the support of two people – Dr Alison Morrison-Low, Principal Curator History of Science and Photography in National Museums Scotland, which is the fortunate guardian of the Howarth-Loomes Collection, and Stephen Croad, former Director of the NMR, who has guided and encouraged me from the beginning. They are run a close third by Roger Cline who gave me access to his extensive library of London material.

Words are poor thanks for the supportive efforts of individuals. John Ward, formerly of the Science Museum, lent me his catalogue to the photographic exhibition *From Today Painting is Dead* at the Victoria & Albert Museum in 1972; Ian Leith of the NMR and David Webb and Robert Pullen, photographic historians, gave much good advice; while Dr Nigel Ramsay urged me to visit the Atget exhibition at the Bibliothèque Nationale in Paris. Dr H R Cobb, formerly Clerk of the Records to the House of Lords, and Professor Michael Port elucidated the almost unidentifiable in the photographs of the Houses of Parliament. Dr Philip Ward-Jackson and Dr David Allan, formerly Archivist and Librarian to the Society of Arts, both gave advice on the Crystal Palace, while John Kenworthy Browne and Jonathan Lill made their research on that

fascinating building available to me before publication. Dr Dale Dishon lectured on the building of the International Exhibition of 1862 and many others helped to identify objects on display within it, including Dr Charles Newton, formerly of the Victoria & Albert Museum, with present colleagues Dr Marian Campbell and Dr Diane Bilbey, while Dr Pamela Taylor, Dr Bryony Llewellyn, Brian MacDermott of the Mathaf Gallery, Belgravia, Dr Karen Hearn of the Tate Gallery and Robert Thompson, Reference Librarian at Shoreditch in Hackney, all joined in trying to solve the mystery of the unidentified painting in the background of the photograph on pp 7 and 159.

Many others gave guidance: Dr Geoffrey Parnell on the Tower of London; Joseph Wisdom, Librarian at St Paul's Cathedral; Dr Tony Trowles at Westminster Abbey; Neil Rhind on Blackheath and Greenwich; Dr A T Heathcote, formerly Archivist and Librarian at Sandhurst and Nigel Arch of Kensington Palace on military manoeuvres in Hornchurch; Bridget Cherry on Hornsey Church Tower; and Dr Peter Barber on Café Monico. John Cumming examined the bridge in Battersea Park and Jean O'Reilly searched the Web for references to the stereoscope in 19th-century novels. Chris Roberts, formerly of the Research Division at Kodak Ltd and Past President of the Royal Photographic Society, kindly discussed the development of the company, as did Tim Glover, a Principal Scientific Officer with Kodak. Professor Maurice Milne advised on additional reading; Marian Jolowicz, school friend, physicist and photographer, discussed many problems.

The staff of the Guildhall Library Print Room – John Fisher, Jeremy Smith, Michael Melia, Jason Burch and Lynne

MacNab – have given unparalleled support, identifying streets and individual buildings that might otherwise have remained unnamed. Gillian Hanhart, Senior Library Assistant, Performing Arts Collection in Westminster City Libraries, has dealt with theatre advertisements, thereby providing close dating for several photographs. Francis Dimond MRVO, formerly Curator of the Royal Photographic Collection at Windsor, has educated me about the photographic enthusiasm of Victoria and Albert. The Librarians of the Hunterian Collection at the Royal College of Surgeons, the Local History staff of Brent, Enfield, Greenwich, Harrow, Islington, Lambeth, Richmond and Southwark Public Libraries have answered questions swiftly and efficiently, and Janice West of the City of Westminster Archive Centre has been most generous with her help.

Staff at the English Heritage National Monuments Record scanned and prepared the images for publication. Initial picture research was undertaken by Jean Irving, Liz Hart, Penny Radford, Lizbeth Gale and Anne Woodward. René Rodgers was responsible for the final edit of the text and for bringing the book to publication; Adèle Campbell and Susan Kelleher helped with proofreading.

More thanks than I can say are due to Linda Fisher who brought order to an untidy manuscript, remaining cheerful throughout, and to my husband, Bruce Saunders, who made himself responsible for feeding the family with excellent culinary results.

ANN SAUNDERS

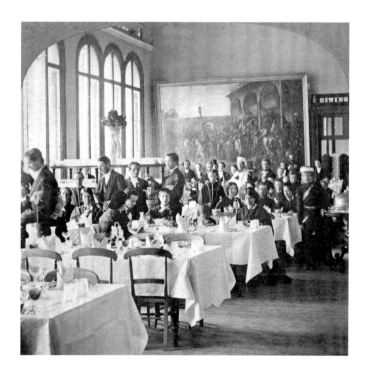

The International Exhibition of 1862 had a dining room on the north side of the building, looking out onto the gardens of the Horticultural Society. This stereo, presumably taken before the exhibition opened, shows the staff posing as diners with the unidentified painting on the wall behind them.
[BB80/00007]

BERNARD HOWARTH-LOOMES AS A COLLECTOR

Alma Howarth-Loomes

WHEN I FIRST MET BERNARD HIS ATTITUDE TO MATERIAL possessions was one of disdain. He maintained that they cluttered one's life and weighed one down, piling on responsibilities and causing untold worries. He always wished to move on, free of impediments, and see what was around the next corner. However, once he had bought his first stereoscope this philosophy changed.

He actually received his first stereoscope at an early age in a packet of breakfast cereal called Force. It was small, folding and metallic, and came with stereo pictures the size of cigarette cards that could be collected and swapped. Swept away with other childhood things, the toy was soon forgotten.

Many years later he had an elderly photographer friend who strongly advocated that travelling salesmen use 35mm stereo transparencies of their products, which he claimed gave prospective customers a better picture than the normal two-dimensional photograph. Unfortunately, few commercial travellers could be persuaded to invest in battery-illuminated plastic stereoscopes and 35mm transparencies. However, this friend had a wooden Brewster stereoscope of *c* 1860 and a collection of stereo cards showing England at that period. Browsing around an antique shop Bernard came upon something with a similar purpose called a 'stereographoscope'. He bought it 'just to demonstrate the difference' and the damage was done. As he quickly discovered the wide variety of types and materials used in these fascinating instruments, his dislike of material possessions mysteriously disappeared and what was to become a lifelong obsession – and ultimately a unique collection – began.

From then onwards, we spent much of our weekends and holidays scouring antique shops for stereoscopes and associated items to illustrate the range available. Bernard would rise at 3am every Friday to visit Bermondsey market, sometimes returning home triumphantly carrying his latest find. He hated missing even one visit; it was only in the last few years of his life that he, very reluctantly, stopped these early morning sorties.

Gradually our purchases began to reveal the whole story of Victorian ingenuity and endeavour, and the collection started to encompass most aspects of 19th-century photography and the earlier optical toys. Bernard then began searching for information and he visited museums and learned societies, in the process building a good relationship with the staff from such places as the Kodak Museum in Harrow, the Science Museum, the Royal Scottish Museum (now National Museums Scotland), the Victoria & Albert Museum and many others. During this time he also became familiar with the National Monuments Record (NMR). The staff there were extremely helpful with the identification of places and dates. In return Bernard let them select from our many thousand stereo and mono photographs for copying and addition to their archive. It is from this great number that the images in this book have been chosen.

In 1971, in collaboration with the Kodak Museum and a fellow collector, he produced an exhibition, *The Victorian Image – Photography*, at Church Farm Museum, Hendon. In the same year we attended Sotheby's first photographic sale and found the room filled with friends and fellow collectors. This sale made early photography 'respectable' and more popular, eventually attracting collectors who

looked on the material as an investment, along with those who just loved the subject. A year later the V&A put on a successful exhibition entitled *From Today Painting is Dead*, to which we contributed over 40 items. As interest in the subject increased, Bernard became involved in several television programmes. He also became a founder member of the Royal Photographic Society Historical Group and started lecturing on the subject. He later wrote *Victorian Photography: A collector's guide* (1974), in which he encapsulated all we would have liked to have known when we first started to collect.

My favourite exhibition took place in 1974 at the National Portrait Gallery. Called *Collecting Faces*, it displayed hundreds of *cartes-de-visite* and the ornate and imaginative albums in which they were housed. It was compiled by Bernard and a fellow collector who at the time was a curator at the National Film Archive; most of the exhibits were loaned from their personal collections. The items were not easy to display, but aided by the enthusiastic and helpful staff from the gallery the show was very successful, appealing to an audience with a wide range of interests. Throughout the following years many items were lent to exhibitions and museums around the country. Notably, in 1980 several full cases were lent to the recently refurbished Kodak Museum, a first-class centre of excellence that sadly closed in 1984. In 1985 the Science Museum constructed three large cases designed to house ephemera and equipment from our collection and to demonstrate the ingenious ways in which the Victorians displayed and viewed photographs. At the same time the optics department of the museum borrowed a

variety of pieces to augment their own impressive display.

Over the years Bernard constantly gave help and advice to researchers, organisations and other collectors from home and overseas, many of whom became good and long-standing friends. I have deliberately omitted naming them for fear of the list being incomplete.

We both hated the idea of ever having to break up the collection, so assiduously amassed over many years. Finally in 2002 the decision was made to pass almost all the items to National Museums Scotland, with the hope that the collection would become its property on my death. Although throughout I have called the collection 'ours', Bernard was the inspiration and motivating force, and it was due to his enthusiasm and intellectual curiosity that it became so comprehensive and successful in its scope. It gave him so much joy and it will be a fitting memorial to a dear husband.

THE HOWARTH-LOOMES COLLECTION

A D Morrison-Low, National Museums Scotland

IT WAS WITH GREAT DELIGHT THAT NATIONAL MUSEUMS Scotland accepted the Howarth-Loomes Collection, parts of which have been arriving in Edinburgh since late 2003. Although an indication of the contents of the collection is broadly shown in B E C Howarth-Loomes's own 1974 publication, *Victorian Photography: A collector's guide*, the intervening 30 years meant that the collection had grown out of those early beginnings and now encompasses a wide range of photographic material – and not only the stereo photographs and their viewers for which it is noted. In fact *Victorian Photography* deliberately used illustrations from public collections where possible, as Bernard was keen at that point to show what was publicly available. This present book uses one small part of the Howarth-Loomes Collection – the stereo and mono images of London – and selects from them some of the most interesting and evocative. But there is much, much more to this collection and National Museums Scotland is keen to see it used to its full potential in the coming years.

The Howarth-Loomes Collection covers a fascinating area of social history, which was reflected for the first time in the new medium of the photograph. But it does not just begin with material dating from 1839, the year taken by photographic historians as the date of the invention of the new science. The collection includes examples of pre-photographic apparatus, which can be linked with aspects of the developing medium and its associated but younger offspring, the cinema. There are, for example, a couple of Claude Lorraine glasses, several kaleidoscopes and a number of devices that move or deceive the eye into believing a false 'reality', such as zograscopes, polyrama panoptiques,

praxinoscopes, zoetropes and phenakistascopes. Not only are these unusual pieces in first-rate condition, but there are associated contemporary prints and ephemera, the social documentation which rarely survives and which has taken dedicated and unceasing collecting to draw together.

The major part of the collection is of course devoted to photography proper: all the major Victorian processes are represented. There are daguerreotypes – the single, positive, glass-protected French invention – from Britain, the United States and one or two from the Continent. One is of a scene at Niagara Falls taken by a commercial photographer named Platt D Babbitt; another stereo is of the building of the 1852 extension to Paddington Station; a third, also stereo, is of the museum display at the Royal College of Surgeons, London, sadly lost in the Blitz. Others show the opening of the Great Exhibition of 1851; a geological 'still life', probably by the French instrument maker Jules Duboscq; as well as countless unidentified portraits of members of the middle classes, eager to be recorded in the new medium. There are rather fewer calotypes, perhaps thanks to the more-or-less effective patenting of the process in England. Ambrotypes – the collodion on glass photograph with black backing, dating from the 1850s – are present in large numbers, showing Victorians at leisure or in their Sunday best; the cheaper tintype process portrays working-class beach holidays and servants posing for some itinerant photographer. There are a number of early colour photographic processes, including the Ives Kromskop with which one viewed special three-fold glass colour slides, and examples of the autochrome. There are instances of unusual uses of photography, such as photo-ceramics where tea cups have been adorned with

family portraits. And there are large numbers of the popular *cartes-de-visite* and the larger cabinet-sized prints.

The largest part of the collection, however, is devoted to stereo photography in all its forms up to the present day. From the moment of its public endorsement by Queen Victoria at the Great Exhibition, the stereoscope and its images – which enable the viewer to see a three-dimensional picture – became a part of Victorian life, and thus enable us in turn to see how they perceived it. As Bernard wrote in his book, 'it should be remembered that stereographs do not give an accurate picture of Victorian life'. It is how they wanted to be seen, with the poverty and squalor eliminated. But they had a thirst to find out more about their world and, for many, looking at these double images through the viewer was how many were able to see the wonders of the world and admire the picturesque beauties of the Lake District or the grandeurs of the Grand Canyon, without leaving the comfort of their drawing rooms. Mass travel was a dream of the future, but with this device, the geography lesson became a pleasure. But the medium was also used to record historic events such as the American Civil War, the international trade exhibitions that proliferated during the latter part of the 19th century and the sea-trials of Isambard Kingdom Brunel's giant ship, the *Great Eastern*.

There were three main surges of popularity for the stereoscope and its photographs during the 19th century: just after the Great Exhibition of 1851, during the 1860s and then again during the 1870s. Although sales continued well into the 20th century – there are examples of stereo cards showing scenes in France during the First World War – the demand slowly began to dry up as other forms of mass entertainment developed, such as the cinema, which by the late 1920s had found a place in the family's weekly diary. Yet each generation seems to rediscover the wonder of three-dimensional images: the View-Master, with its images on a circular disc, appeared in the 1950s and in the 1960s books were printed with special three-dimensional effects and purchasers were supplied with 'spectacles' with one red, one green 'lens'. Most recently, in the 1990s, books with a special three-dimensional effect were produced in which the viewer had to concentrate on an image without any device at all and the picture would resolve itself through the brain's ability to create order. The Howarth-Loomes Collection has kept pace with all of these developments and all these permutations of stereoscopy are represented in this wonderful collection.

» INTRODUCTION

Bernard Howarth-Loomes collected photographs and photographic equipment for most of his adult life. He would share his findings with the staff of the NMR and, most generously, permit them to copy those examples which they found to be of particular interest, often filling gaps in the national collection. A fair proportion of these were of London and, from them, we have chosen almost 220 to reproduce here. The photographs, many of them stereoscopic, range in date from two daguerrotypes of perhaps 1852 to others as recent as 1915 – that is, the greater part of Victoria's reign, the entire sovereignty of her son Edward VII and the first years of George V's kingship. The subject matter is as varied as London itself and we have grouped related scenes together in order to create a coherent narrative.

LONDON: THE GROWING METROPOLIS
During the years covered by the photographs in this book, London increased enormously in size. Though the nucleus – the Square Mile of the City – always remained independent, its companion Westminster and the parishes and villages of the surrounding hinterland came under the administrative control of the Metropolitan Board of Works in 1855, which in 1889 developed into the elected London County Council (LCC), controlling some 125 square miles. This, in 1965, became part of the Greater London Council (GLC) covering an area of 610 square miles; its boundaries are those chosen for this selection of photographs. During Victoria's reign, the population increased from well under 2 million to 6½, and buildings to house and service them followed suit.

With these photographs, we can see London being transformed from a city into a metropolis. In 1837, when Victoria came to the throne, you could easily walk across the capital diagonally from Primrose Hill just outside the north-western edge of the newly built Regent's Park to Peckham in the south-east, or stride out from Islington to Camberwell, or tramp through the centre from the Edgware Road to the West India Docks on the Isle of Dogs. By the time of the queen's death on 22 January 1901, it would have been another matter. London was much, much larger and was moving faster.

In 1837 there were six bridges across the Thames in central London – from west to east, they were Vauxhall, Westminster, Waterloo, Blackfriars, Southwark and the new London Bridge (*facing page*; *see also* p 39), opened in 1831 by the queen's late uncle, William IV. By 1901 seven more bridges – some of them railway bridges and others road bridges – had been

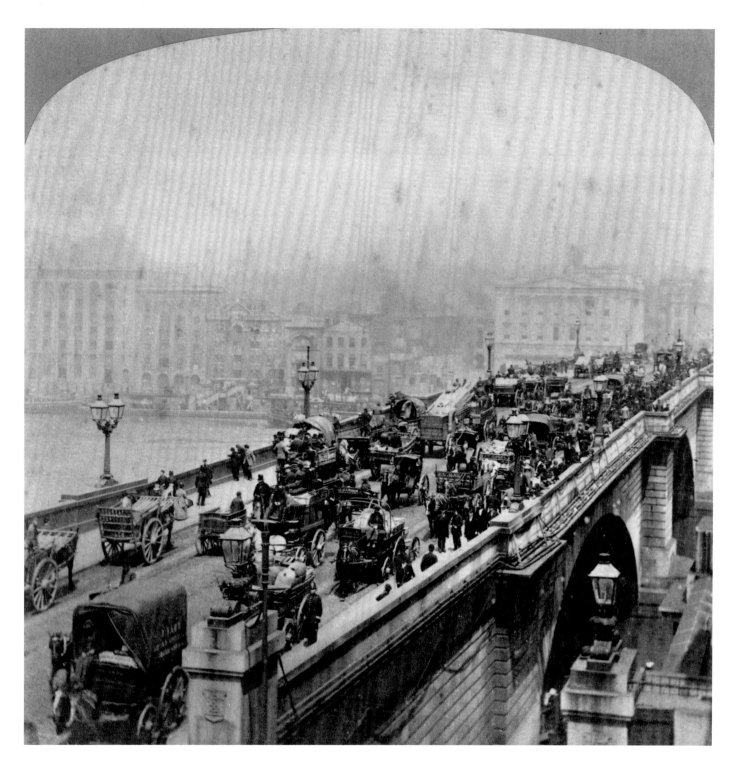

added so that Hammersmith, Hungerford, Grosvenor (or
Victoria), Chelsea, Lambeth, Albert and Tower Bridges
now also spanned the river. The docks increased in size and
number. Battersea and Victoria Parks were laid out in the
1840s–50s to provide south London and the more crowded
eastern parts of the capital with areas of recreation and rest.
The London suburbs spread out, the flavour of them captured

Looking northwards across London Bridge towards the City, c 1870.
[BB83/05717B]

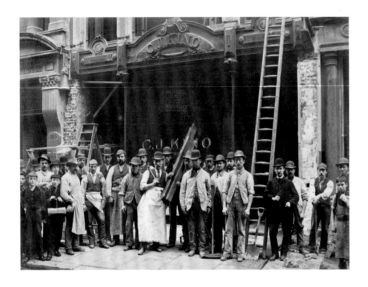

Demolition of the shop front of C J Kino, tailor, at 164 Fenchurch Street on 24 September 1888. [BB91/17984]

by George Grossmith's *Diary of a Nobody*, first published in *Punch* in 1888, centring around Mr Charles Pooter of The Laurels, Brickfield Terrace, Holloway, and his family.

The photographs featured in this book are rich in topographical information and the evidence of change. Examine those of the central area of the City. The photograph on p 50 looks westwards along Poultry showing the buildings which pre-dated the cutting through of Queen Victoria Street; that on p 51, taken perhaps 30 years later, reveals a different aspect with Mappin and Webb's familiar landmark building filling the junction of the two thoroughfares. Turning the other way towards the Royal Exchange, the photograph on p 52 records the 18th-century brick buildings that gave way to the offices visible in the preceding photograph on p 51.

There are mysteries in these photographs too. What are the Asiatic figures on Monarch Kino's in Cheapside (*see* p 54)? Are these figures symbolic of the tailoring going on within at the time? Who are the members of the demolition team wrecking the elaborate plasterwork façade of another

Kino establishment at 164 Fenchurch Street in the early morning of 24 September 1888 (*left*; *see also* p 23)? The house staff of the 1862 International Exhibition building pose as customers in the refectory of the building, but what and by whom is the enormous painting of an oriental scene hanging behind them, slightly askew (*see* pp 7 and 159)? And for whom are the crowds in Pall Mall watching expectantly (*see* p 91)?

STEREO PHOTOGRAPHY

Photography was an increasingly important part of this changing world. The dream of fixing an image had been achieved by 1839 but still, in 1851, the catalogue of the Great Exhibition contains only four pages of entries for photographic equipment and photographs. Among them, however, was a stereographic viewer (or stereoscope) with slides from Messrs Duboscq-Soleil of Paris, which was inspected by Queen Victoria. She was so entranced by what she saw that an order went out from the palace for similar equipment and she and, more especially, Prince Albert became eager enthusiasts for this new, magical means of recording.

The stereo card was an immediate success and where the queen led, her subjects, high and low, followed. The sheer visual shock of contemplating a well-focused stereo photograph satisfied a longing for reality, a grasping of a precise moment. In an age eager for knowledge and yearning for wider experience of the world, the stereoscope provided an answer. Surely it must have been the sight of William England's alpine scenes, still breathtaking today, which impelled Alice Vavasor, the impetuous heroine of Anthony Trollope's novel *Can You Forgive Her?*, to insist on making an indiscreet expedition to Switzerland with her cousins.

The stereo series *Instantaneous Views of London* captured part of the attraction of the stereo view with an apt quotation from the poet William Cowper (*The Task*, Book IV, lines 88–90), which was printed on its cards:

'Tis pleasant, through the loophole of retreat,

to peep at such a world, to see the stir
of the Great Babel, and not feel the crowd.

Stereo cards were reproduced in their thousands and
sold across the world; viewing devices ranged from simple
hand-held models to elaborately decorated pieces of
drawing-room furniture, though the optical quality varied.
Views of England, and in particular of London, were highly
saleable; sets of them were available on the European market
(for example, *see* the image on p 96, which is captioned in
French) and across the expanding British Empire, reminding
those stationed or trading abroad of the appearance of
'Home'. As a result, one of the finest collections of stereo
cards is in the Macleay Museum in the University of Sydney,
Australia.

The London Stereoscopic & Photographic Company
(*right*; originally called the London Stereoscopic Company)
was started in 1854 by George Nottage, a future Lord Mayor
of London; its 1858 catalogue listed over 100,000 stereo
cards showing views ranging from the streets of London and
British landmarks to the beauties of France, Italy and the
Pyrenees. Before long, the photographs would bring lands
still further away into the living rooms of Britain and an
enterprising young man, Thomas Cook, would lead parties
to view those lands in reality; it is significant that the word
'tourist' came in with the 19th century.

Stereo photography exploits the way in which the eye and
brain judge depth and distance. Usually, a special twin-lens
camera takes two simultaneous photographs of the same
image from two viewpoints just a few centimetres apart,
recreating a similar viewing configuration as the human
eyes. The two resulting prints are mounted on a stereo card
and, when they are viewed using a stereoscope, the brain is
tricked into seeing in three dimensions (*see* image on p 16).
The Fine Art Photographers' Publishing Co printed the
following directions for use on its stereo cards:

When looking through the Realisticscope, press the
velvet edge of the hood quite close & (touching) the face.

*Cheapside, c 1890. The London Stereoscopic & Photographic Company
occupies the whole of 54 Cheapside. Note the glasshouse on the roof, where
prints were exposed while developing.* [BB95/11991]

This stereo card of the International Exhibition of 1862 demonstrates the principle on which stereo photography is based. This pair of stereo images, taken from a few centimetres apart, overlaps substantially and is almost but not entirely identical. When viewed through a stereoscope, the brain merges the two pictures to create a three-dimensional effect. [BB86/02157]

Slide the carrier (containing the photograph) backwards and forwards until the correct focus is obtained, when figures and objects will be seen solid, in relief. Hold the Realisticscope so that a strong light falls on the face of the photograph.

The majority, though by no means all, of the photographs reproduced in this book are from original stereo prints mounted on card (stereo cards), in which case we have reproduced just one of each pair of images. The images are therefore seen here as two-dimensional reproductions;

they are even more compelling when viewed as they were meant to be seen in their original stereo pairs. Also, where they exist, the captions and series information (often giving details of the manufacturers and distributors) from the stereo cards are given in italics after the image captions; this information has been transcribed exactly as it was written on the stereo cards.

THE HOWARTH-LOOMES COLLECTION
Bernard Howarth-Loomes was as enthusiastic about photography as any of Victoria's subjects. He did not set out to build up a collection focused on any particular subject or place – what enthralled him was the photographic process and especially stereoscopy. Nevertheless, the collection has its own particular strengths such as the images of transport of all types. An 1852 daguerrotype shows track being laid at Paddington and there is an early, misty view of Philip Hardwick's majestic Doric Arch at Euston. The directors

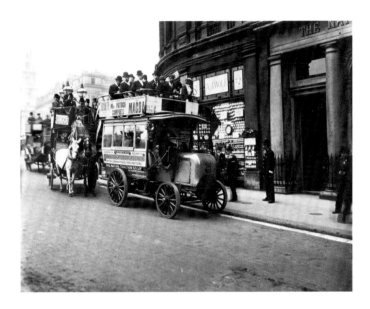

As a Motor Traction Company's omnibus draws up in Charing Cross, a horse-bus pulls out to overtake. Theatre posters date this scene to 1900. [BB90/14585]

thought their railway station, the first such structure ever built, 'needed some architectural embellishment' and £35,000 was spent on the arch. It expresses everything for which the newly developed railway stood – a gateway to a hopeful future symbolised in the stone dignity of the past. The frontage given to King's Cross makes the most direct statement about the purpose of travel of any railway station. Enormous, functional twin brick arches stand side by side, leading into two train sheds, one for arrivals, the other for departures; it makes clear the essence of travel, which is about coming and going. Between the arches is a square clock tower, leaving no excuse for unpunctuality.

Horse-drawn transport is seen in many of the outdoor scenes. Horses trot briskly down the Haymarket or wait patiently at the kerbside in Whitehall or in front of London Bridge Station. Ubiquitous pedestrians dodge the hooves and the wheels in Oxford Street and three ladies have ascended, daringly, the steps of an omnibus in Piccadilly and are seated on the top deck. Suddenly, entrances to the

London Underground burst through the pavements at Tottenham Court Road (*see* p 173) and then, with the turn of the 20th century, the motor car arrives to challenge and then vanquish the carriage – a rivalry epitomised in the shot of Charing Cross where a horse-bus pulls out to overtake the Motor Traction Company's omnibus (*left; see also* p 172).

Victoria's London was a city that contemplated and examined itself, and this self-awareness was increased by the 1851 Great Exhibition in Hyde Park. There are no photographs of that amazing structure in this selection, but there are a generous number of its successor – the Crystal Palace at Sydenham – some of them datable with reasonable accuracy by the absence or presence of statuary on the plinths in the gardens. There are plenty of stereo images too of the International Exhibition of 1862, housed in a short-lived building on the site now occupied by the Natural History Museum. The recording of that display was remarkably thorough, which elicited approval from *The Art Journal* for the London Stereoscopic & Photographic Company that had undertaken the work.

If the royal family was keenly interested in photography, then their subjects were equally receptive of photographs of the royal family and their surroundings. When Edward VII succeeded Queen Victoria on the throne, he set about a thorough refurbishment and redecoration of Buckingham Palace with impressive results. Some photographs of that reordering entered the Howarth-Loomes Collection and are reproduced here.

There are also some intriguing individual shots here, such as what is probably a unique stereo photograph of Robert Mylne's Blackfriars Bridge (opened 1769, *see* p 41), otherwise known only in paintings and engravings, and an amazing (though not unique) daguerreotype of a section of the Hunterian Collection in the keeping of the Royal College of Surgeons (*see* image on p 18, *see also* p 176). Howarth-Loomes so treasured this photographic incunabulum that he reproduced it in his *Victorian Photography: A collector's guide*. Taken in the summer of 1852 by Timothy Le Beau, it is remarkable that the

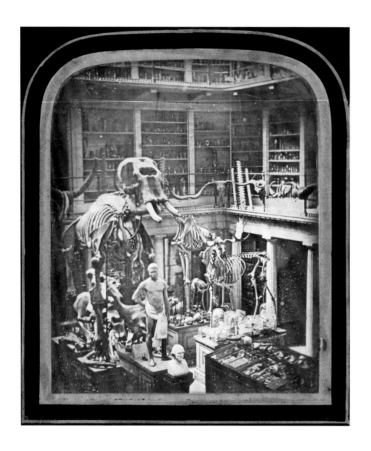

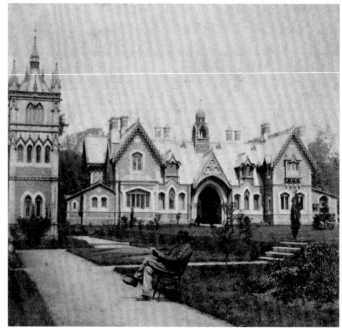

Holly Village, Highgate, was a model village designed in 1865 by Henry Darbishire for the philanthropist Baroness Angela Burdett-Coutts. [BB89/00463]

This early daguerreotype of a room in the museum of the Royal College of Surgeons, taken in the summer of 1852 by Timothy Le Beau, shows the skeletons of several animals, as well as a cast of an African by Antonio Santorini. [BB72/05026]

Keeper of the Hunterian Collection should have made use so early of the newly invented means of recording.

There is strong local feeling shown in the sections on churches and suburbs. A record is made of St Nicholas's Church, Sutton (*see* p 111), before demolition because of cramped conditions, and Christ Church, Lee Park (*see* p 117), is photographed before completion, so proud are the parishioners. The façade of St Paul's National School in Kilburn (*see* p 195), popular in its brief heyday, clearly sold well for a while, and there are three shots of odd corners in

Hampstead and Highgate (*above*; *see also* p 197). Tottenham High Road, in what is today Haringey (*see* p 200), looks calm and prosperous, and Kingston-upon-Thames rejoices in its new town hall (*see* p 206).

Another, more modern but equally unusual, group of photographs are those of the Kodak factory and its idiosyncratic shops all over London. The company was the creation of the American entrepreneur George Eastman. The story is that, wanting a memorable title for his business, he selected the letter K – the initial of his mother's maiden name, Kilbourn – and evolved the inimitable, unforgettable Kodak.

Far too little is known of the early photographers whose work is celebrated here – too few are even identified. The names of William Henry Fox Talbot and Julia Margaret

Cameron may be familiar, and those of Roger Fenton, Philip Henry Delamotte and Francis Bedford are known to historians of photography, but none of these individuals is represented here. J Davis Burton signed his recording of the Tower of London in the late 1860s, but who was Fred[c] Jones, 146 Oxford Street, who, at much the same time, took the atmospheric stereo image of the same building seen through a tangle of masts and rigging across the Thames (*see* p 66)? The creators of these images were more likely to have combined commercial photography with other work, like Mr Ayliffe whose name is displayed on the wall of a small shop beside All Saints' Church, Kingston-upon-Thames, proclaiming that 'portrait rooms' may be found within (*see* p 110), or George Hilditch who took the unsigned shot of Brentford Ait at Richmond (*see* p 209).

SCOPE AND CONTRIBUTION OF THIS BOOK
Eugène Atget recorded Paris for half a lifetime, from the 1890s to the 1920s, gazing at his city as a lover might contemplate the face of his beloved; London lacks an admirer of such prolonged dedication, though in 1875 the Society for Photographing Relics of Old London was formed and issued two albums, the main photographers being Henry Dixon and Alfred and John Bool. The spontaneity, the immediacy, the unselfconsciousness of many of these shots speak to us – a dog saunters contemplatively on the edge of Blackheath (*see* p 199); top-hatted crowds hurry in front of the Bank of England mindful only of their own business (*see* p 170); transport delivering to Borough Market swarms onto London Bridge in a state of confusion, which three policemen strive to regulate (*see* p 40).

The photographs reproduced in this volume are drawn from what is undeniably a random collection, filtered through one man. Winnowed first by time, then by the chance of their recognition and purchase by Bernard Howarth-Loomes, and by his choice of those which he showed to the NMR, followed finally by their selection and inclusion here, they can only be an unsystematic record of London. Nevertheless, they are full of interest and value.

The individual nature of this collection of photographs means that the resulting book is unlike any other volume attempting to represent an earlier London. James Howgego's *The Victorian and Edwardian City of London from Old Photographs* (1977), John Fisher's *City of London Past and Present* (1976) and Warren Grynberg's *Images of the City of London* (2005) all confine their scope to the Square Mile and are rich with human beings, as is John Betjeman's *Victorian and Edwardian London from Old Photographs* (1969). Gavin Stamp's *The Changing Metropolis: Earliest photographs of London 1839–1879* (1984) follows exactly the limits laid down in its subtitle and he gives a particularly valuable introduction and full captions. Hermione Hobhouse's *Lost London* (1971) follows a wider brief, tracing the destruction of important buildings from the 1860s and 1870s to the time of writing and making the case for preservation. To this end, she uses paintings and engravings as appropriate, but there is a preponderance of photographs. Roger Whitehouse's *A London Album* (1980) shows the capital and its inhabitants from 1840 to 1915, while Mike Seaborne's *Photographers' London 1839–1994* (1995) uses the Museum of London's collections arranged chronologically by photographer. On the wider subject of the importance of photography to society in general, there is a perceptive section in Asa Briggs' *Victorian Things* (1988).

The selection presented here has been made from a part of the collection of one man; it confines itself to a single city and scarcely strays beyond the limits of Victoria's reign. The author feels that these restrictions give an inward strength; she hopes that the book may prove a small tribute to a remarkable collector.

» LONDONERS

Streets, villages, towns, cities – all develop because they are places where people live. The stereo images and photographs in the Howarth-Loomes Collection have tended to record natural features such as the Thames and the buildings that make up the city and its hinterland. These few photographs show some of those for whom London was a place of work or a home. Other Londoners can be found throughout the book.

HORNCHURCH, HAVERING
The caption to this image reads: 'Last march of the 1st Sportsmen's [sic] Battalion, from 8 months camp'. The 1st Sportsman's Battalion was part of the 23rd Battalion of the Royal Fusiliers. Led possibly by the regimental sergeant major, this stereo view records them as they march through the main street of Hornchurch between typical Essex clapperboard houses, watched sympathetically by bystanders. The bass drum is carried between two bandsmen, the mounted officer in the centre of the group is presumably the colonel and one house displays two Union Jacks. Since greatcoats are not worn, the date is probably autumn 1915. [BB88/07119]
Caption: As above
Series: Photographer, Underwood & Underwood Ltd

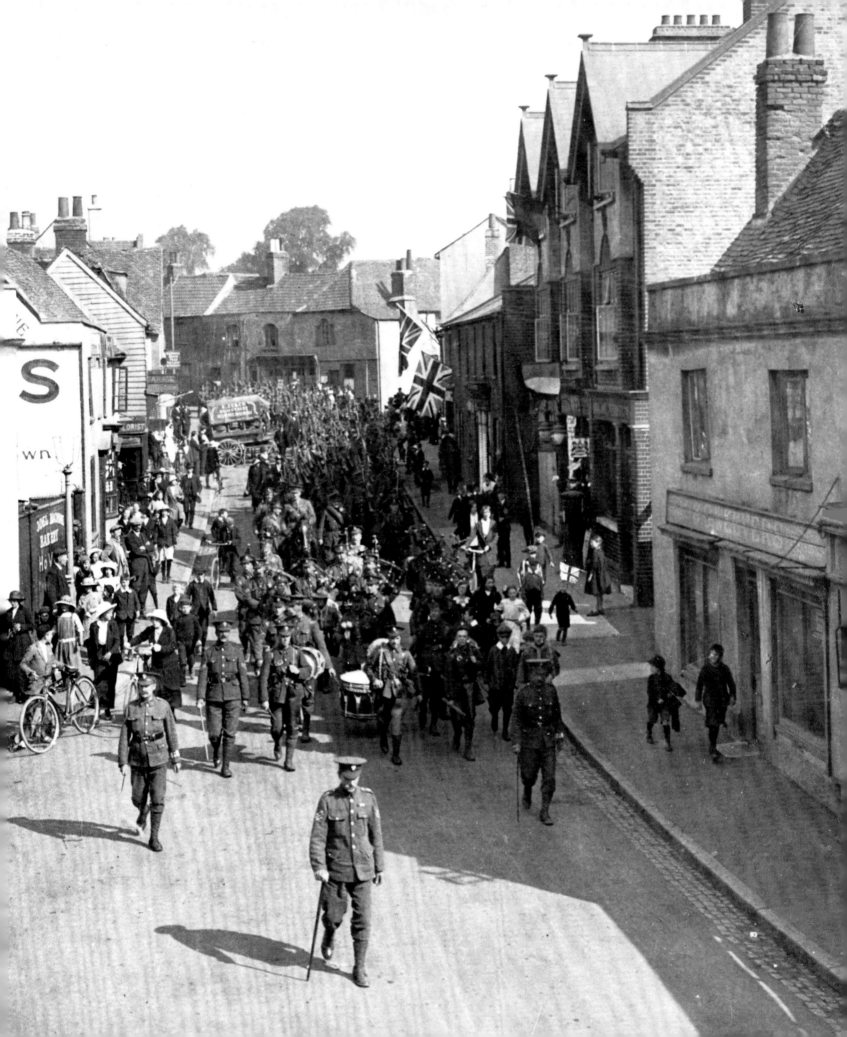

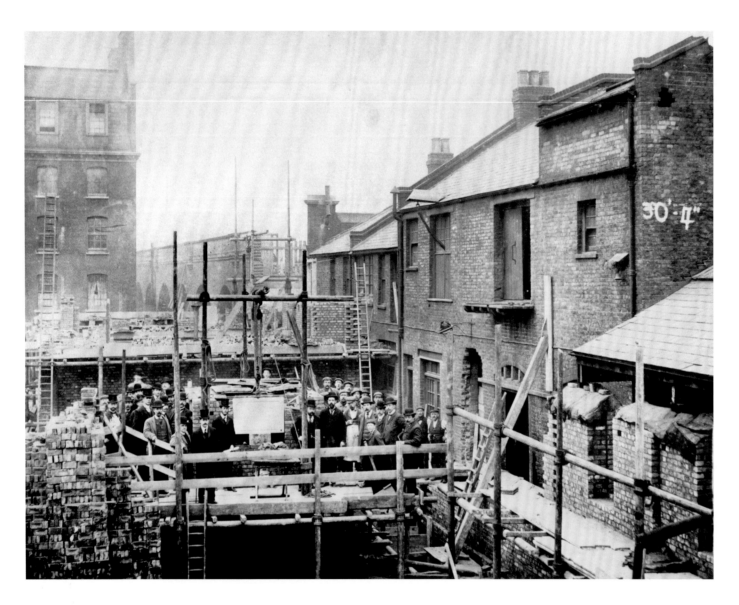

ALBERT WORKS, LAMBETH

The caption to this image reads: 'The laying of the foundation stone on 25th February 1901 at the reconstruction of the Albert Works, Lambeth. Builder, B E Nightingale. Architect, Alfred E Nightingale.' The works lay between Glasshouse and Tinworth Streets, with an additional entrance on Vauxhall Walk. Judging by the number of top hats, this was felt to be an important occasion. The incomplete railway arches in the background suggest that the Waterloo to Vauxhall line is being widened from four to six tracks. [BB98/13455]

Caption: As above

Photographer: A & G Taylor, Victoria St, E.C.

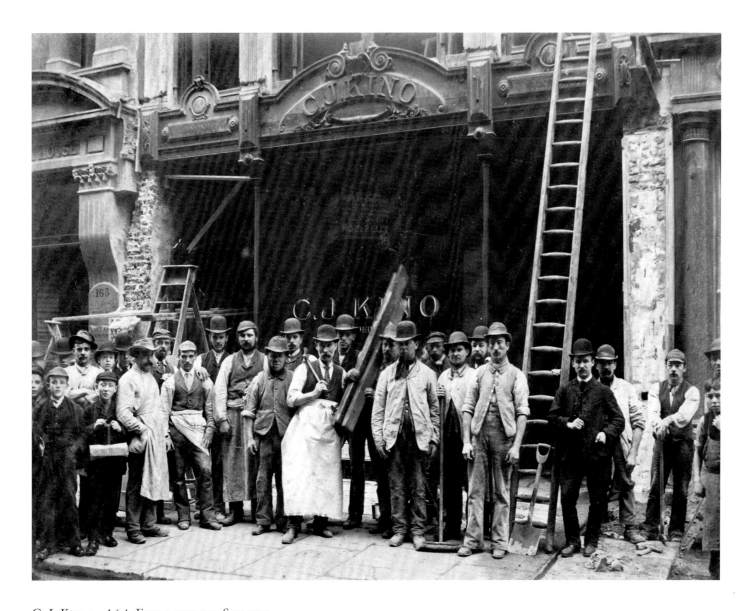

C J Kino, 164 Fenchurch Street

'Monday morning, 24th September 1888' and demolition is in progress on the former premises of Charles Julius Kino, tailor, at 164 Fenchurch Street. The reason is unknown; trading continued in the next door premises for two or three years but it then closed. Other, possibly related, branches under the name of Monarch Kino continued to make clothes for ladies as well as gentlemen in Regent Street and elsewhere.

Aprons and tools are evident in the crowd. The foreman – or proprietor? – stands slightly apart, dark-suited and bowler-hatted, while apprentices and schoolboys crowd into the edges of the photograph as the ornate façade crumbles. [BB91/17984]

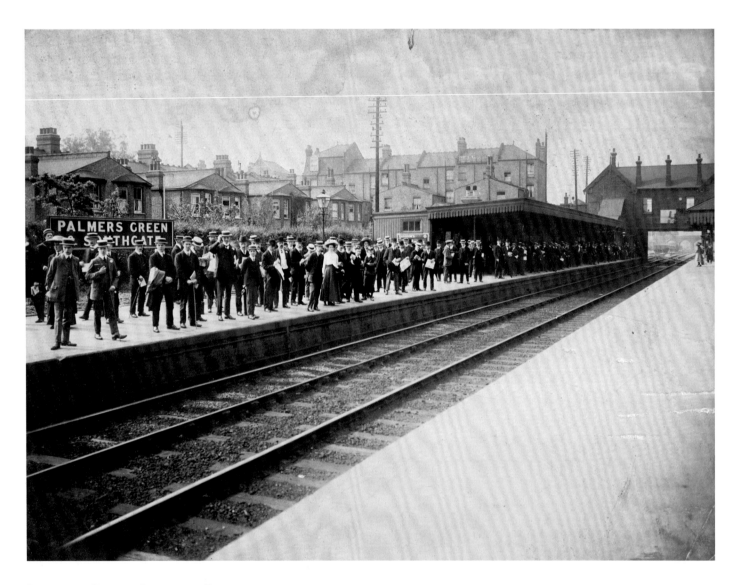

PALMERS GREEN STATION, ENFIELD

The photograph, dated 1914, shows the up platform of Palmers Green Station on the Great Northern Railway's Enfield Branch, which opened in 1871. The houses visible in the background are those in Devonshire Road, first occupied in 1904.

The preponderance of boaters over bowler hats proclaims that it is high summer. To the right, under the canopy, a few formal top hats indicate that the passengers are on their way to posts in the City. In the centre, two ladies in wide-brimmed hats are perhaps setting out on shopping expeditions. From this same platform, outings to destinations as far away as Hove and Worthing were run from time to time; photographs in the Enfield Public Library Local History Collection record such jovial occasions. Soon after this photograph was taken the First World War would break out. [BB92/20713]

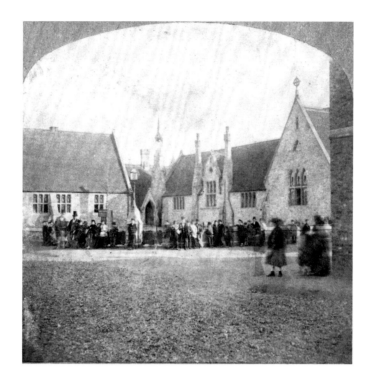

ST JOHN'S SCHOOL, DEPTFORD

St John's Church and School were established on Albyn
Road in 1885, possibly absorbing an earlier girls' school.
Before long boys were admitted and there was a staff of
three. For 20 years the school was most successful until
the London School Board began to open others in the
neighbourhood. It is now used by St Stephen's Primary
School. This stereo image shows St John's in its heyday,
probably about 1870. Children cluster around the top-hatted
headmaster while the older boys have grouped themselves
separately. [BB91/21621]

» THE RIVER THAMES

The clear water of the Thames with its ready supply of fish is one of the reasons for early settlements along its banks; the river also provides a means of communication upstream with the hinterland and downstream with north-western Europe. Being so conveniently placed, it was inevitable that, once a town developed, the river would become home to a port that would increase in size and significance along with London itself.

Until a number of new docks were built in the 19th and early 20th centuries – starting with the West India Docks which opened in 1802 – most shipping docked at the quays and wharves downriver of London Bridge. Ships could wait several days for a berth. Even after the London docks system had been constructed, the Pool of London remained one of the busiest ports in the world.

VICTORIA EMBANKMENT
The embanking of the Thames was first proposed by Sir Christopher Wren, but only happened two centuries later when, between 1860 and 1870, Sir Joseph Bazalgette achieved the immense undertaking. Then 37 acres were reclaimed from the Thames and a retaining wall was built at a cost of over £1,260,000. In this photograph, taken from Westminster Bridge in about 1885, we can see the young trees planted along the roadside and the gaping maw of Charing Cross Station built on the site of Hungerford Market. Two brick piers from the original suspension bridge were reused in the later railway bridge.

Meanwhile a paddle steamer sedately disembarks its passengers while another noses up alongside, on its way downstream. [BB80/03240]
Caption: The Thames Embankment from Waterloo [sic] Bridge

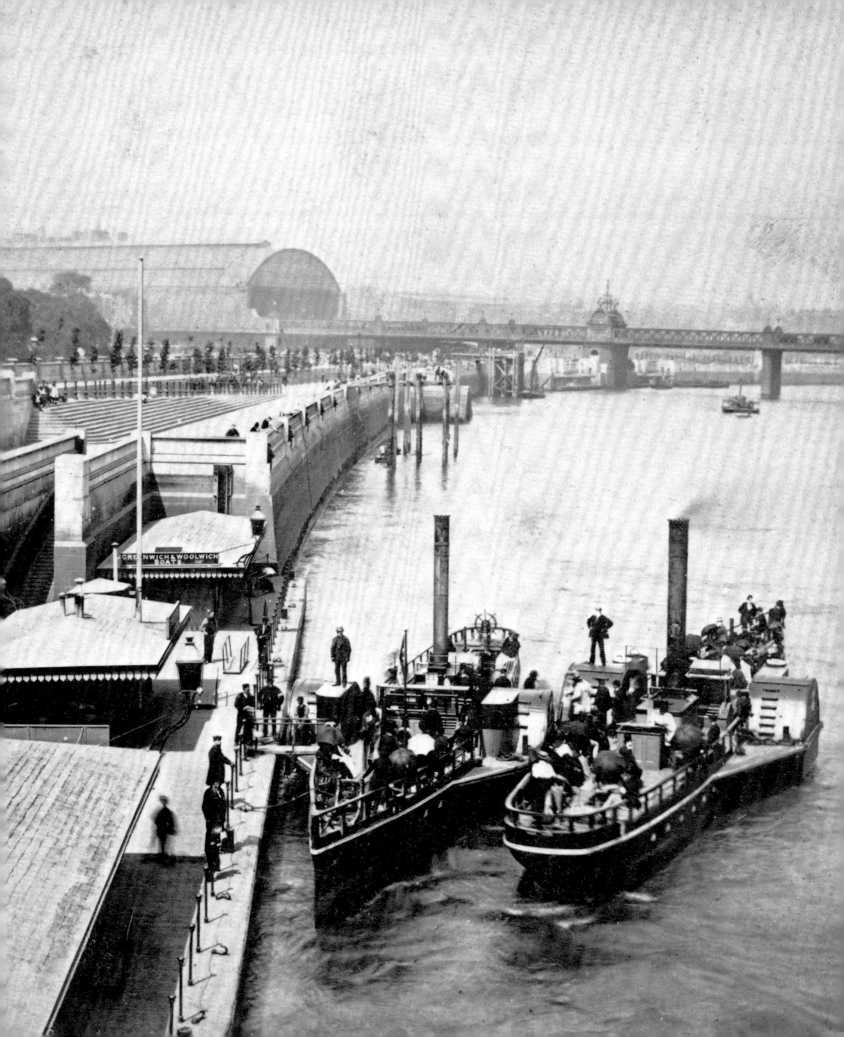

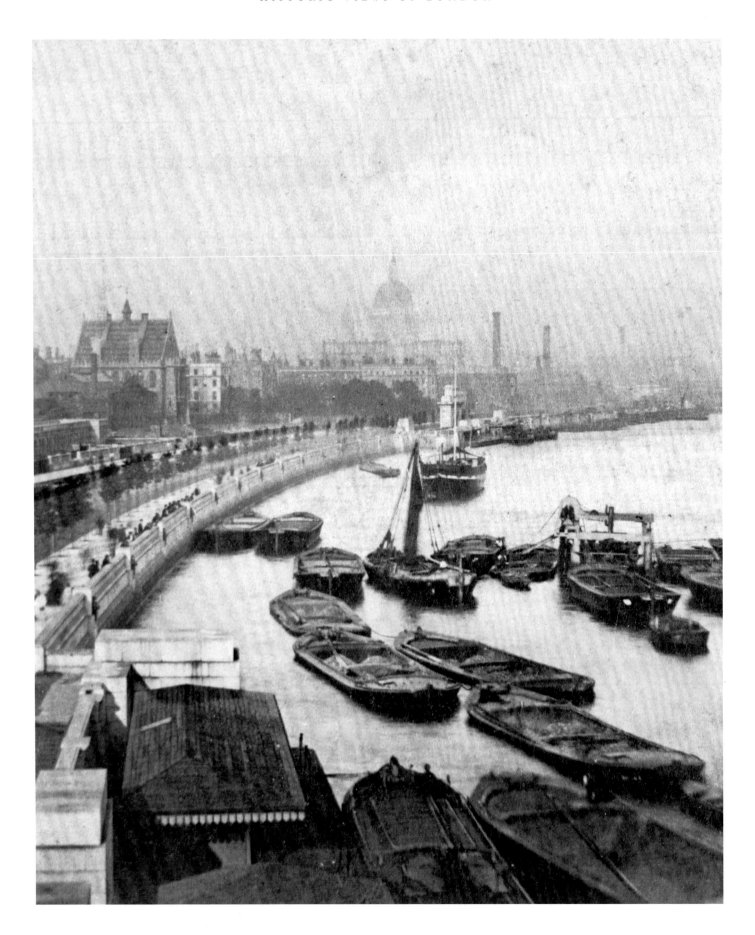

<< VICTORIA EMBANKMENT

This stereo card, taken in the early 1870s from Waterloo Bridge, looks eastwards towards St Paul's with the City Gas Works between the cathedral and the river. To the left of the view is the library of the Middle Temple Hall, destroyed during the Blitz with the loss of 45,000 books. The hall itself was also destroyed, but it was restored through the generosity of the American Bar, sufficient fragments of the hammerbeam roof and screen having been salvaged to make this possible.

To the extreme left of the view is Temple Underground Station, which opened in 1870. Passers-by look out towards the water with the Thames River Police jetty in the foreground; barges and a more substantial vessel can be seen beyond. [BB93/06525]

Caption: The Thames Embankment from Waterloo Bridge

BLACKWALL REACH >>

This photograph, taken well downstream at Blackwall, probably in the 1870s, emphasises the width of the river and the swiftness of the current. Figures sit or loiter along the bank, watching the paddle steamer as she goes busily on her way. [BB91/27804]

Caption: No. 110. Steamboat on the Thames at Blackwall [Cowper quotation, see pp 14–15]

Series: Instantaneous Views of London

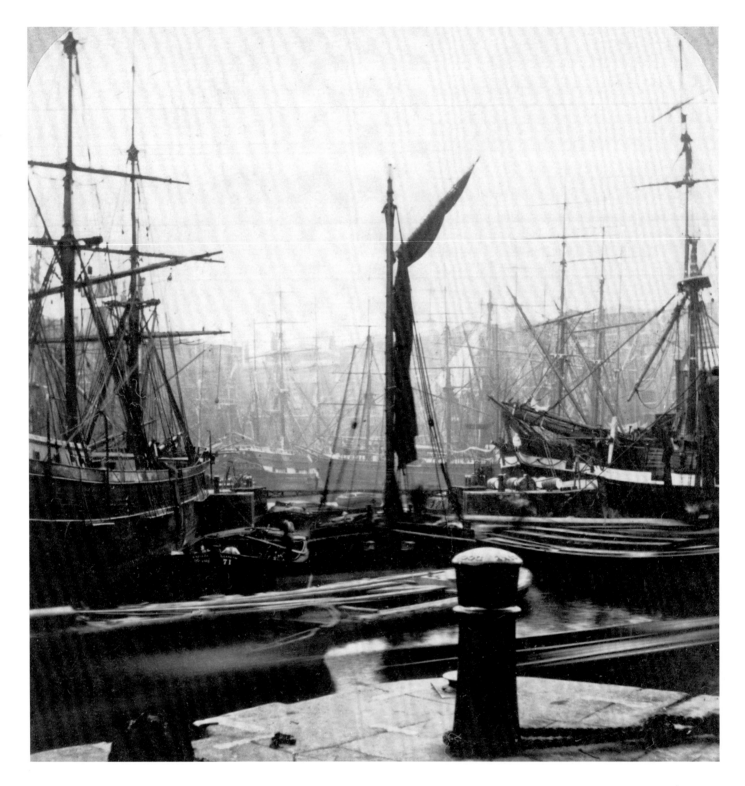

St Katharine's Dock

The centre of this stereo view of St Katharine's Dock is emphasised by the bollard on the quay and the furled sail of the barge. A more substantial vessel is to the left, while to the right is a seagoing merchant ship, her sides painted with a broad white band in imitation of armed naval ships in order to discourage the attentions of pirates. In the background, other merchant ships appear to have adopted the same precautionary camouflage. [BB85/02234A]

Caption: 13. St Katherine's [sic] Dock

Series: Views of London

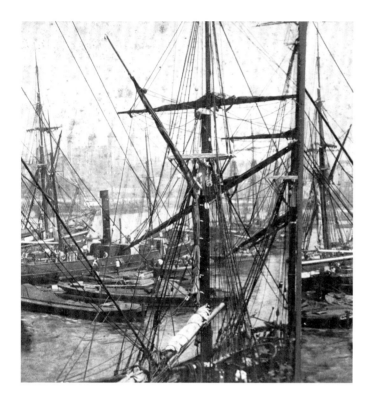

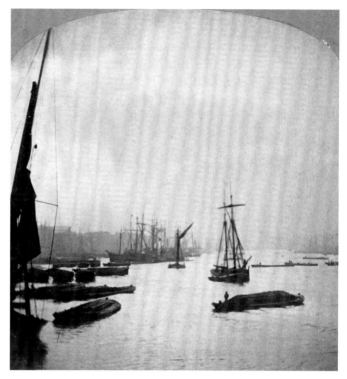

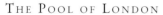

THE POOL OF LONDON

The Pool of London from the Surrey side. This stereo photograph was taken about 1880–90, looking towards the Tower of London from behind a screen of masts and rigging. These are larger square-rigged vessels and the work of unloading and reloading is in progress; steam tugs nose up closely and a small lighter rows purposefully away towards the quay. The distinctive silhouette of the Tower stands out boldly. [BB83/05825]

Caption: 124. Shipping on the Thames – Tower in the distance

Series: Instantaneous

THE PORT OF LONDON

Evening on the Port of London. Sailing vessels lie at anchor; a solitary figure keeps watch over the cargo of the lighter in the foreground. Masts crowd the shoreline, the buildings beyond providing for shipbuilding, repairs and warehousing. [BB91/27803]

Caption: No. 146. Evening. The Port of London [Cowper quotation, see pp 14–15]

Series: Instantaneous Views of London

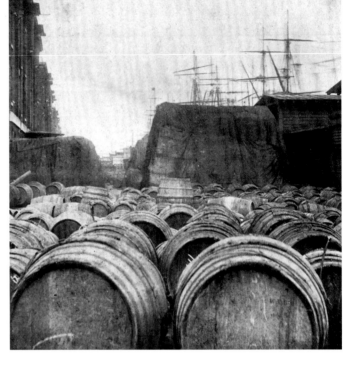

NORTH QUAY, LONDON DOCK

The cargo unladen at last. By the 19th century the river was so crowded with shipping that it could take a fortnight's patient waiting before a berth could be found at which to unload. An identical stereo card in the Guildhall Collection identifies the location as 'North Quay, London Docks before 1896', but does not tell us what is within these decorated barrels. The warehouses on the left were designed by Daniel Asher Alexander in 1804–5 with a distinctive white band above the ground-floor windows. A mast supports the dock bell and, along the river, other ships await their turn to unload. [BB83/03190B]

Caption: No. 617. The London Docks

Series: London and Neighbourhood. By F York & Son

LONDON DOCK

The satisfying shapes and symmetry of the barrels were irresistible to a visiting French photographer, but although the caption on the front reads, 'Docks des Indes à Londres', we are really looking at the North Quay of the London Dock, recognisable from the warehouses on the left. Stacks of additional cargo seem to be covered with tarpaulins and to the right ships' masts line the riverside. [BB86/02156]

Caption: No. 45. Docks des Indes à Londres

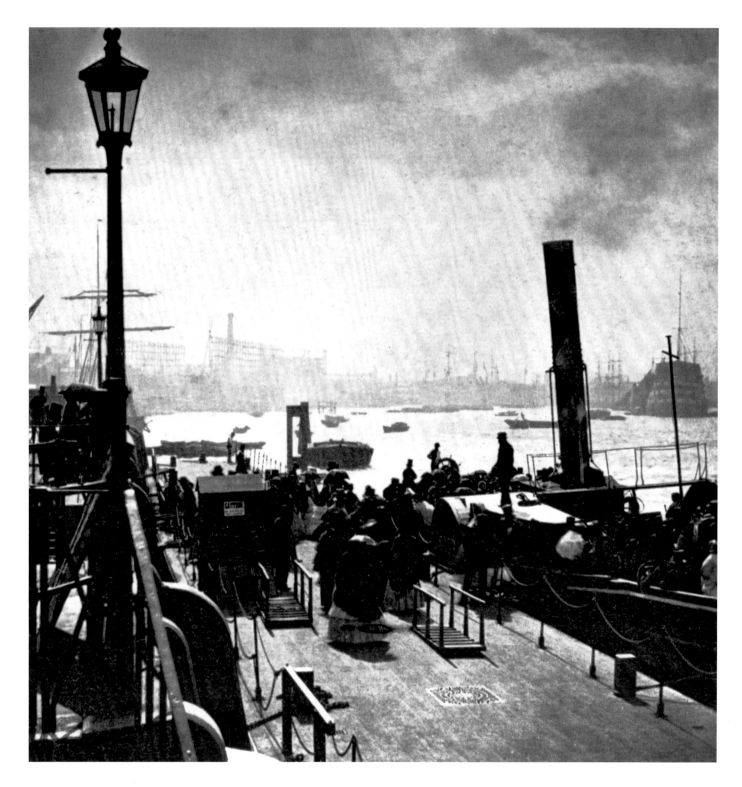

GREENWICH PIER

This stereo card, perhaps of the late 1850s, shows passengers waiting to board a paddle steamer at Greenwich Pier as they make their way past the ticket office. Steam and smoke billow from the funnel; the helmsman at his wheel is totally exposed to the weather. The farther shore is fringed with a line of masts and in the distance, to the right, is the hull of a retired warship; she may well be the *Dreadnought*, which fought at Trafalgar and was pensioned off to serve as a hospital ship for sick or injured sailors. [BB68/03038B]

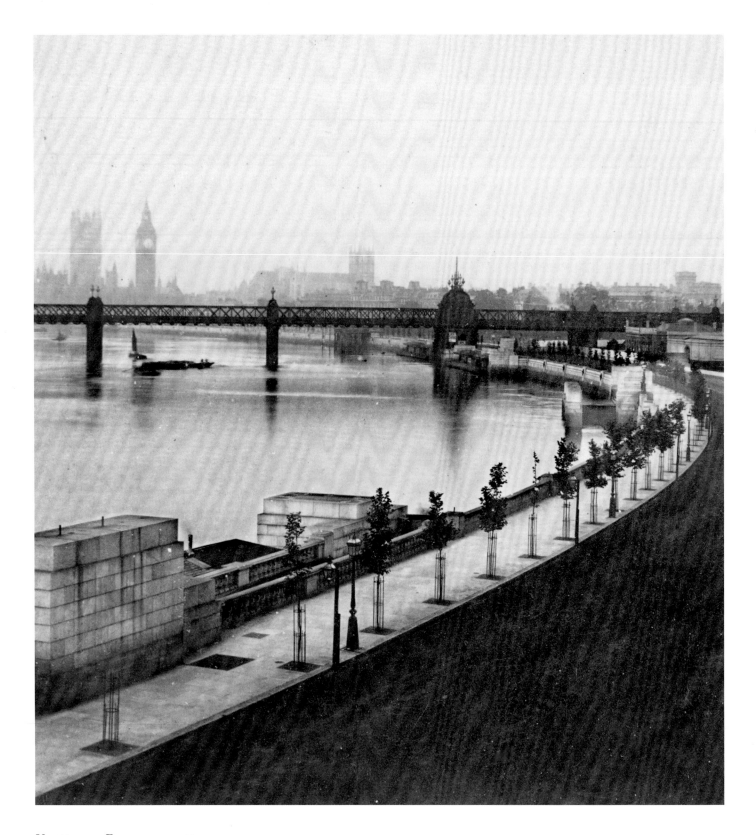

VICTORIA EMBANKMENT

A calm river. We look westwards from Waterloo Bridge, past Hungerford Bridge, towards Westminster where the Victoria Tower and Big Ben stand out and the line of the nave and west towers mark Westminster Abbey. Young trees, flourishing for the most part, line the roadside. [BB67/08239]

Caption: The Thames Embankment from Waterloo Bridge

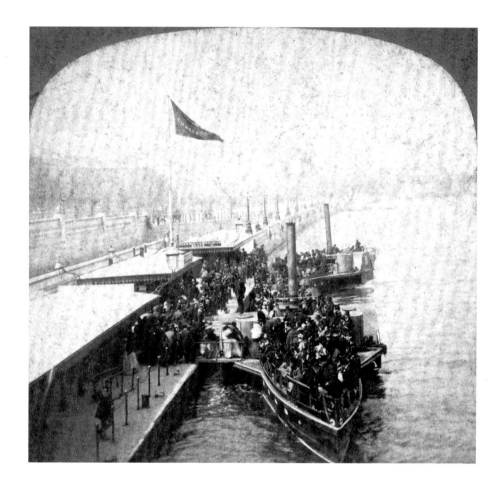

VICTORIA EMBANKMENT

This stereo card shows how overcrowded a paddle steamer could be at holiday times. The deck of this vessel is already thronged, while other eager passengers press forward along the quayside to hurry aboard. It was such overloading that sank the *Princess Alice* on 3 September 1878 with the loss of over 700 lives. In this view, the lamp standards, erected in 1870, are clearly visible beside the river; dolphins, modelled by Timothy Baker, were coiled about their bases. [BB83/04744]

Caption: 285. Embankment

Series: London and neighbourhood. G R & Co

»...AND ITS BRIDGES

For the invading Romans, the Thames was a barrier between south-eastern England (today's Kent, Sussex and Surrey) and the rest of the future province. We do not know how the Roman army crossed the Thames, but before the 1st century AD a bridge had been built, making it possible to cross dry-shod. That original timber bridge must have been repaired many times until at last, in 1176, a new one of stone was begun, the first in Europe since the Romans. Its architect was Peter of Colechurch; London Bridge was completed in 1209, four years after his death, and he was buried on the bridge in the undercroft of the little chapel above the ninth pier from the north. Today 34 road, foot and rail bridges span the Thames within London.

LONDON BRIDGE, LOOKING NORTH
Colechurch's bridge endured until the 19th century when a replacement, designed by the elder John Rennie and completed by his son, was opened by William IV and his queen, Adelaide, on 1 August 1831. Widened in 1902–4, it survived, despite wartime bombing, until 1970 when it was sold to Lake Havasu City in Arizona, USA, for £1,000,000; its replacement was opened by Queen Elizabeth II on 16 March 1973.

This stereo card shows London Bridge with half its roadway being resurfaced – traffic is crowded over to the eastern side and pedestrians keep to the pavement. Halfway across, there seems to be a hut, possibly for storage of tools and materials. Beyond, on the north bank, office buildings line the waterfront. St Magnus, the church of the Fishmongers' Company, stands out with the Monument to the Great Fire of 1666 close behind it and the tower and spire of St Margaret Pattens to the east; these still dominate the view from certain points along the river. [BB69/05664A]
Caption: London Bridge, London, England, 7-1698
Series: E W Kelley Publisher, Studio and Home Office, Chicago, USA

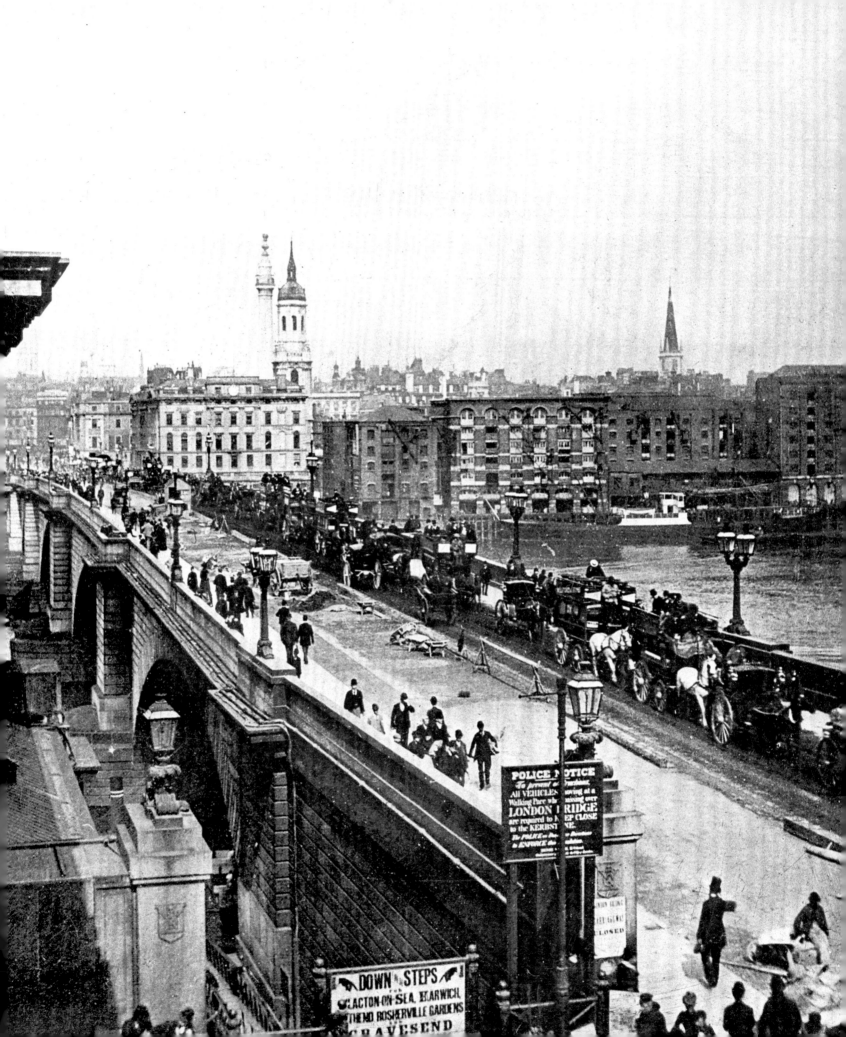

POLICE NOTICE
To prevent obstruction.
All VEHICLES moving at a
Walking Pace when passing over
LONDON BRIDGE
are required to KEEP CLOSE
to the KERBSTONE.
The POLICE have Instructions
to ENFORCE this Regulation.

CLOSED

DOWN STEPS
FOR
CLACTON-ON-SEA, HARWICH,
SOUTHEND, ROSHERVILLE GARDENS
AND
GRAVESEND

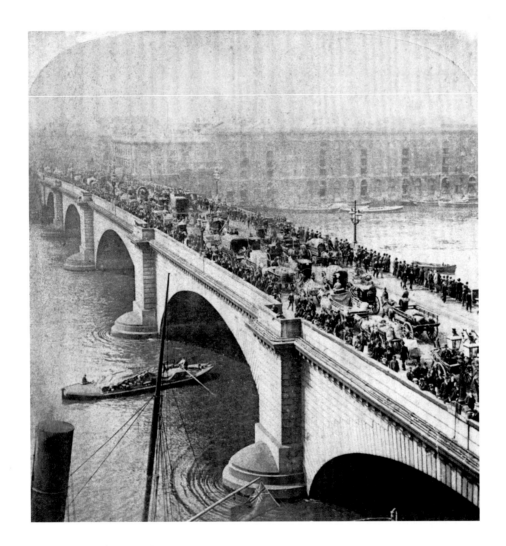

LONDON BRIDGE

The tower of St Saviour's, later Southwark Cathedral, can barely be discerned behind the warehouses on the south shore. Crowds of pedestrians flow across the bridge and the water swirls around the stone footings as a lighter slips through the bridge. Beside it are the Hibernia Wharves and warehouses, which take their name from Ralph de Hibernia and his son Alan, who held land here in the 13th century. [BB82/13468A]

Caption: London Bridge, England

Series: J F Jarvis, Publisher, Washington, DC. Sold only by Underwood & Underwood, Baltimore, etc.

Copyright 1887

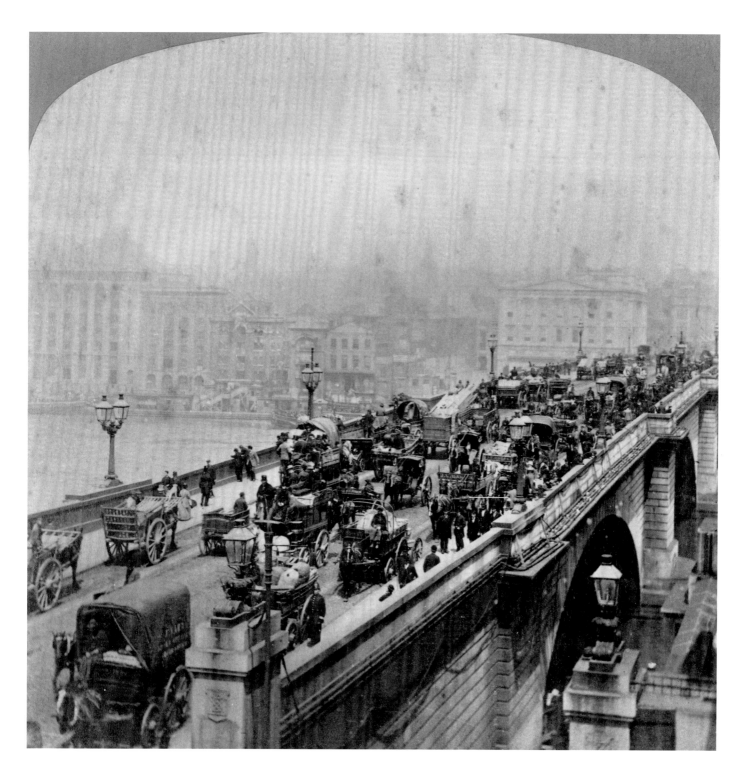

LONDON BRIDGE, LOOKING NORTH

This stereo card of about 1870 looks northwards across the bridge, busy with horse-drawn traffic. The spires of the City churches are scarcely visible, but Fishmongers' Hall stands out to the left of the bridgehead. The Fishmongers' Company had occupied the site since the early 16th century; the post-Great Fire hall had to be rebuilt along with London Bridge in the 1820s–30s. Its architect was Henry Roberts, much influenced by Sir Robert Smirke, who designed the new bridge approaches. [BB83/05717B]

Caption: London Bridge

Series: London & Neighbourhood, by York & Son. Stamped: Billikin & Lawley, 165 Strand, London (ie retailer)

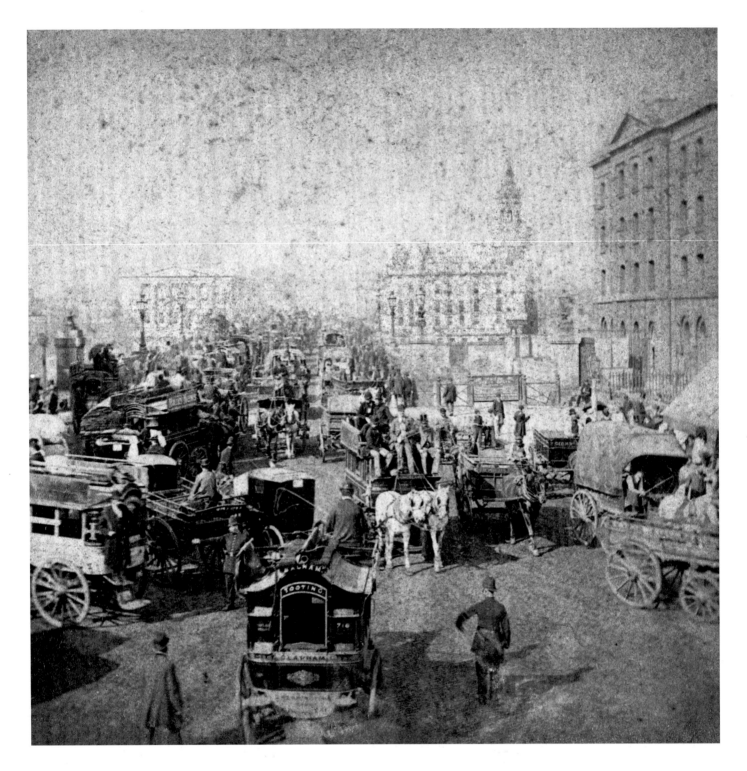

LONDON BRIDGE

This jumble of carts and wagons at the southern end of London Bridge must be the overspill from Borough Market to which Edward VI gave a charter in 1550, its rights vested in the Lord Mayor and citizens of London. This was confirmed by Charles II in 1671 and it continues, thriving, to the present day, selling fruit, vegetables, meat, poultry and fish. This stereo card of the 1850s shows Fennings Wharf to the right and on the north side of the river Fishmongers' Hall, London Bridge Wharf and the spire of St Magnus. This arresting shot catches the congestion, which three policemen struggle to control, and the sheer variety of carts going about their business. [BB83/04742]

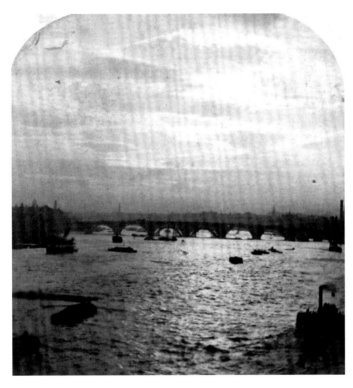

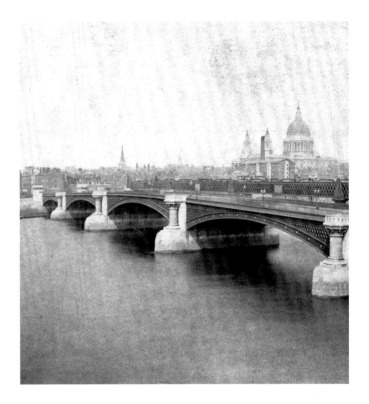

BLACKFRIARS BRIDGE

Blackfriars Bridge was the third to span the river in the central area of London. Completed in 1769 to designs by the young Robert Mylne, it served for almost a century before demolition in 1869. This rare stereo, showing steamers, barges and choppy waters, must have been taken in the late 1850s and provides a record of a structure otherwise known only from paintings and engravings. [By permission of the Trustees of the National Museums of Scotland]

BLACKFRIARS BRIDGE

The present-day bridge, opened in 1870, was designed by Joseph Cubitt with massive granite columns. St Paul's still dominates the City in this view. Between the bridge and the cathedral we can see Blackfriars Railway Bridge with Carron's Warehouse beside it. The steeple to the left belongs to St Martin Ludgate. [BB85/02144A]

Series: [Purple stamp] Orchadia, Goulton Road, Clapton, NE

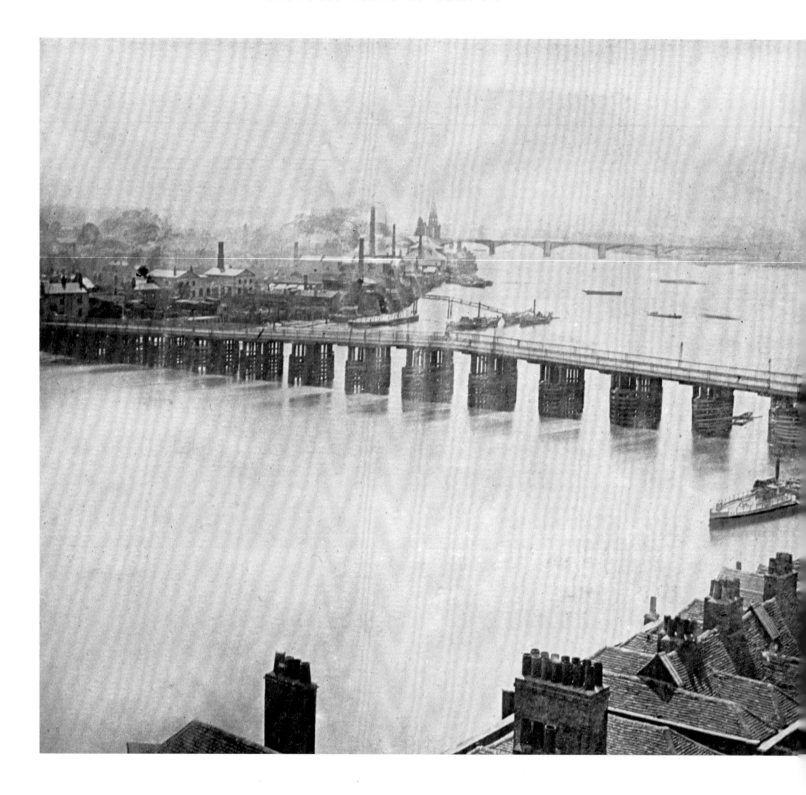

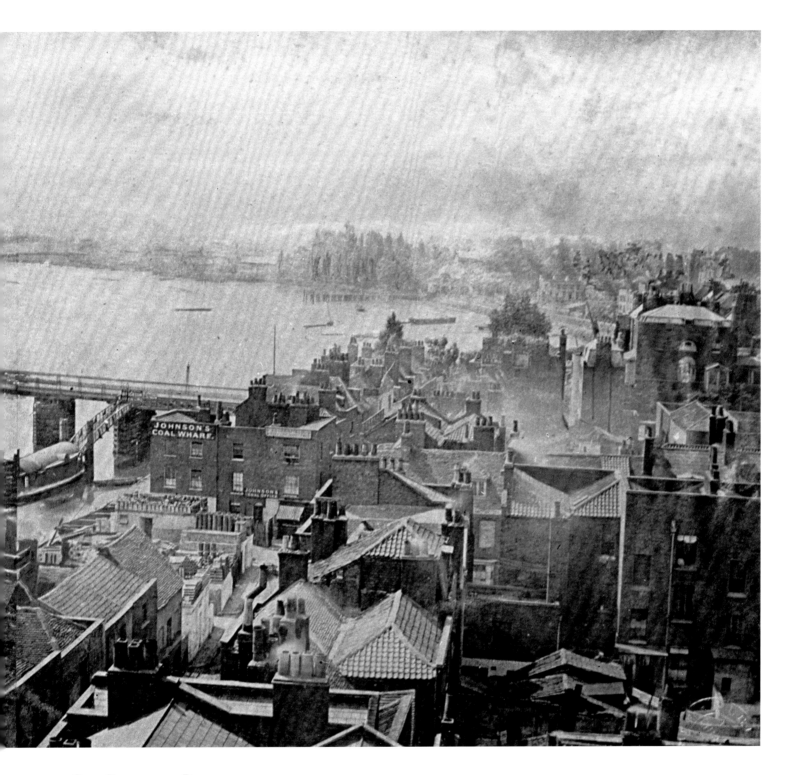

OLD BATTERSEA BRIDGE

This wooden structure was the subject of James McNeill Whistler's nocturne *Blue and Gold*, which he exhibited at the Grosvenor Gallery in 1877 alongside *Nocturne in Black and Gold: The Falling Rocket*. Ruskin's savage review of the latter work led to a libel suit brought by the artist which he won, though the costs nearly ruined him.

The sharpness of the buildings in the foreground is startling – it is possible to read the inscription on Johnson's Coal Wharf. This photograph was taken *c* 1870 by James Hedderly to record the area prior to the construction of the Chelsea Embankment. [BB91/27464]

43

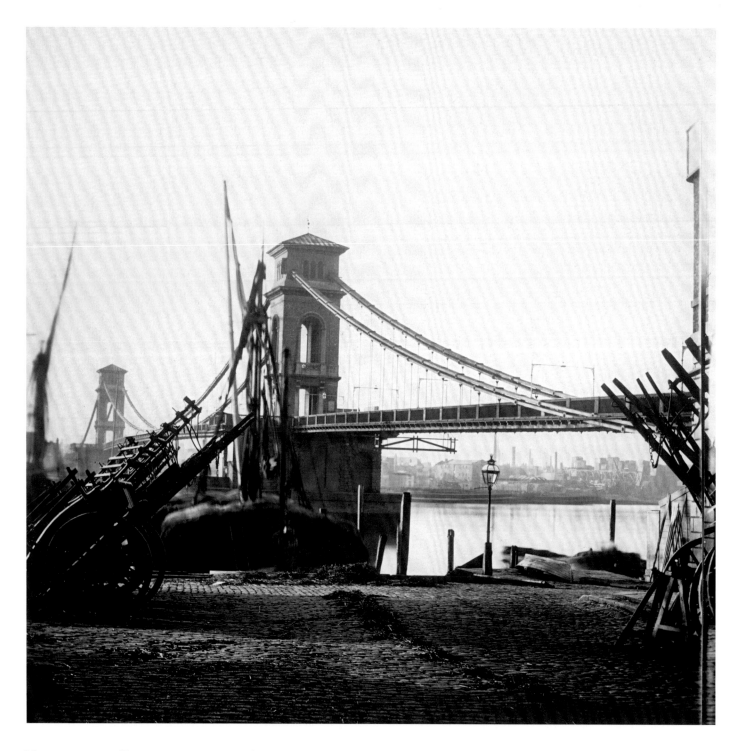

HUNGERFORD BRIDGE

Hungerford suspension bridge, completed in 1845 to designs by Brunel, was intended to provide a pedestrian link between Hungerford Market and the south bank, but the market closed in 1854 after a fire and the bridge was demolished to make way for Charing Cross Station. The chains, most appropriately, were used to complete Brunel's Clifton Suspension Bridge and two of the original piers were incorporated into the railway bridge on the downstream side, having been built in such a way that steamboat passengers could alight on them and climb a stairway to the bridge above. The present structure still has a footbridge to either side of the railway. [BB85/02179]

Caption: 874. Vue du pont suspendu à Londres

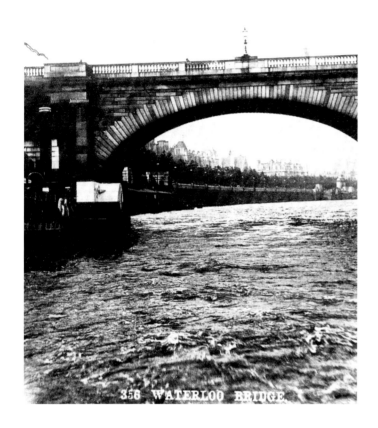

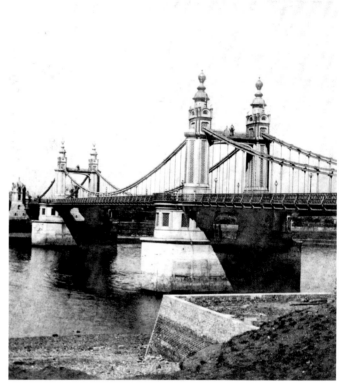

WATERLOO BRIDGE

The Thames runs fast under old Waterloo Bridge in this early stereo. The structure was designed by John Rennie, built 1811–17 and opened on the second anniversary of Waterloo, 18 June 1817, by the Prince Regent. Built of granite and spanning the river with nine elliptical arches, Antonio Canova described it as 'the noblest bridge in the world, worth a visit from the remotest corners of the earth'. It suffered a serious settlement in 1923 and was demolished in 1936, in spite of strong protests; it was replaced by a new bridge in 1937–42 with Sir Giles Gilbert Scott as its architect. [BB68/02379]

Caption: 356. Waterloo Bridge

CHELSEA BRIDGE

Chelsea suspension bridge was begun in 1851 to designs by Thomas Page and was opened in 1858 by Prince Albert and the Prince of Wales. It survived the onslaught of increasing traffic until 1935 when it was replaced by the present bridge, built to the designs of Sir Pierson Frank. [BB72/05898A]

Caption: No. 75. Chelsea Suspension Bridge

Series: Views of London and its Vicinity (Registered). By the London Stereoscopic & Photographic Co

» THE CITY OF LONDON

Within the boundaries of the Square Mile, first laid out by the Romans, London thrived and Londoners multiplied both within the City and in the countryside around. In 1851 the population of the county of London was just over 2¼ million; by the end of Queen Victoria's reign in 1901, it was more than 6½ million. There was great wealth here, contrasting with appalling, subhuman poverty and, always, ceaseless activity; these photos catch something of all three. This was Charles Dickens' London.

TEMPLE BAR

Temple Bar marked the western limit of the City, straddling Fleet Street with one great archway for vehicles and smaller entrances on either side for pedestrians. There had been a demarcation here since the 13th century, a simple bar slung across the road, but after the Great Fire of 1666 Sir Christopher Wren designed an arch of Portland stone. Here we are looking from the western side into the City.

This photograph was probably taken in the early 1860s. The arch was taken down in 1878 as it obstructed traffic. The stones were carefully numbered and stored, and Sir Henry Meux, the brewer and a former Lord Mayor, reconstructed it as a gateway to his estate at Theobalds, Middlesex. But the longing to return it to the City remained, so in 1976 a trust was formed and Temple Bar now stands on the south side of Paternoster Square facing St Paul's. [BB85/02171B]

Caption: No. 43. Temple Bar
Series: Views of London and its vicinity. Registered. By the London Stereoscopic & Photographic Co

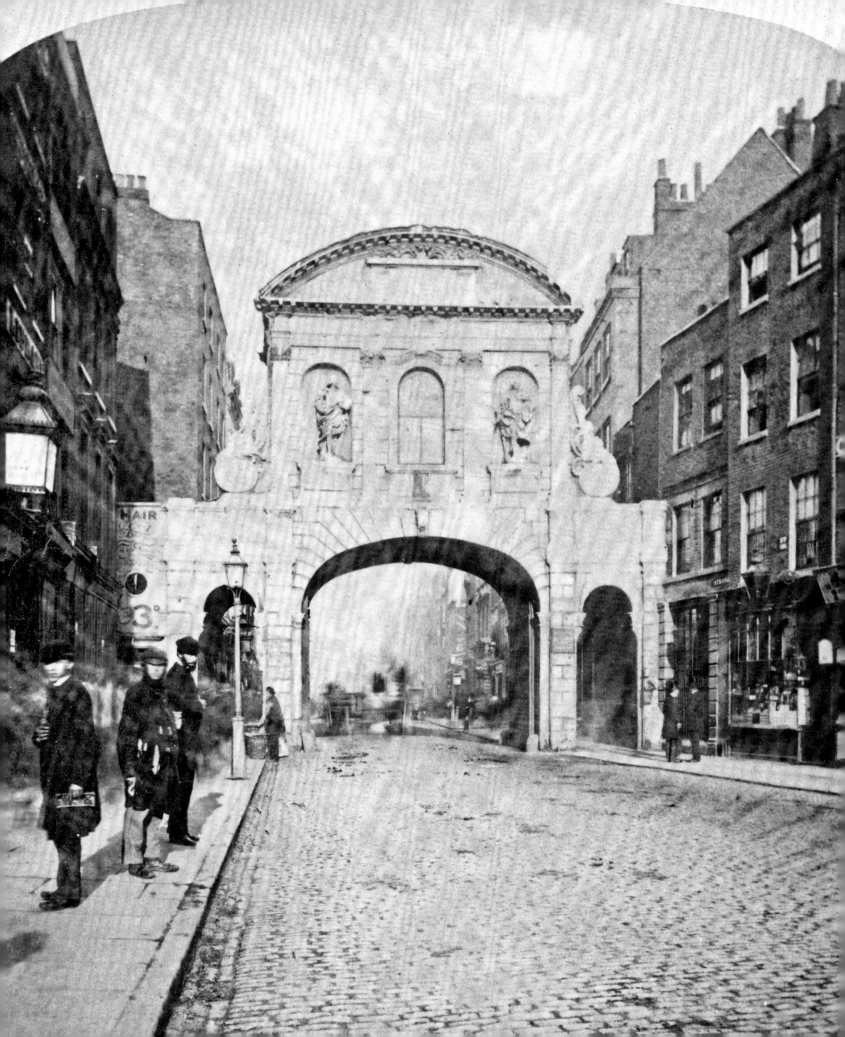

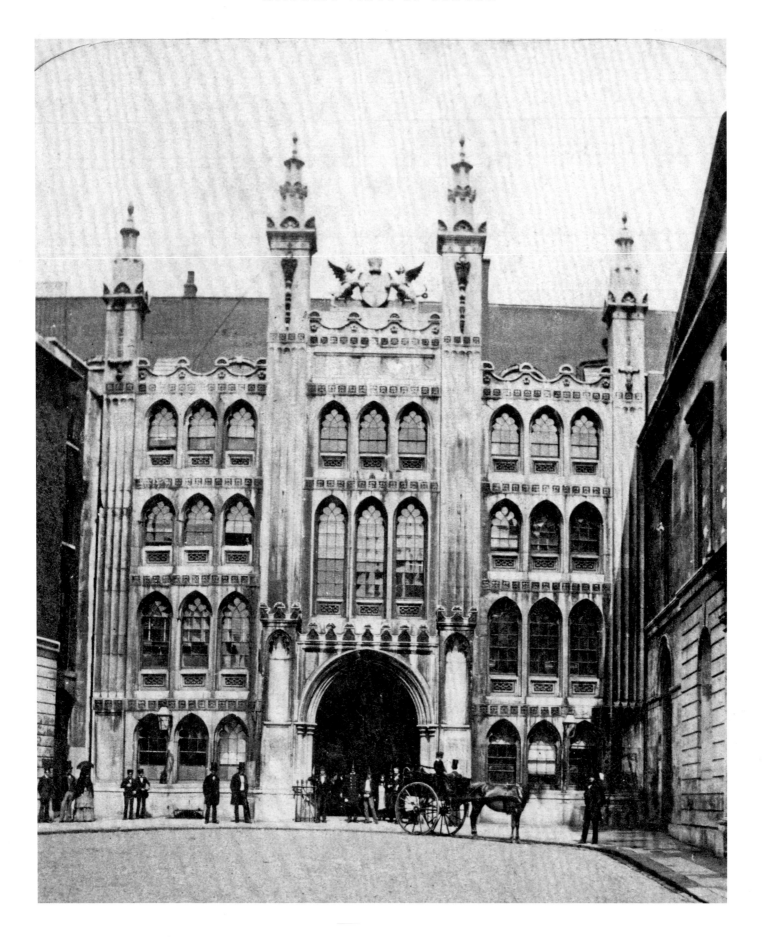

« THE GUILDHALL

The Guildhall, built on the site of the Roman amphitheatre, has been the administrative headquarters of the City of London since at least the mid-12th century and possibly even before the Norman Conquest. The present Great Hall, its roofline visible in this stereo image, was built between 1411 and 1430, probably by John Croxton; its walls survived both the Great Fire of 1666 and the Blitz of 1940 and, much restored, still stand today. This photograph probably dates from the late 1860s since it shows the new roof designed in 1850 by Sir Horace Jones, the City Surveyor. A carriage waits in front of the porch, which was given a new façade by George Dance the Younger in 1788. To the left is the corner of St Lawrence Jewry, one of Wren's post-Great Fire churches; to the right stands the Court of Queen's Bench, built 1823, also housing the Court of Common Pleas – much damaged in May 1941, it was demolished in 1987. [BB91/17988]

Caption: 4. Guildhall, City
Series: Views of London

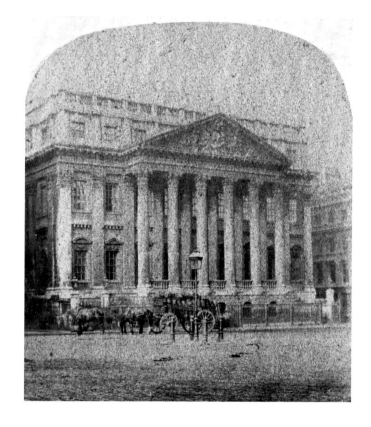

THE MANSION HOUSE »

This early stereo view shows the main façade of the Mansion House with its six Corinthian columns; the sculpture filling the pediment – by the young Robert Taylor – symbolises the dignity and opulence of the City. Horses wait patiently in the granite-paved roadway, their vehicle laden with wicker baskets – possibly filled with vegetables – ready for delivery.

Until the middle of the 18th century there was no official residence for the Lord Mayor – he entertained in his own house or rented some suitable mansion for the purpose. However, a need for such a residence began to be felt and so a committee was set up, money was raised, a site was selected – that of the old Stocks Market – and the Mansion House was built to the designs of George Dance the Elder, the City Surveyor. Its first resident was Sir Crisp Gascoyne in 1752; the magnificent dress worn by his niece for the grand opening is in the Museum of London. [BB91/18048]

Caption: 298. Mansion House, London

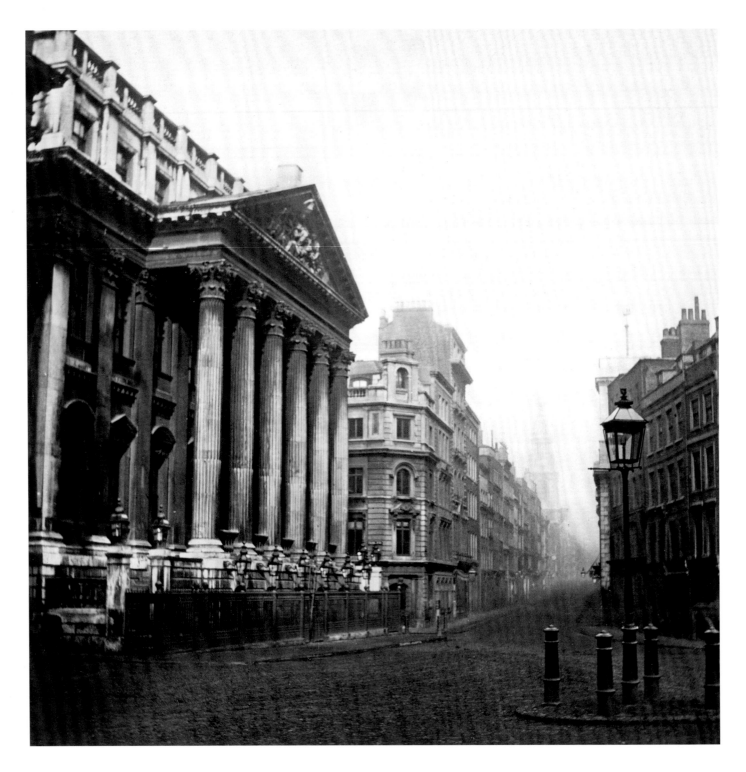

THE MANSION HOUSE AND POULTRY

This photograph of the 1860s, slightly later than the image on p 49, looks westwards along Poultry towards Cheapside. The iron bollards shielding the lamp-post are visible in this view. The building just beyond the Mansion House pre-dates Messrs Mappin and Webb, silversmiths, who had arrived here by 1871; they were later replaced in the 1990s by James Stirling's No. 1 Poultry. Queen Victoria Street, created in 1869–71 to link the Victoria Embankment to the Bank of England, has not yet been cut through. There is a curious absence of passers-by, presumably because this shot was taken early in the morning. [BB85/02176]

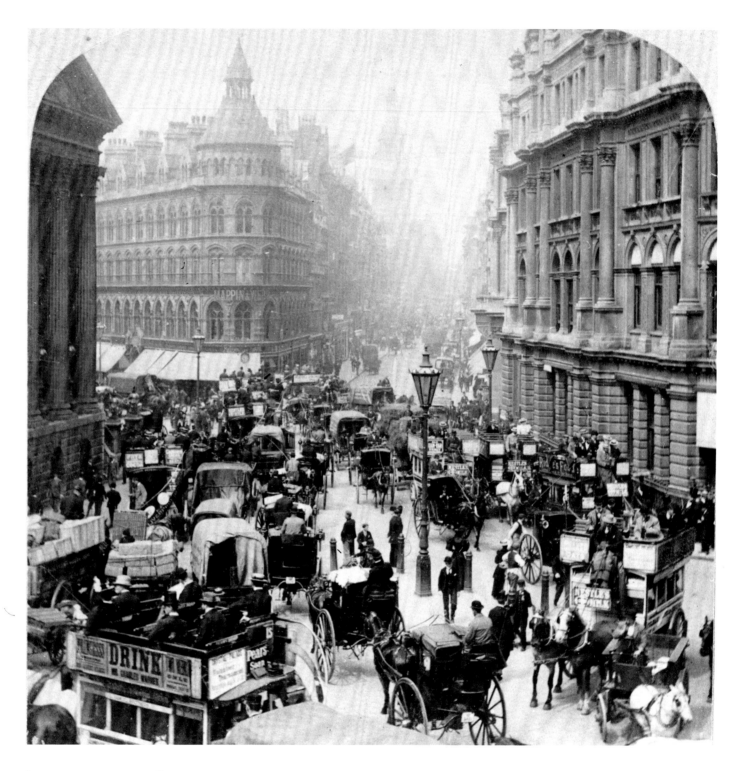

LOOKING TOWARDS POULTRY

The same scene, perhaps 30 years later, *c* 1896. The corner of the Mansion House is visible to the left. Queen Victoria Street has now been cut through, making an angle with Poultry, its apex filled by Messrs Mappin and Webb; their distinctive building was designed by J & J Belcher and was much loved. Open-topped buses, cabs, drays, carts and other vehicles throng the roadway. [BB69/03301A]

Caption: Cheapside, the World's Commercial Centre, London, England
Series: Strohmeyer & Wyman, Publishers, New York. Sold only by Underwood
& Underwood, New York etc. Copyright 1896

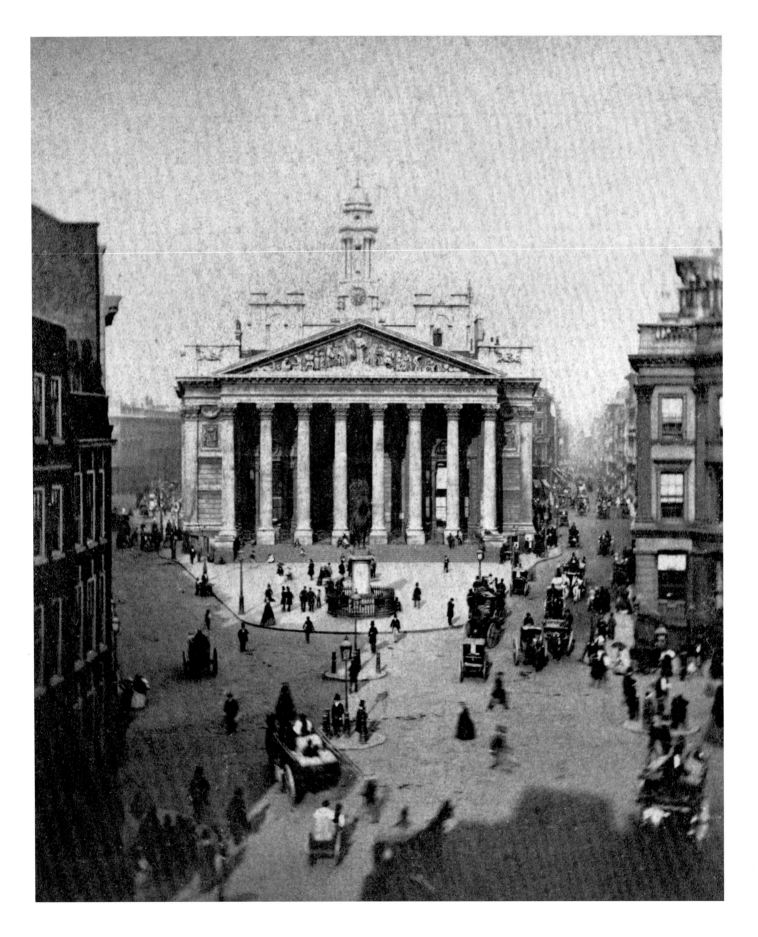

« THE ROYAL EXCHANGE

Following the example of the Bourse in Antwerp, in 1570
Thomas Gresham established the Royal Exchange – at his
own expense on land provided by the City – as a meeting
place for merchants. He had hoped it would be known by
his name, but when Elizabeth I visited the new building
on 23 January 1571, she declared that it must be known
as the Royal Exchange and so it has been ever since. That
first building disappeared in the Great Fire of 1666 and
was replaced three years later by another to the designs of
Edward Jerman, City Surveyor. This too was accidentally
burnt down in 1837 and this third building by Sir William
Tite now stands on the site. It is no longer a meeting place
for merchants – they have been replaced by office workers
– but there is still a central inner courtyard with small
expensive shops, the result of an internal reconstruction in
1991 by Colin Christmas. Gresham's grasshopper crest still
surmounts the cupola.

On the left are 18th-century brick buildings that would
soon give way to stone-clad offices (*see* p 51) and we can
look into the distance along Threadneedle Street and
Cornhill. Among the carts and behatted office workers, a
woman crosses the street in front of the statue of the Duke
of Wellington; it is a summer afternoon, perhaps some time
in the 1870s. [BB83/03182B]

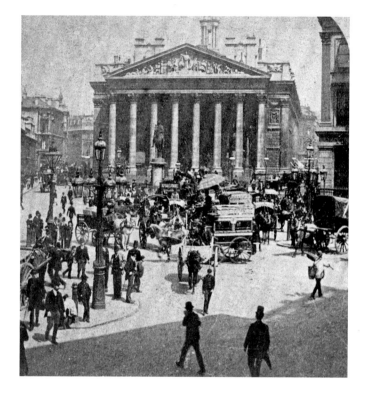

THE ROYAL EXCHANGE »

The same scene on another summer's day, perhaps a few
years later. There is more traffic now; an omnibus trundles
across the central space. Everyone wears a hat of some
description, ranging from caps for boys to top hats and
bowlers for the more established merchants and office
workers. [BB69/03303A]

Series: The Universal Stereoscopic View Co, 82 Broad St, NY

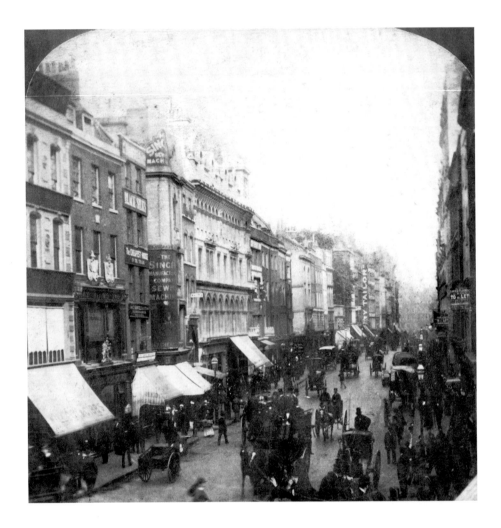

CHEAPSIDE
A busy day in 1880. Most of the premises are shared between several companies.
A group of figures at first-floor level with – possibly – an oriental pair above
mark the façade of No. 149, occupied by Lowden & Co, haberdashers; woollen
manufacturers Russell, Macfarlane & Co; and Monarch Kino, tailors (*see also* p 23).
The Singer Sewing Machine Company is nearby. [BB83/04741]

Caption: No. 756. Cheapside, with traffic

Series: London and Neighbourhood, by F York & Son

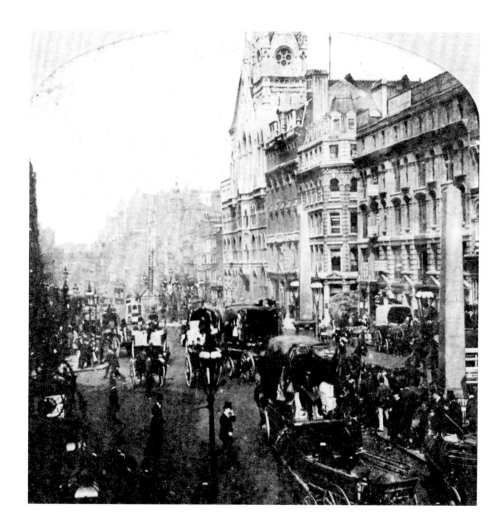

FARRINGDON STREET

Though the caption to this view describes it as Ludgate Hill, it is in fact a view north-westward up Farringdon Street, taken near the junction with Ludgate Circus. The impressive building on the right is the Congregational Memorial Hall, built on the site of the Fleet Prison and completed in 1872. The Labour Party was founded here in 1900 and the General Strike was organised from here in 1926. In front of it are two granite obelisks. One, set up in 1775, came to be seen as a memorial to John Wilkes. The other commemorated another radical mayor, Robert Waithman; erected in 1833 to designs by James Elmes, it now stands in Salisbury Square off Fleet Street. Wilkes's obelisk was dismantled in 1950 but unfortunately fell to pieces. [BB67/08247]

Caption: 2597. London, Ludgate Hill

Series: Foreign and American Views. Griffith & Griffith, Philadelphia, Pa.

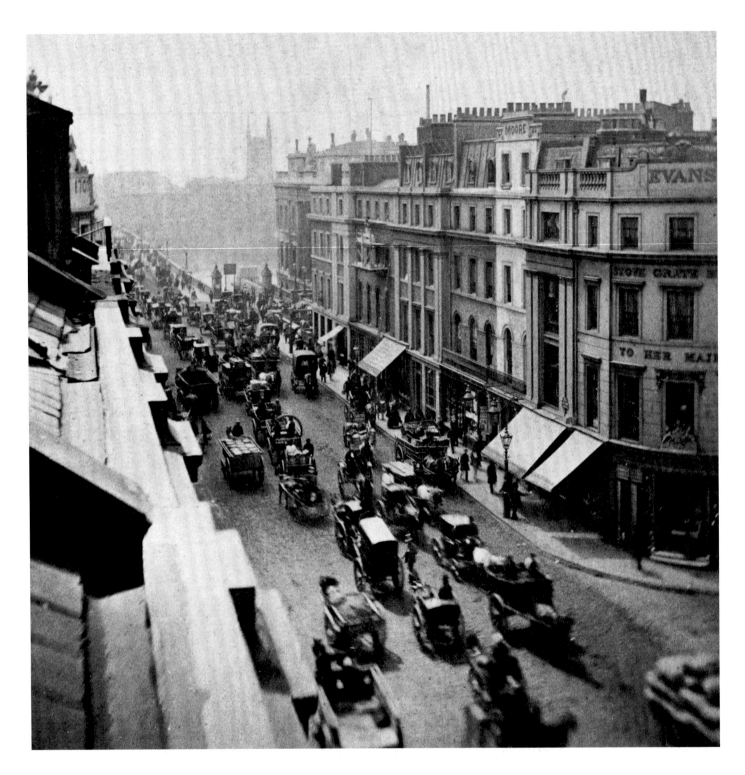

KING WILLIAM STREET

Laid out in 1829–35 as part of the approaches to the new London Bridge, King William Street was named in honour of the reigning monarch. The horse-drawn vehicles seem to flow briskly on a summer afternoon in the 1880s; we can see the bridge in the distance and across the river the tower of St Saviour's Church, now Southwark Cathedral. Lettering on the façade of the corner house with Arthur Street proclaims it as the offices of Messrs Evans, stove and grate suppliers to Queen Victoria. [BB83/03184B]

Caption: No. 59. London Bridge, looking towards Southwark. [Cowper quotation, see pp 14–15]

Series: Instantaneous Views of London

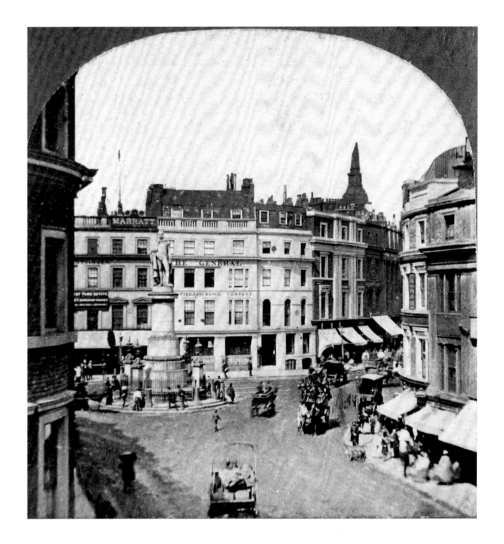

KING WILLIAM STREET

Near the London Bridge end of the street stood a statue of William IV by Samuel Nixon, erected in 1844; it marked the site of the Boar's Head Tavern where Shakespeare set Falstaff's roisterings in *Henry IV*. The statue has now been moved to Greenwich Park, but this stereo image of about 1865 shows it in its early glory. The spire to the right is that of Wren's St Benet, demolished in 1867. [BB93/06529]

Caption: London – King William Street

Series: Poulton's Stereoscopic Series of English Scenery and Buildings

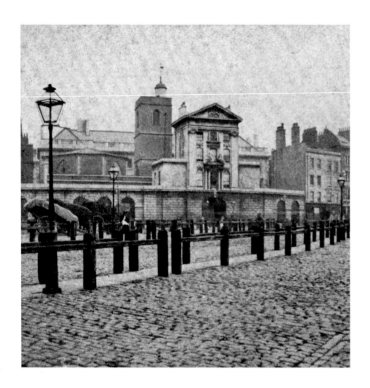

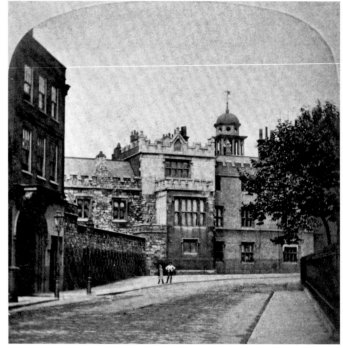

ST BARTHOLOMEW'S HOSPITAL

St Bartholomew's Hospital is London's oldest hospital, founded in 1123 by Rahere, Henry I's court jester, as part of the Augustinian priory which he established. Henry VIII, realising that a great city needs medical services, re-established the hospital and it continues to this day in buildings that are partly modern and partly those designed by James Gibbs in the second quarter of the 18th century, for which work he declined all fees.

Here we can see the gatehouse with a central statue of Henry VIII, flanked by Caius Gabriel Cibber's figures of Raving and Melancholy Madness, and behind it the tower of St Bartholomew-the-Less, the hospital's chapel. In front is the paved space of Smithfield, used as a live sheep and cattle market until 1855. This 1860s photograph shows the railings still in position; Smithfield has remained London's central meat market to this day. [BB013750]

Caption: 16. St Bartholomew's Hospital
Series: Views of London

CHARTERHOUSE

In 1350–1 Sir Walter de Manny, one of Edward III's most redoubtable knights, bought and gave to the City 13 acres of ground to provide a burial place for victims of the Black Death and in 1370 he founded a Carthusian monastery – the Charterhouse – here. It was dissolved at the Reformation and the buildings passed through various hands until Thomas Sutton, 'the richest Commoner in England', bought it to accommodate a school for 44 poor boys and a home for 80 poor gentlemen. The school moved to Godalming, Surrey, in 1872, but the pensioners remain and, despite wartime bombing, much of the medieval building survives.

In this stereo image of about 1860 we see the gatehouse and other buildings; to the right are the railings around Charterhouse Square. Two urchins stand, rather defiantly, on the pavement, watching the photographer. [BB95/03353]

Caption: No. 448. The Charter-house, Aldersgate
Series: Stereographs of London, by Valentine Blanchard

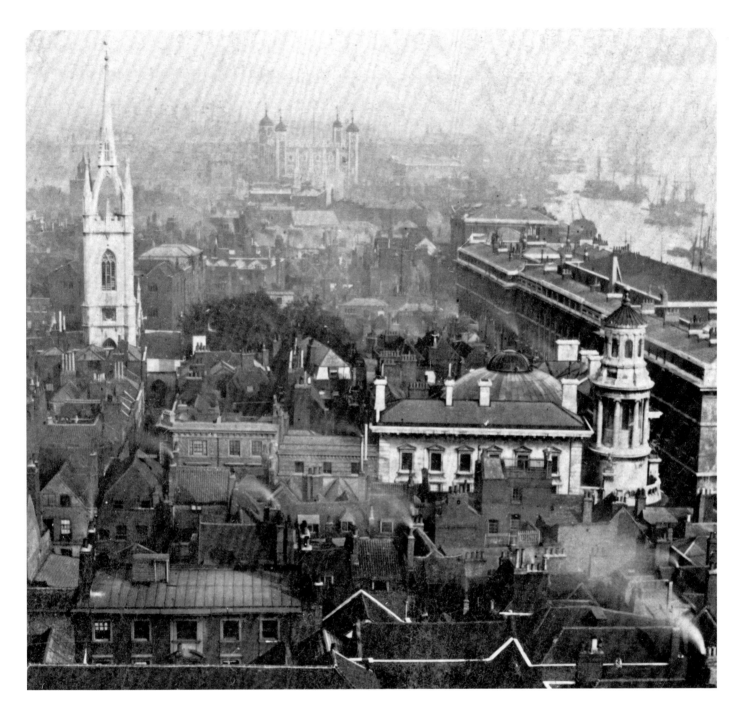

VIEW FROM THE MONUMENT
TO THE GREAT FIRE OF 1666

This 1870s stereo view, taken from the Monument, shows the tower and spire of Wren's St Dunstan's-in-the-East and to its right the rotunda and tower of the Coal Exchange. This early cast-iron building, designed by J B Bunning in 1847–9, was opened by Prince Albert; in spite of protests, the Coal Exchange was demolished in the 1960s.

In the distance, the Tower of London stands out clearly and the river is busy with substantial shipping. On the right is the new structure of Billingsgate Fish Market, rebuilt to designs by Sir Horace Jones, City Architect, and opened in 1877; there has been a market here since before the Norman Conquest, though in 1982 it was moved to a new site on the Isle of Dogs. [BB72/05905B]

Caption: London, from the Monument – the Tower and River in the distance
Series: J Elliot

» ST PAUL'S CATHEDRAL

On the western side of the City, on a low hill, stands St Paul's Cathedral. It is not the first place of worship to occupy this site since the original cathedral was established by St Mellitus in AD 604. Fires and Danish attacks destroyed that and subsequent buildings but the great structure – begun by Bishop Maurice soon after the Norman Conquest and finally completed in the mid-14th century – became one of the seven wonders of medieval Europe, with a tower and spire reaching 489ft (149m) into the air. This extraordinary building vanished in the Great Fire of 1666, to be replaced by Sir Christopher Wren's amazing and complex structure that, despite the Blitz and the bomb damage of the last war, still stands today.

St Paul's Cathedral
This view of St Paul's from Bull Wharf emphasises the relationship between the cathedral and its city. The dome and west towers dominate protectively and the spires and towers of a bevy of churches add their blessings. From left to right we have the tower of St Mary Somerset, the tower and spire of St Nicholas Cole Abbey (now Cole Abbey Presbyterian Church), and the tower and spire of St Michael Queenhythe (demolished in 1876 though its weathervane, a laden grain ship, survives today on Cole Abbey Presbyterian Church). The distant spire is probably that of St Augustine's (with St Faith, Old Change). On the river, barges and lighters push in to the quayside. [BB91/18987]
Inscription: T E Tayler, St Paul's [ie retailer]

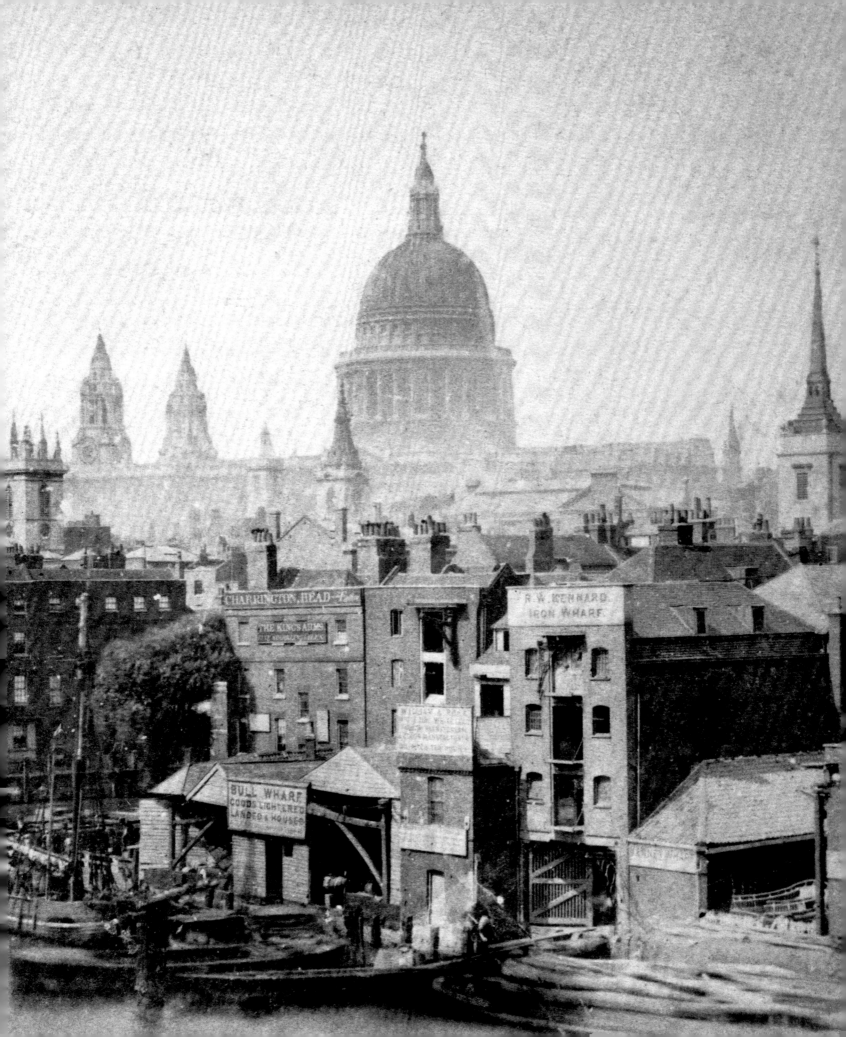

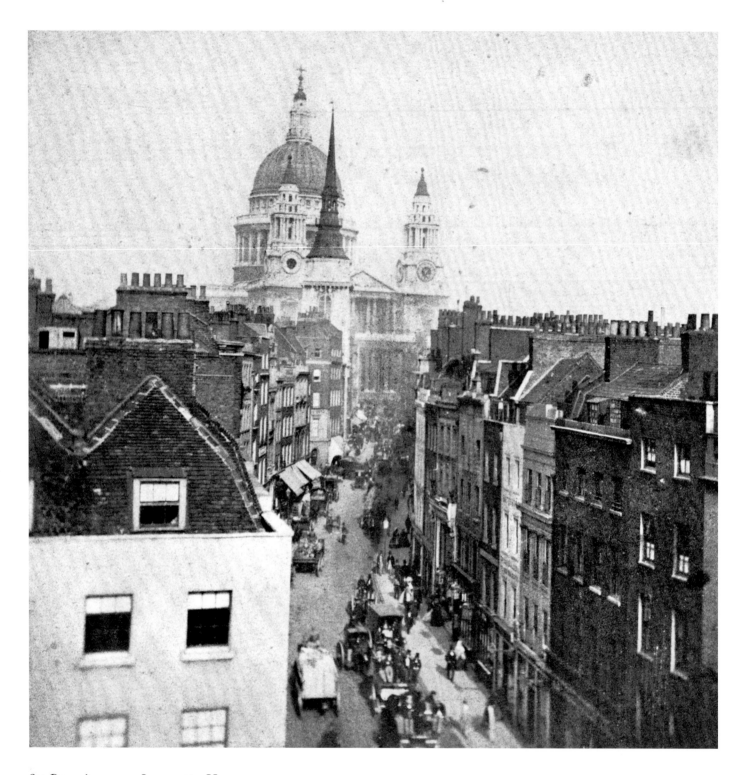

ST PAUL'S FROM LUDGATE HILL

Looking up Ludgate Hill towards the west front of the cathedral. The spire of St Martin Ludgate separates the view of the western towers, as Wren intended it to do; from the middle of the road further down the hill, that spire exactly bisects the sight of the dome itself. The traffic winds its way up the steep hill and walkers hurry along the pavements.

The house to the left has a roof of interesting pitch and structure; its tiles or slates look old. [BB83/01004B]

Caption: No. 57. St Paul's, from the foot of Ludgate Hill. [Cowper quotation, see pp 14–15]

Series: Instantaneous Views of London

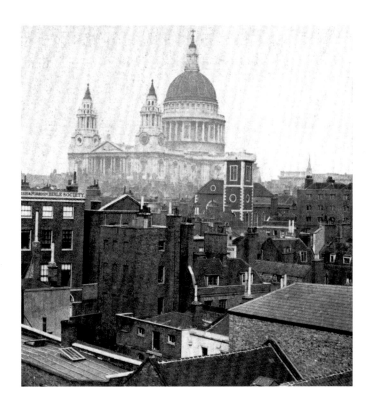

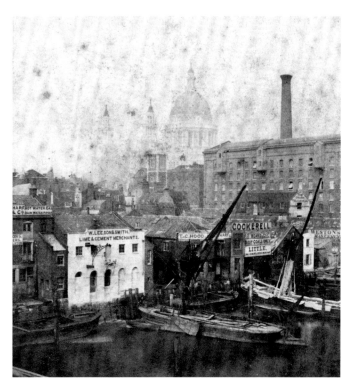

ST PAUL'S FROM BLACKFRIARS BRIDGE

This stereo view of St Paul's was probably taken about 1868, judging from a date written in ink on the back of the card. It shows the surroundings of the cathedral before Queen Victoria Street was cut through (in 1869–71). To the extreme left are the old headquarters of the British and Foreign Bible Society before they moved to newer premises in Queen Victoria Street and then, travelling across the image, we can see the tower of St Andrew-by-the-Wardrobe, the name of which indicates the proximity of the medieval Royal Wardrobe workrooms, and a more distant spire which could be that of St Augustine's (with St Faith, Old Change). [BB91/18988]

Caption: 18. St Paul's Cathedral from Blackfriars Bridge
Series: Views of London

ST PAUL'S FROM THE RIVER

St Paul's looms over this busy riverside scene of industrious dock workers and cranes swinging their loads, which was probably taken before 1860. The inscriptions on the wharves and warehouses advertise the various goods and services, such as providing rainwater pots, lime and cement, and coal; the firms are those of founders and engineers. We can also see the tower of St Andrew-by-the-Wardrobe and the chimney and massive bulk of Carron's Warehouse for cast-iron goods. [BB67/08244]

» THE TOWER OF LONDON

Following his victory at Hastings on 14 October 1066, William the Conqueror was crowned in Westminster Abbey on Christmas Day. Almost immediately he ordered the building of a rudimentary wooden fort beside the Thames, saying it would provide protection from attack upriver, though the Londoners realised it was intended to overawe them after their determined support of Harold at Hastings. William began the construction of the present Tower 11 years later. His architect was Gundulf, a monk from Normandy, who became Bishop of Rochester, and some of the stone for the building came from Caen, a tribute both to William's authority and his capacity for organisation.

When entrance fees were regulated and reduced in 1838, public access greatly increased and the Tower remains one of London's most popular attractions. The Tower is less sinister today but still formidable enough to be of use in the First and Second World Wars.

THE TOWER OF LONDON

The central keep of William's original castle – known as the White Tower because it was painted white in Henry III's day – stands 90ft (27.4m) high with walls 15ft (4.6m) thick at the base. Each corner is marked by a turret, three of them square and one circular to contain a staircase. Other defences grew up over the centuries, but by 1307 the whole complex was more or less complete, with two encircling walls, the inner with 13 towers and the outer with 6. Though there was comfortable living accommodation for the royal family and governor, and a chapel within its walls, the Tower still stood as a place of imprisonment, torture and execution, the symbol of ultimate authority.

The White Tower stands out clearly in this stereo image. The walls enclose it, with the Devereux Tower in the left foreground and the western end of the Waterloo Barracks behind it. Cab horses with their vehicles wait patiently for fares. This stereo card is undated, but was probably taken in the 1860s. [BB83/04740]

Caption: 108. The Tower of London

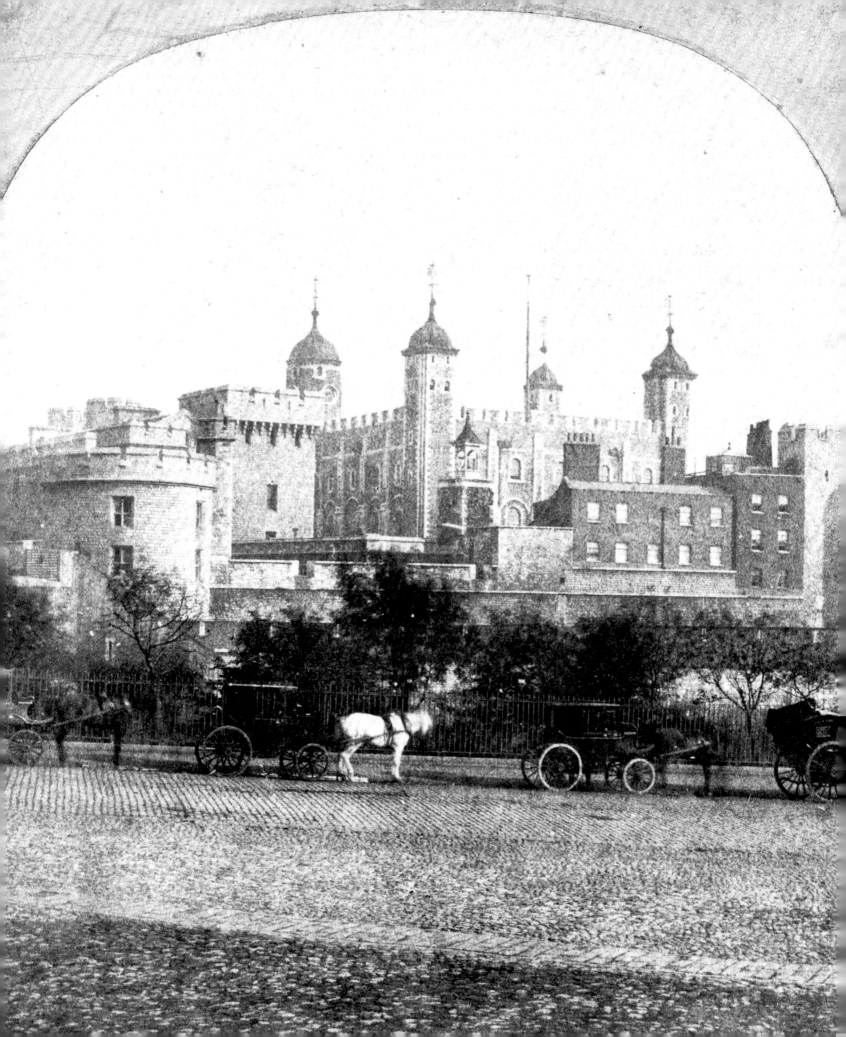

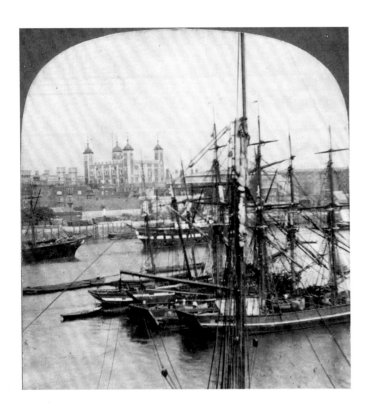

« THE TOWER OF LONDON
The Tower is seen here from the southern side through masts and rigging. The White Tower stands out and beyond we can see the Byward Tower. [BB85/02111A-2]

Caption: 104. The Tower, London. Taken from the Thames

Series: Instantaneous. Fred[c] Jones, 146 Oxford St, London

THE TOWER OF LONDON »
This handsome stereo view of the western approach to the Tower was probably taken from the roof of the Mazawattee Tea Warehouse, a vast Victorian storehouse on Tower Hill, burnt out in the Blitz. Between the two gatehouses we can see the square silhouette of the 18th-century Wharf Guard, demolished by 1870. The Lion Tower and menagerie buildings, which once would have filled the foreground, were demolished in the 1850s and the remaining animals sent to the Zoological Gardens in Regent's Park. The picket fence around the entrance and the sentry box on top of the left-hand Middle Tower are now gone. The Byward Tower fills the left centre and beyond we can see the bell turret of the Bell Tower; the view then opens up across the waters of the Thames and the Pool of London. This stereo photograph is one of the series taken by J Davis Burton in 1868. After the Wharf Guard was demolished, he returned and took the same shot for a second, fuller, series in 1870. [BB85/02174A]

Caption: No. 14. General view of the Tower from Tower Hill

Series: The Tower of London, photographed by special permission by J Davis Burton (Reg. No. 90)

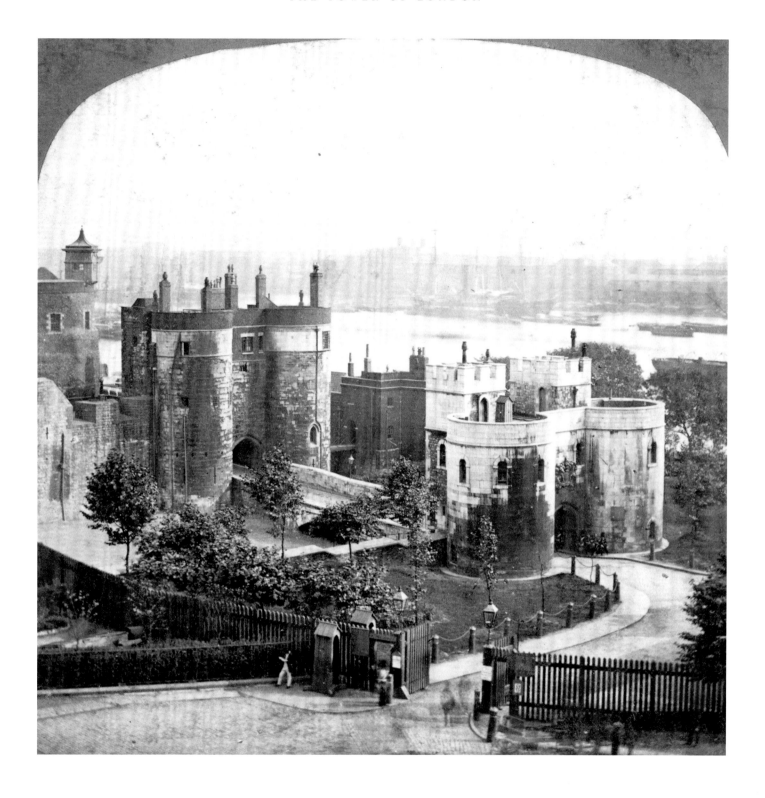

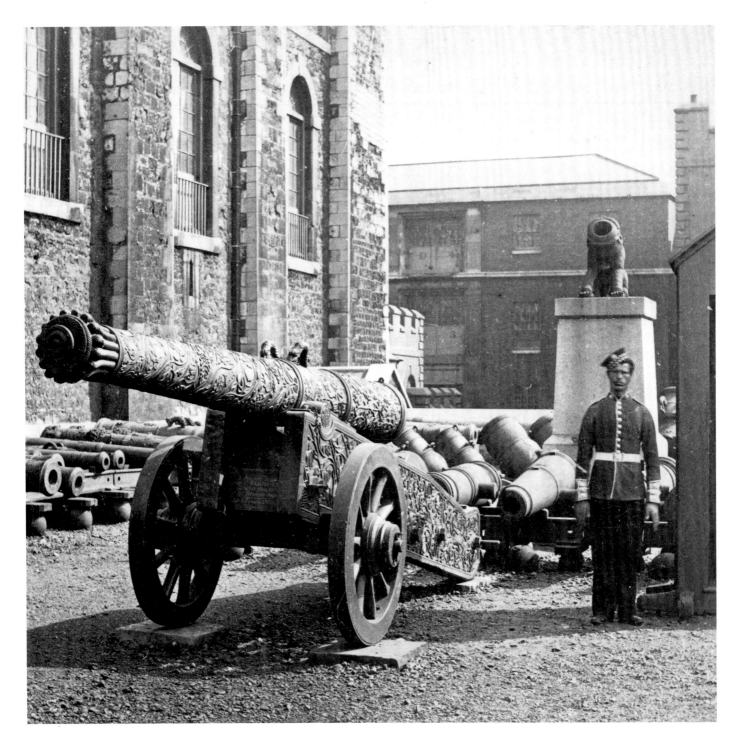

THE SULTAN'S GUN BESIDE THE WHITE TOWER

This magnificent bronze gun was presented to Queen Victoria by the Sultan of Turkey, Abdul Mejid, in March 1857 after the end of the Crimean War. The sentry guards it proudly with a stern expression. Behind him in the distance is the back of D-Stores, a storehouse built in 1789, but soon to be demolished. On the plinth immediately to the right stood a statue of the Duke of Wellington, now removed to the Royal Arsenal at Woolwich; here, it is occupied by the Tipoo mortar, taken after the Indian Mutiny in 1857–8. [BB83/05818]

Caption: No. 3. Trophy of Guns. West of the White Tower, the magnificent bronze gun in the foreground was presented by the Sultan to Her Majesty

Series: The Tower of London, photographed by special permission by J Davis Burton

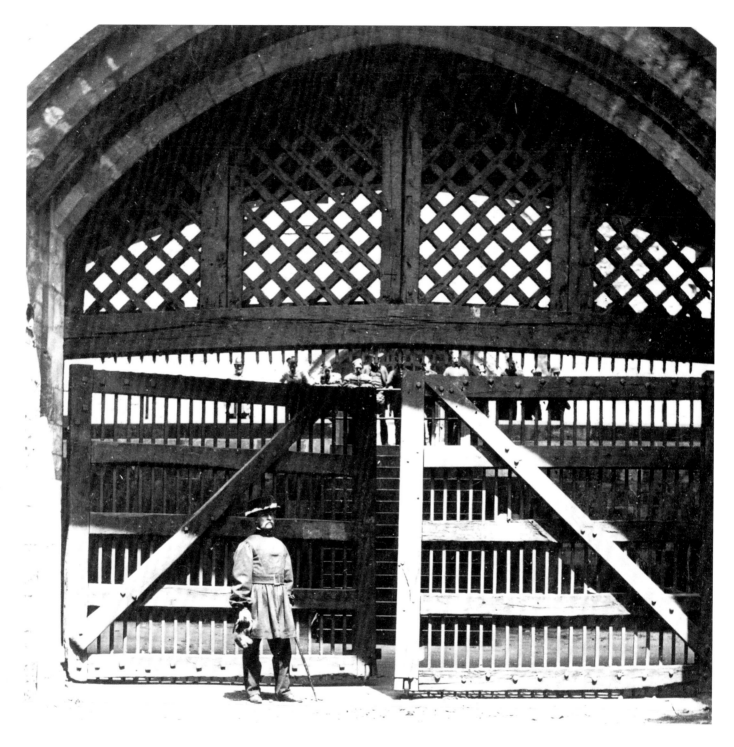

TRAITORS' GATE

Traitors' Gate was the riverside entrance to the Tower; according to tradition, a royal or political prisoner could be brought through here unobtrusively, his or her approach by water making any attempt at escape or rescue even less likely. Beside the massive gate stands a Yeoman Warder (one of the garrison of the Tower, also known as Beefeaters), resplendent in his uniform which dates from 1552. This one appears to be holding a cat by the scruff of its neck. [BB83/05824]

Caption: No. 17. The Traitor's Gate, the River's side – from the moat [followed by long description]

Series: The Tower of London, photographed by special permission by J Davis Burton

THE PARADE

The Waterloo Barracks were built in 1845 to designs by Major Lewis Alexander Hall, after a disastrous fire four years earlier had destroyed the Grand Storehouse. Before them, on the Parade Ground, the resident garrison is being drilled, a dog joining in the inspection. The troops wear fatigue tunics and stand at ease with their rifles held before them. This stereo photograph was taken in 1868. To the left of the view, though out of sight, lies the scaffold on which three queens of England perished – Anne Boleyn, Catherine Howard and Lady Jane Grey. [BB83/04749]

Caption: 11. Interior of Tower of London: The Parade

Series: Views of London [J Davis Burton]

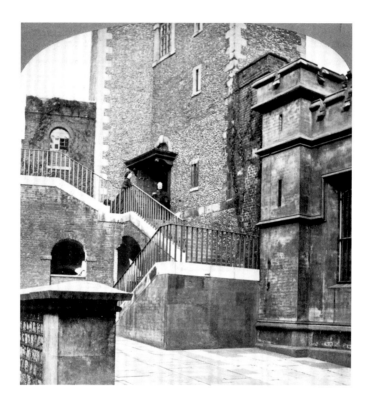

THE MARTIN TOWER AND THE JEWEL OFFICE
The 13th-century Martin Tower, once the prison of Anne
Boleyn and Lady Jane Grey, became the home of the
Crown Jewels in 1669 after the restoration of Charles
II to the throne nine years earlier. A famous attempt by
Colonel Blood to steal the jewels in 1671 was foiled; the
king, unaccountably, pardoned the miscreant and gave him
a pension. The Victorian building to the right became the
Jewel House in the mid-19th century. The couple visible at
the door of the tower are almost certainly the Keeper of the
Jewels, Lieutenant-Colonel Charles Wyndham, and his wife.
[BB83/05828]

Caption: No. 9. The Martin Tower and the Jewel Office [followed by a long description]

Series: The Tower of London, photographed by special permission by J Davis Burton

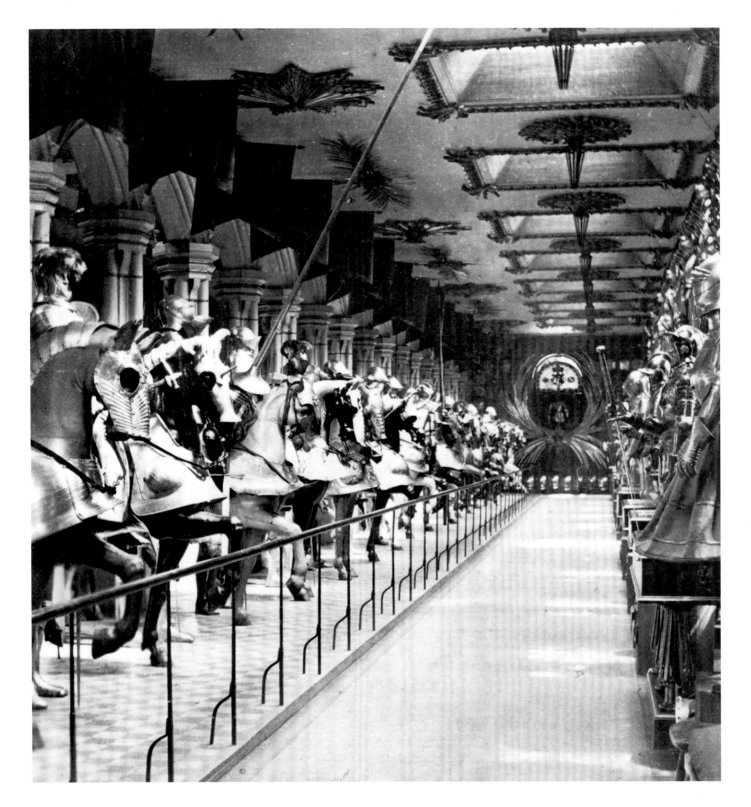

THE ARMOURY

The Line of Kings, one of the most popular sights in the Armoury. The mounted monarchs, seated on horses carved by Grinling Gibbons, display their armour and magnificent accoutrements. [BB72/05883B]

Caption: No. 7. The Horse Armoury [followed by a long description]
Series: The Tower of London, photographed by Special Permission,
by J Davis Burton

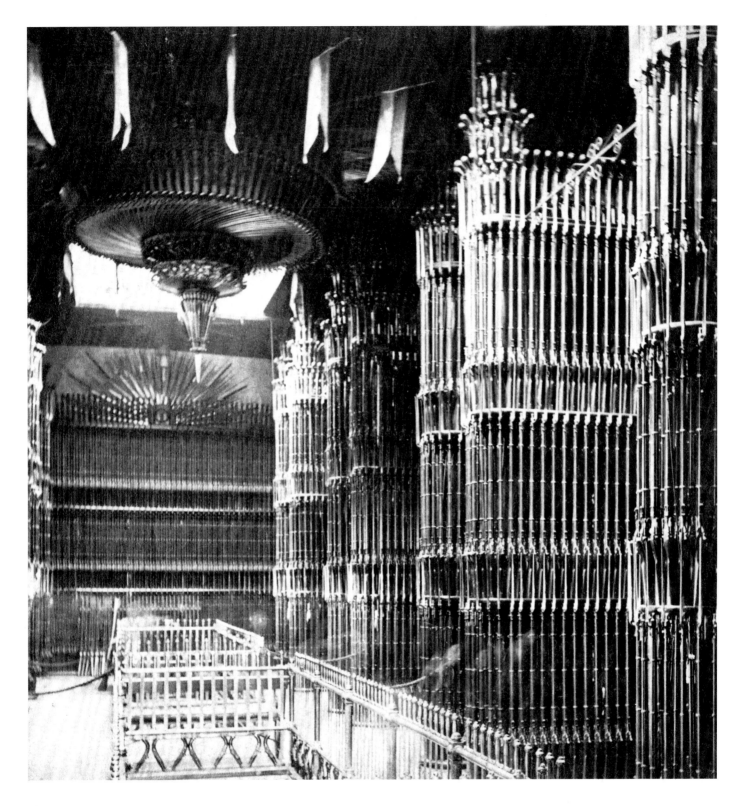

THE ARMOURY
This stereo image shows the Volunteers Armoury with the
breech-loading Lee Enfield rifles arranged in great towers.
The display was installed in 1863, so the photograph must
have been taken after that date. [BB94/00371]

Caption: The Tower of London
Inscription: S A Gracely, 27 Warwick St
Series: Views of London and its Vicinity (Registered) by the London
Stereoscopic Company, 110–108 Regent Street & 54 Cheapside

» WESTMINSTER ABBEY

A crossing place on the Thames, some two miles upriver from the Roman city, was the probable origin of Westminster; here a tiny church was built on Thorney Island. A monastery was later established there in 1052 by the last unchallenged Saxon king, Edward the Confessor. He moved his residence there from the Roman city, thus separating the seat of royal power and government from the commercial centre. Edward died on 5 January 1066 and was buried within the walls of his new foundation. The Norman Conquest followed and William was crowned in the abbey on Christmas Day, standing beside Edward's tomb. Thereafter, the abbey became the place of coronation, with Edward's hall beside it as the monarch's usual residence when in London. Of Edward's great abbey little remains since Henry III began rebuilding it in 1245. The original Romanesque building was replaced by a superb and lofty Gothic church finally completed in 1745.

WESTMINSTER ABBEY FROM THE NORTH-EAST
This view shows the laying out of Parliament Square to Sir Charles Barry's designs, intended to provide a setting for the rebuilt Houses of Parliament (*see* pp 78–89). The original granite bollards have been replaced by Gothic railings and Viscount Palmerston's statue by Thomas Woolner stands facing the ornate gates to the Houses of Parliament created by John Hardman of Birmingham; the figure has now been moved to the adjacent, Whitehall side of the square. This square received London's first traffic signals in 1868 and became the first gyratory system in 1926; the 1950 rearrangement by Grey Wornum means that the central space is less accessible.

Beyond the square we can see the west towers and north aisle of the abbey with the apse of Henry VII's Lady Chapel to the east. Beside it, obscured by trees, is the tower of St Margaret's, Westminster, the parish church of the House of Commons since 1614. It is among the most delightful churches in London, with a wealth of funeral monuments to royal servants and companions. [BB85/02231B]

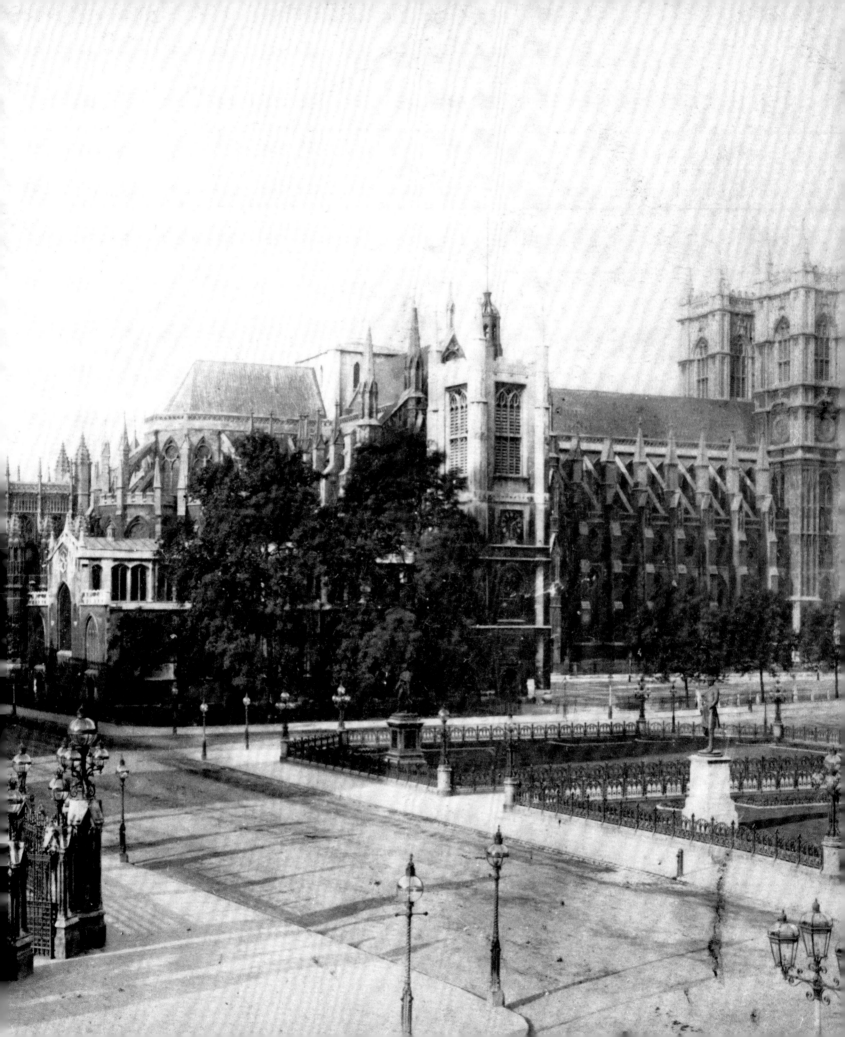

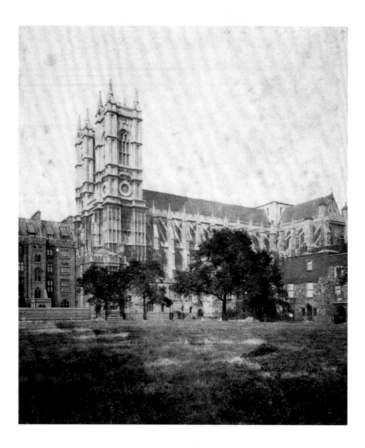

WESTMINSTER ABBEY FROM THE SOUTH-WEST
This view looks towards the south aisle and transept from Dean's Yard. This is a private space, well away from the bustle of traffic outside. On the right is No. 20 Dean's Yard, then the rectory of St Margaret's, Westminster, now the chapter office. On the left we can see the twin west towers added by Nicholas Hawksmoor in 1745, modifying plans by Sir Christopher Wren. [BB82/12126]

WESTMINSTER ABBEY FROM THE SOUTH-EAST
This early stereo photograph was taken in the late 1850s from near the top of the almost completed Victoria Tower. The outline of the abbey's roofs is clear before us and in the centre ground is the unrestored chapter house which George Gilbert Scott rescued from complete decay from 1863 onwards. The line of windows directly to the left of it lights the library, as it does today, with the cloisters beyond, and the twin gables show where the deanery was. In the distance on the left, work is beginning on the demolition of medieval Westminster and the building of its replacement, much of which is still with us. [AA006316]

Caption: Westminster Abbey from the Houses of Parliament

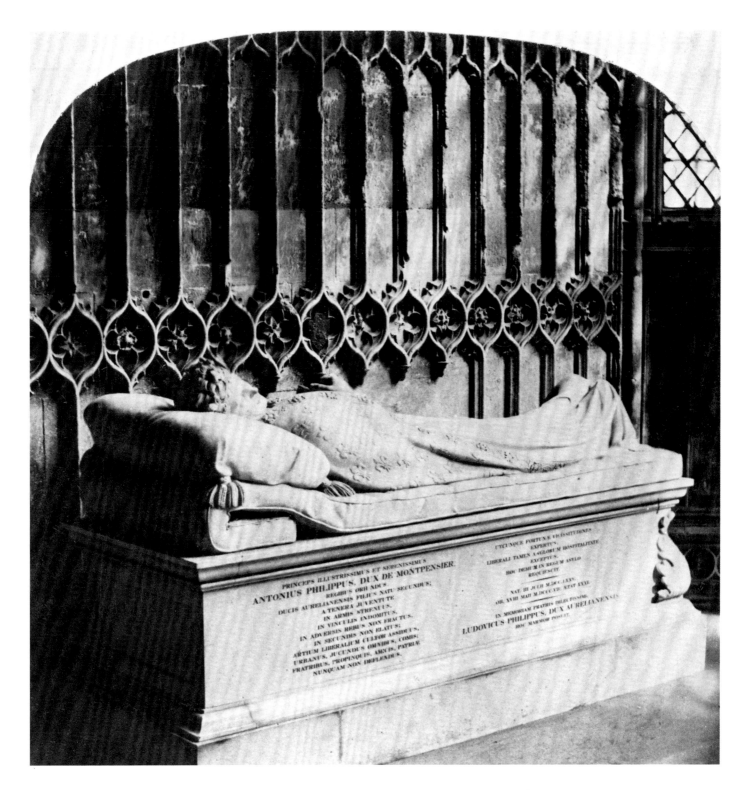

HENRY VII's LADY CHAPEL

This is the tomb of Antoine-Philippe, Duc de Montpensier, who died aged 32 in 1807. It was commissioned by his brother, Louis-Philippe, afterwards King of France, with an effigy by Sir Richard Westmacott. This shot provides an excellent record of the quality of the stone carving in Henry VII's Lady Chapel. There seem to have been questions as to whether it was proper that a member of a foreign royal family should be admitted to the sanctum, but the unfortunate young man keeps his place. [BB70/01567]

Series: V A Prout, Phot[ographer], Pub[lished] by J Elliott

THE HOUSES OF
PARLIAMENT

England's first parliament met in 1265 in the chapter house of Westminster Abbey. In the 1530s Henry VIII bestowed St Stephen's Chapel in the Palace of Westminster on his Members of Parliament as a settled meeting place. Though the accommodation was not perhaps particularly well suited to parliamentary business, and though the collegiate seating arrangements in the chapel tended to emphasise differences of opinion, the old Palace of Westminster remained the meeting place of both Houses until 16 October 1834, when a disastrous fire destroyed or damaged most of the buildings except the Great Hall. Charles Barry won the competition for a new Parliament building, with the volatile Augustus Pugin as his imaginative designer. Though parliamentarians grumbled, the new buildings went up surprisingly swiftly, the Commons' Chamber being in use by 1847 and supplied with central heating and ventilation designed by Dr David Boswell Reid.

THE PALACE OF WESTMINSTER
This shot of Parliament across the Thames has an infinitely romantic air. The stereo view probably dates from the 1860s since to the left we can see wharves and jetties that had all disappeared well before 1880. Further in the distance are the twin west towers of the abbey. [BB82/12127]
Caption: No. 426. The Houses of Parliament from Southwark
Series: Stereographs of London by Valentine Blanchard

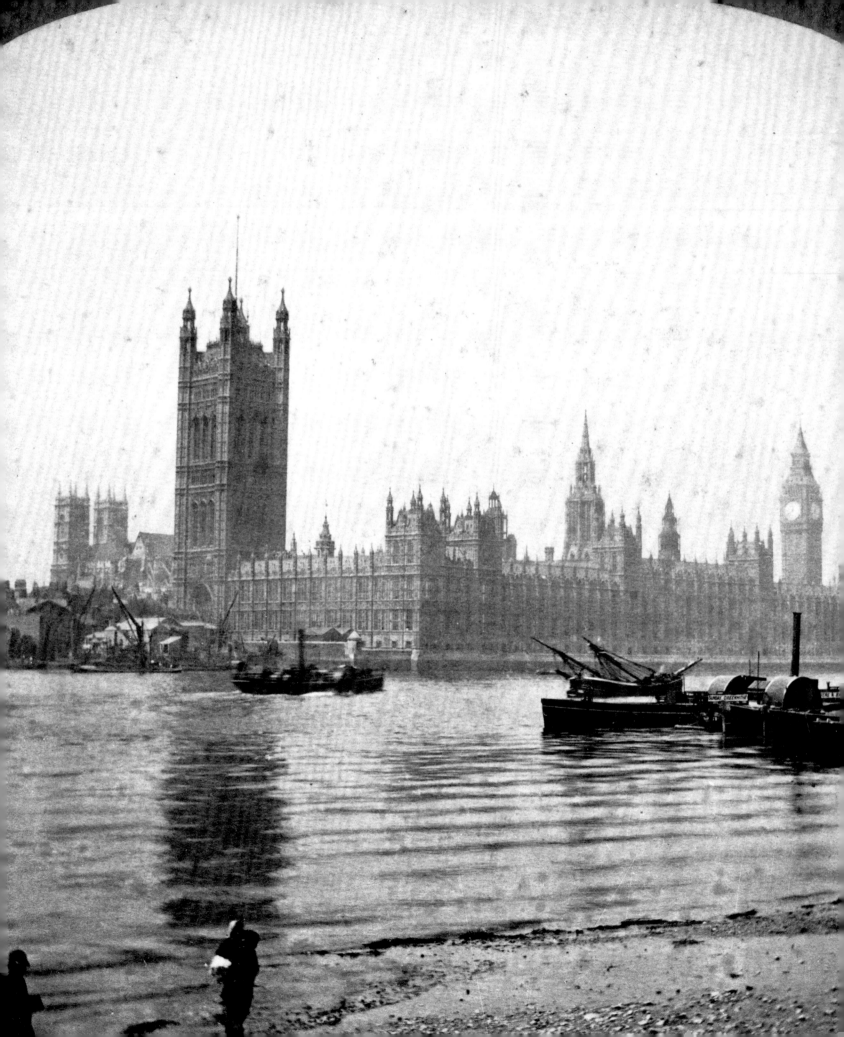

THE PALACE OF WESTMINSTER

This stereo photograph of 1860–70 shows the new palace complete and facing the river while William Kent's unifying frontage to the earlier Law Courts still runs along the western side and Sir John Soane's tower and entrance to those courts turn the corner to the north. These were all demolished in 1882–3. [BB83/01004A]

THE VICTORIA TOWER

Completed just before Barry's death on 12 May 1860, the Victoria Tower rises through 331ft (100.9m) with the Royal Entrance at its base and the muniments of Parliament on the floors above. To the left of the view, Kent's Law Courts are still standing and on the extreme right, a morsel of the eastern end of Henry VII's Lady Chapel is just in sight. [BB83/03761]

Caption: Victoria Tower – House of Lords

Series: London views, pub by F Jones

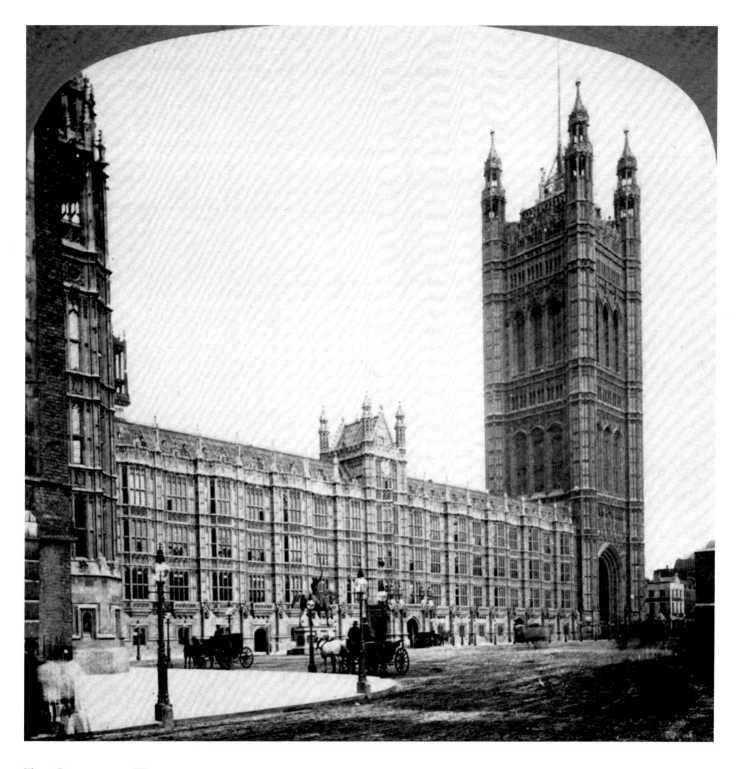

THE PALACE OF WESTMINSTER

This view shows Barry's new Palace of Westminster with the Victoria Tower, which was completed in 1860. Therefore this stereo image must have been taken after the tower's completion but before 1882 since, on the extreme left, a sliver of the brickwork of Sir John Soane's Law Courts, which were demolished then, is just in sight. [BB88/02307]

Caption: 6. Houses of Parliament, Victoria Tower
Series: London and Neighbourhood, by F York

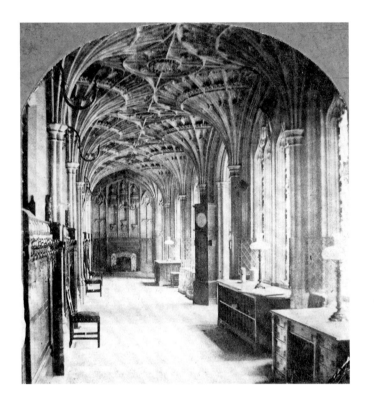

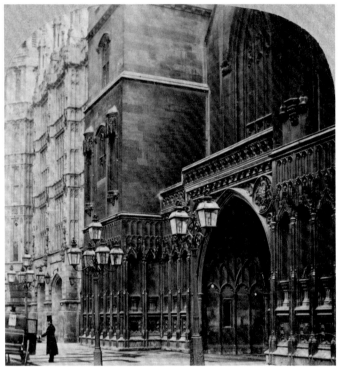

St Stephen's Cloister

This medieval cloister leading to St Stephen's Chapel has been heavily restored. Built in 1526–9, the bosses are carved with the arms of Henry VIII and Catherine of Aragon. When this stereo image was taken, perhaps in 1870–80, the corridor was in use as a Members' cloakroom. [BB91/14810]

Caption: Old St Stephen's Cloister, now used as a Members' cloakroom

Series: The British Houses of Parliament (Photographed by special permission)

West front of Westminster Hall

Westminster Hall is the oldest surviving part of the Palace of Westminster; William the Conqueror's son, William Rufus, built his stone Great Hall in 1097 around the wooden hall erected by Edward the Confessor. The upper half was raised and rebuilt for Richard II between 1397–9 with Henry Yevele as master mason and Hugh Herland as master carpenter.

This view shows the main entrance to Westminster Hall. The top-hatted doorkeeper opens the cab door deferentially; perhaps a Member of Parliament is arriving? [BB85/03137]

Caption: No. 1. Entrance to Westminster Hall

Series: Houses of Parliament

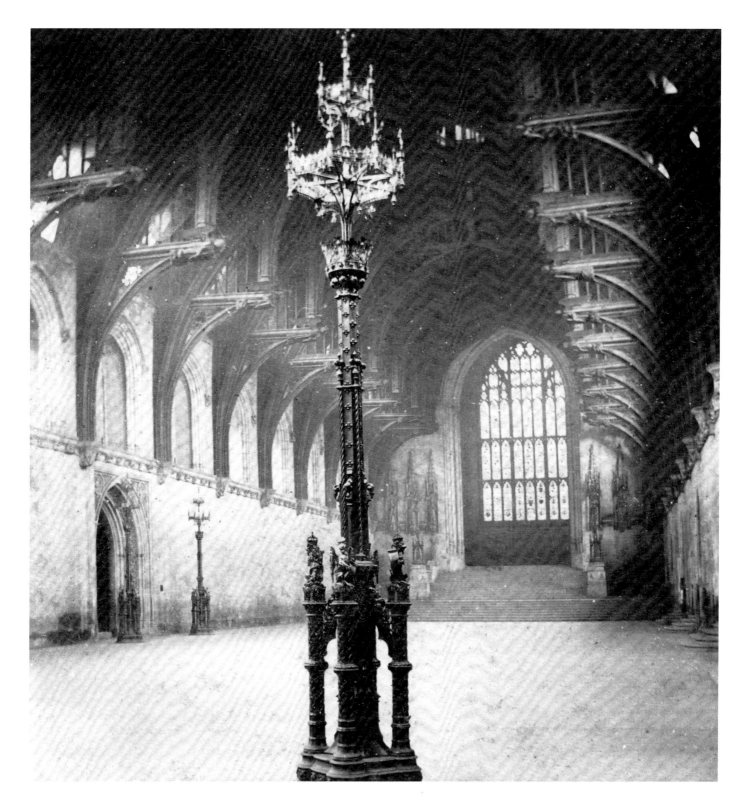

WESTMINSTER HALL

The most amazing feature of Westminster Hall was the oak hammerbeam roof, which leaps across the vault, avoiding the need for supporting pillars and so leaving the floor clear. This stereo image shows the carving of the projecting beam-ends, a magnificent candelabrum designed by Pugin in the centre of the floor and the great window at the upper end. [BB82/12128]

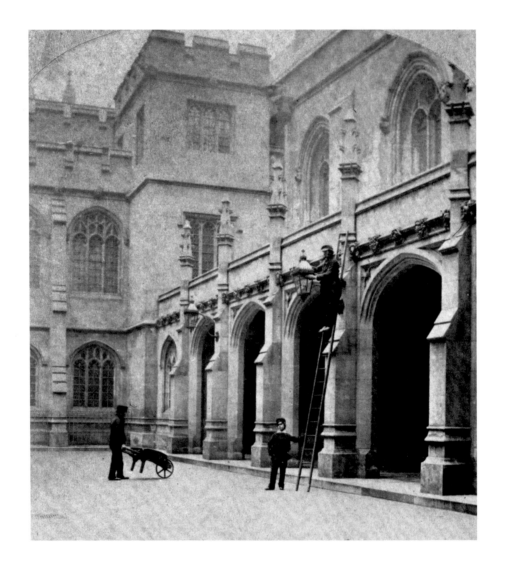

MEMBERS' PRIVATE ENTRANCE

Maintenance work goes on for the gas lamp outside the Members' Private
Entrance. A boy in a cap steadies the ladder while another top-hatted assistant
trundles a barrow across the courtyard. [BB95/12035]

Caption: The Colonnade, Members Private Entrance, Star Chamber Court

Series: Houses of Parliament

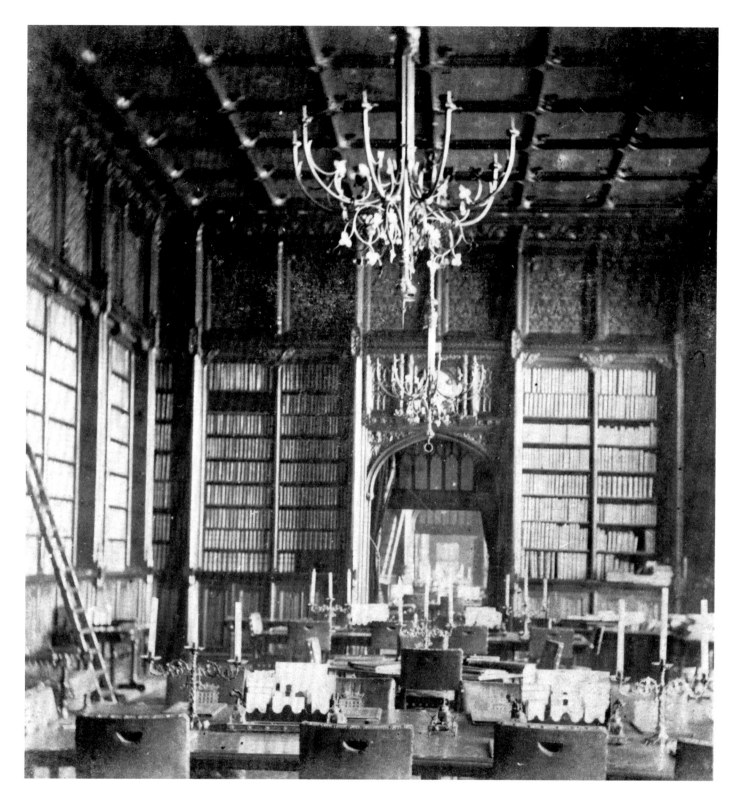

HOUSE OF COMMONS LIBRARY

This is where the Members prepare their work – one of the hardest used libraries in the world. Volumes and reports line the shelves; a ladder is propped up, ready to retrieve whatever may be required. Once again, the candelabra are to Pugin's designs. [BB95/12034]

Caption: The Library of The House of Commons

Series: The British Houses of Parliament (Photographed by special permission)

RICHARD I, OLD PALACE YARD

Carlo Marochetti's statue of Richard I, who was known as Coeur de Lion, dominates Old Palace Yard; the plaster model for it had been displayed in the 1851 Great Exhibition in Hyde Park and a cast was in the Crystal Palace. The exposed late medieval brickwork on the left has been revealed, temporarily, as the rebuilding progresses. [BB90/14886]

Caption: Statue de Georges IV, Londres [sic]

Note: This stereo card is unusual in that it is covered in a French tissue, pinpricked at intervals to create a night-and-day effect.

BROAD SANCTUARY

This shot of Broad Sanctuary – the surroundings of Westminster Abbey – gives a wider prospect. St Margaret's, Westminster, the Commons' own church, sits on the abbey's lawn with Big Ben behind it. The archway a third of the way up Big Ben was intended to provide an abutment for a wing enclosing New Palace Yard; that plan was abandoned in 1864 when Barry's son, also Charles, designed a Gothic arcade and the railings that complete the enclosure today.

On the left is William Inwood's battlemented Westminster Hospital, with the single storey of the Old Middlesex Guildhall. In the distance is the north side of Bridge Street with houses built in 1741 by Andrews Jelfe. These houses disappeared between 1860 and 1864, when Westminster Bridge was rebuilt and Bridge Street widened; Portcullis House fills the site today. [BB83/05826]

Caption: 127. St Margaret's Church and Clock Tower, Westminster

Series: Instantaneous

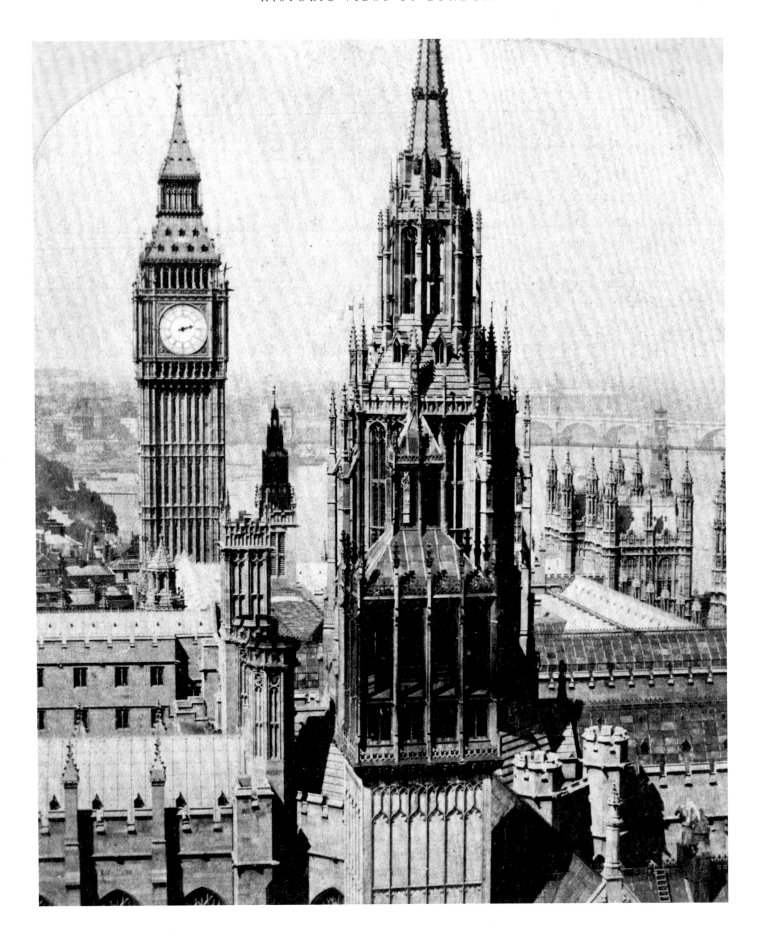

« BIG BEN AND TURRETS

This elevated view is of the rooftops of Parliament with Big Ben and the central tower, which provides ventilation to the building, dominating the scene. The small turrets serve as the outlet stacks to Dr Reid's ventilating scheme. The surviving wharves (*see* p 79) are just in sight beyond Big Ben.

In the background to the right, John Rennie's Waterloo Bridge (1811–17) is visible. The line in front of it, seemingly at river level, is the deck of Brunel's suspension bridge removed in 1860 and replaced by Hungerford railway bridge. Those with good eyesight may be able to discern, on the extreme right, a diagonal line representing one of the chains of the bridge which were put to proper use again, four years later, holding up Clifton Suspension Bridge near Bristol. [BB83/05817]

Caption: Clock tower and turrets of the Houses of Parliament, with Hungerford and Waterloo Bridges in the distance

STAR CHAMBER COURT »

Industrious efforts are being made to keep Star Chamber Court, adjacent to the Members' Private Entrance, immaculately tidy. [BB83/04738]

Caption: Houses of Parliament, Star Chamber Court

» LANDMARKS OF WESTMINSTER

Westminster Abbey, the Palace of Westminster, the Law Courts and finally Parliament had settled together in a tight enclave, which acted as a magnet for the rapid development of a second centre, upriver from the original Roman city. Royal officials and royal suppliers alike needed accommodation and housing; more humble individuals ready to provide their services followed them. Land was purchased or leased and buildings grew up. Even after Whitehall Palace was burned down in 1691 and 1698, the officials remained, their departments becoming the government ministries which fill the street today.

PALL MALL

The stereo view shows the western end of Pall Mall, just beside Marlborough Gate; the photographer seems to be working from an upper storey in St James's Palace. Below him, the Life Guards are drawn up and the watchers thronging the north side of the street peer eagerly eastwards. We are close to Marlborough House on the south side of Pall Mall, in which the future Edward VII and his bride, Princess Alexandra of Denmark, made their home. The broad crinolines of the watchful ladies indicate a date in the early 1860s. Could they be waiting for Edward and Alexandra, returning from their honeymoon in April 1863?

We can see the Shakespeare Gallery – the pedimented building on the far right of the image – which was designed by the younger George Dance for Alderman John Boydell, surely one of the noblest and most generous of attempts to support the arts in Britain. Constructed in 1788–9, the façade had a large panel by Thomas Banks showing the playwright reclining against a rock between the Dramatic Muse and the Genius of Painting. The building was acquired by the British Institution when the loss of trade due to the Napoleonic Wars ruined the good alderman. By the late 1860s the British Institution was failing too and in 1868 the building was demolished and replaced by the Marlborough Club. Banks's panel was moved to Stratford-upon-Avon and survives in the New Place Garden. [BB94/00369]

Caption: Pall Mell [sic]

Series: Views of London and its Vicinity (Registered), by The London Stereoscopic Company, 110 & 108 Regent Street & 54 Cheapside

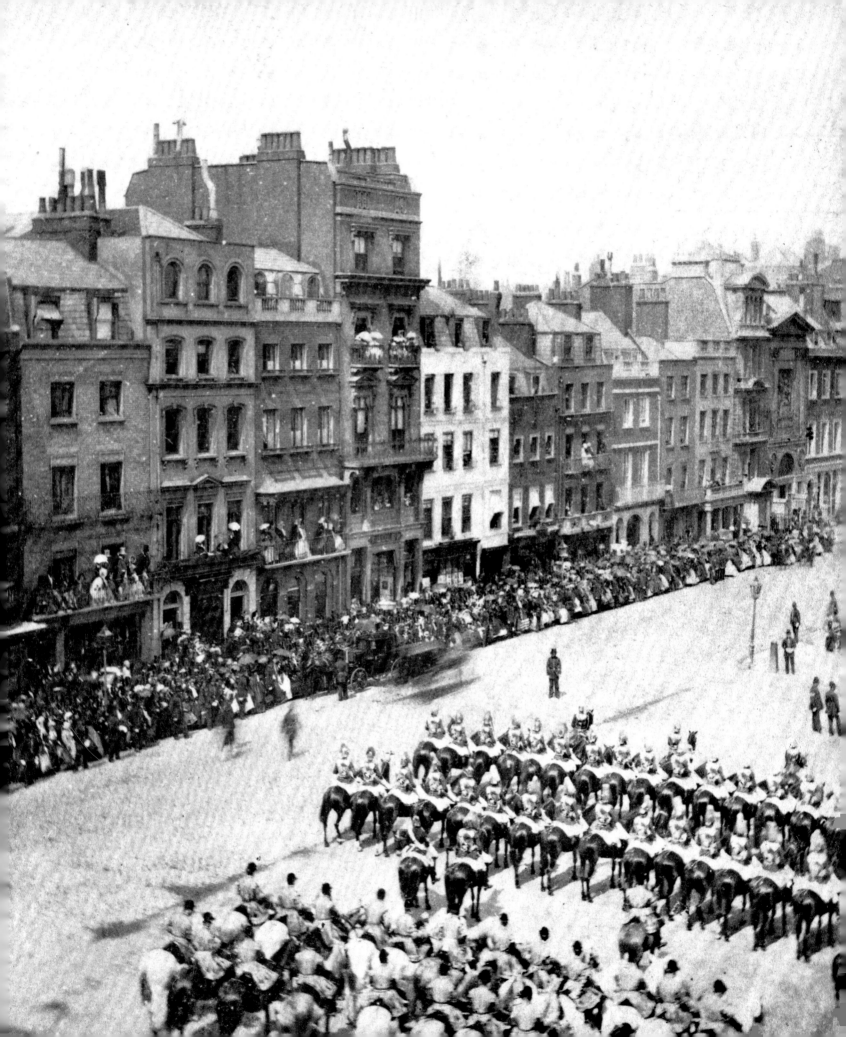

ADMIRALTY, WHITEHALL

This early stereo photograph shows the Admiralty, which stands at the northern end of Whitehall on the west side. The main house of 1723–6 by Thomas Ripley, Sir John Vanbrugh's successor as Comptroller of the Office of Works, replaced an earlier mansion by Wren which had burned down; wood carvings of nautical instruments, possibly by Grinling Gibbons and saved from the earlier building, are in the boardroom. Across the street entrance to the courtyard is Robert Adams's screen of 1760–1. Ten Tuscan pillars, of supreme grace and elegance, support an entablature from which two seahorses rise majestically. Wider entrances, pierced through the screen to either side of the central gateway in 1827–8, were not closed until the early 20th century. However, the line of the dress worn by the lady to the right suggests a date of about 1867–8. [BB67/08245]

Caption: 215. The Admiralty

Series: London and Neighbourhood. G R & Co

THE BANQUETING HOUSE, WHITEHALL

On the opposite side of Whitehall is the Banqueting House, built 1619–22 for James I by Inigo Jones; it is one of the few survivors from the Whitehall Palace fires in 1691 and 1698. Jones's exquisite, stone-faced, Italianate building must have presented an amazing contrast to the brick of Tudor Whitehall. After the 17th-century fires, the Banqueting House became the Chapel Royal until 1890, its role when this stereo photograph was taken. Later it became the museum of the Royal United Services Institute.

What are the people in the foreground doing waiting in a line? What is the two-wheeled vehicle and what is resting on it? Is it just a hand cart or is it a bier supporting a coffin? We shall probably never know. [BB91/14802]

Caption: Chapel Royal, Whitehall (Inscription: No. 55 Banqueting Hall)

Series: Views of London, Hampton Court and Windsor. Registered Series

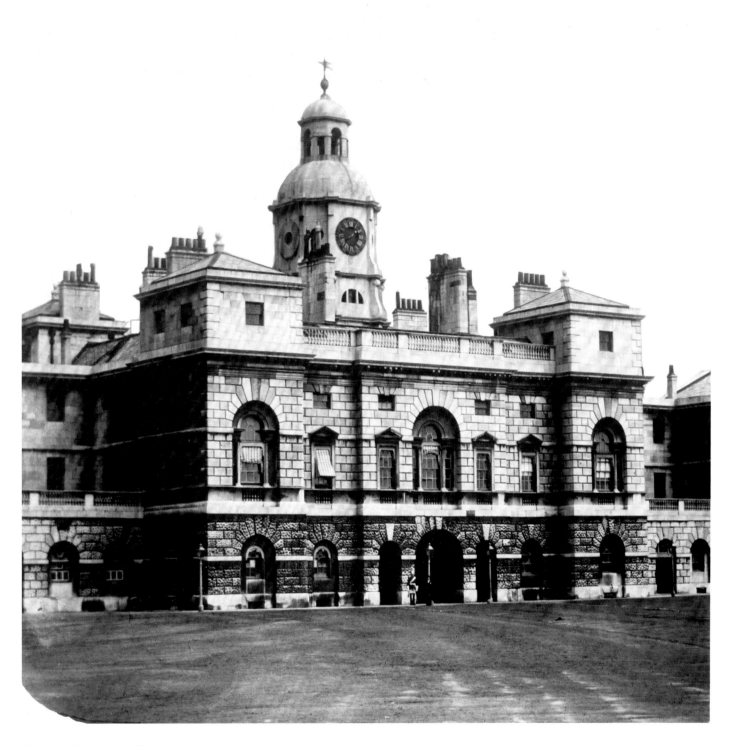

HORSE GUARDS, WHITEHALL

Horse Guards Parade lies immediately to the south of the Admiralty. The façade, with its horses and sentry boxes, beloved of tourists, faces onto Whitehall; however, march through the central arches and you are in a different world. The parade ground, originally the tiltyard of the Tudor palace, is vast, even larger than the stereo view reveals. Made for military and ceremonial parades as well as more ordinary daily drilling, it fulfils its purpose with absolute functionality. The first drawings were by William Kent (c 1686–1748), who in an earlier career had designed stage scenery; these were adapted by his assistant Stephen Wright and were built with William Robinson and the elder John Vardy in charge. [BB85/02182]

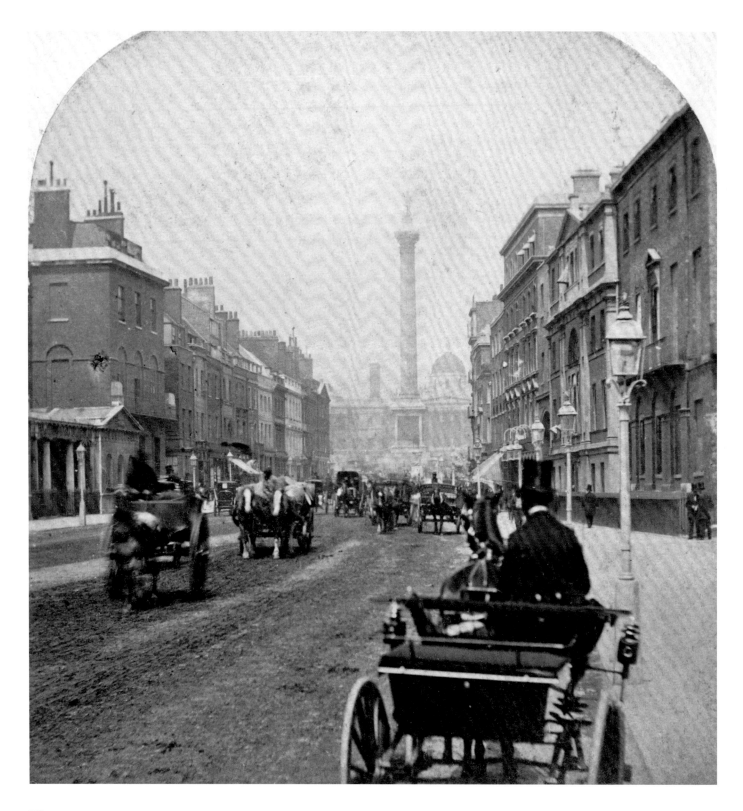

WHITEHALL

The horses trot briskly northwards along Whitehall in this evocative view; one open carriage waits, its driver in formal attire. Nelson's Column is visible in the distance with the dome of the National Gallery behind it. [BB90/03259]

Caption: No. 48. Whitehall
Series: Views of London and its Vicinity (Registered) by The London Stereoscopic & Photographic Co

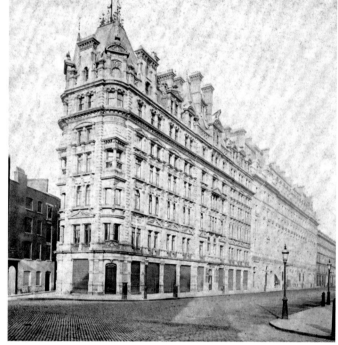

CHARING CROSS: TRAFALGAR SQUARE

This early stereo image, taken perhaps about 1865, looks northwards into Trafalgar Square. A woman holding a child trips past Charles I's statue (*see* p 179), while a boy lounges against a lamp-post. Beyond is General Havelock's statue and then St Martin-in-the-Fields, designed in 1722–4 by James Gibbs, Wren's disciple, with a handsome portico and soaring steeple. It is this south-eastern corner of the square, where Charing Cross meets the Strand, which is the central point of London, from which all distances across the country are measured; a plaque marks the spot.

Just in sight, on the north side of the square, is William Wilkins' National Gallery. Founded in 1824, the building was constructed in 1832–8 to house Sir George Beaumont's bequest and the collection he persuaded the government to purchase from the estate of John Julius Angerstein, the Russian-born banker and connoisseur. [BB83/04747]

Caption: No. 445. The Statue of Charles I. St Martin's Church in the distance
Series: Stereographs of London, by Valentine Blanchard

NORTHUMBERLAND AVENUE

The grounds of Northumberland House, demolished in 1874 (*see* p 179), gave way to paved streets, gas lamps and large, late 19th-century buildings, several of them hotels. The absence of traffic and pedestrians suggests that this stereo image was taken early one morning soon after the demolition and redevelopment. [BB71/01957B]

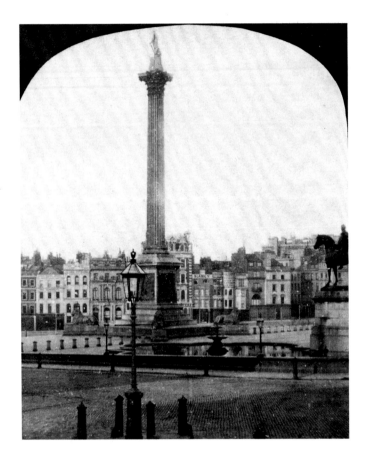

TRAFALGAR SQUARE »

This stereo photograph shows almost the full extent of Trafalgar Square. The square was laid out on the site of the Royal Mews, where hawks had been kept since the 13th century with stables later added by Henry VIII. They were demolished by 1830 as part of John Nash's Charing Cross Improvements Plan, which he did not live to complete. The commission was taken over by Sir Charles Barry, the square was named for the naval victory and Nelson's statue, by E H Bailey, was installed on top of William Railton's 145ft (44.2m) granite column in 1845. The bronze bas-reliefs were added to the base in 1849 – we can see *The Death of Nelson* by J E Carew, along with Sir Edwin Landseer's lions, added in 1867; this stereograph therefore must have been taken after the latter date. The shot emphasises the height of the column. [BB94/00368]

Caption: Trafalgar Square

Series: Views of London and its Vicinity (Registered) by The London Stereoscopic Company, 110 & 108 Regent Street & 54 Cheapside

« NELSON'S COLUMN

Something for the French market. This shot, taken from the north-eastern corner of Trafalgar Square, concentrates on the column with George IV's equestrian statue by Sir Francis Chantry and T Earle just in the picture; the king rides without stirrups. Since the lions are in position at the base of the column, the stereo view cannot have been taken before 1867 and is probably some 10 years later. It shows Barry's original fountain, replaced in 1939 to Sir Edwin Lutyens' design and, after the war, adorned with mermen, mermaids and dolphins by Sir Charles Wheeler and William Macmillan.

Beyond the column is the medley of 18th- and early 19th-century houses that developed along the Spring Garden – this was originally a grove on the northern edge of St James's Park, which by Charles II's day had become a public pleasure garden where refreshments were served. [BB67/08246]

Inscription on negative: Londres. Colonne Trafalgar

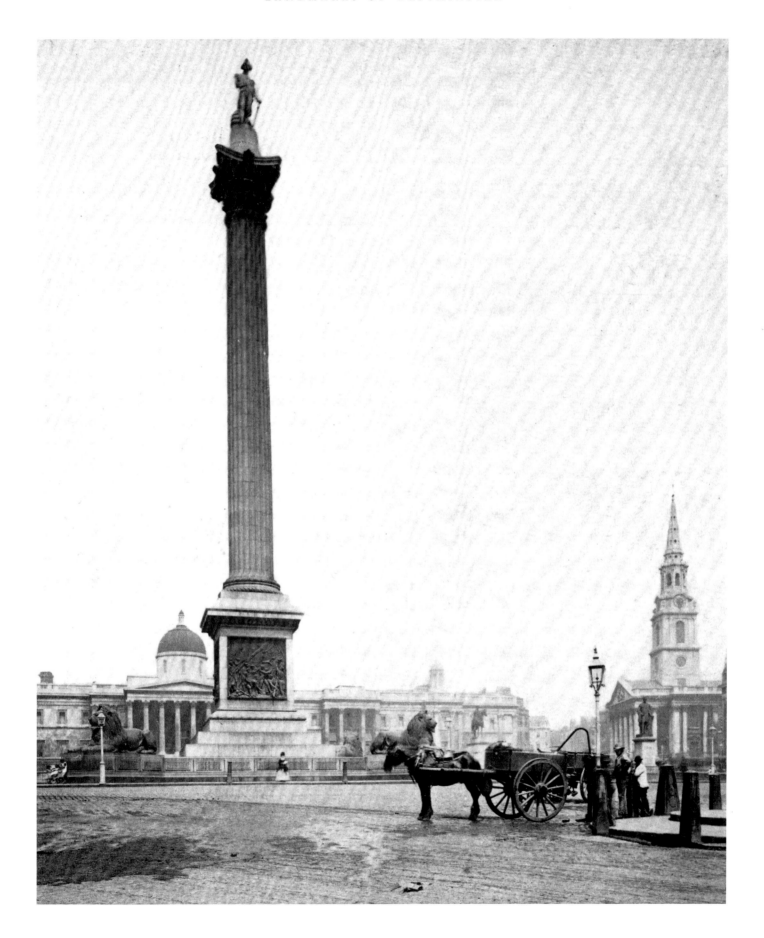

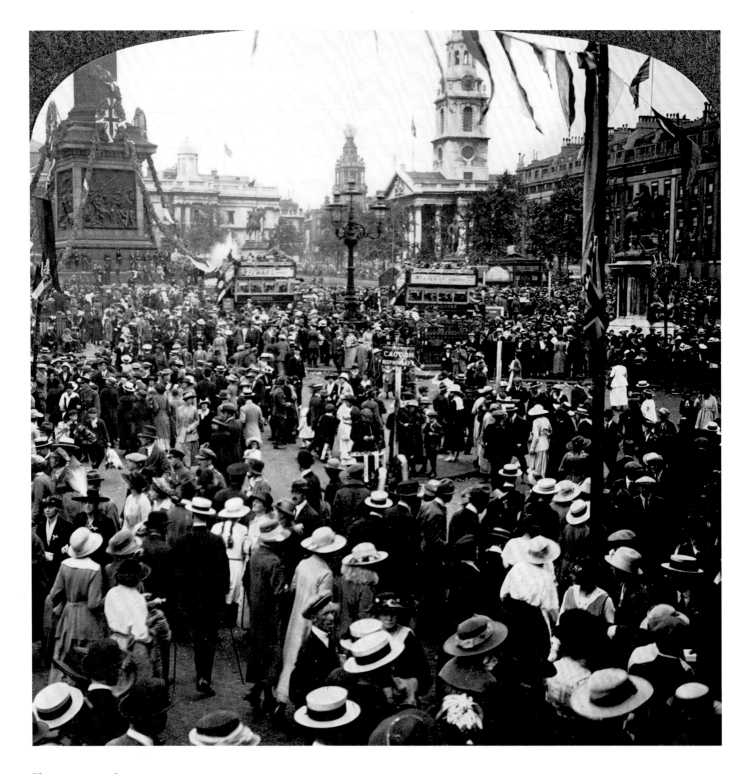

TRAFALGAR SQUARE

Peace celebrations with flying flags at the end of the First World War in 1918. This late stereo photograph shows the crowds on the south-eastern side of the square, looking towards St Martin-in-the-Fields with the tower and globe of the Coliseum – built 1902–4 to designs by Frank Matcham – beyond. [BB88/07117]

Series: Underwood & Underwood Ltd

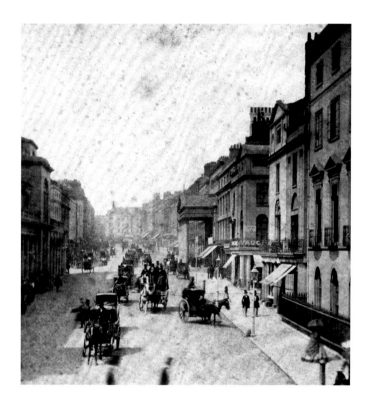

HAYMARKET

Most of the vehicles seem to be moving south in this stereo image of about the 1860s or 1870s. The name commemorates the sale of hay and straw here for the inmates of the Royal Mews, which occupied the site of Trafalgar Square until 1830 when it was removed to Cumberland Market on the east side of Regent's Park and the square was laid out.

The east side of the street is dominated by the portico, stretching over the pavement, of the Theatre Royal, Haymarket. A theatre has existed here since 1720, but the present building, just to the south of the old, is that designed by John Nash in 1820–1. One shop that survives unaltered, though it is scarcely distinguishable in this scene, is Fribourg and Treyer at No. 34, 'Purveyors of Foreign Stuffs to Her Majesty and the Royal Family'; today it is a gift and souvenir shop. [BB83/05819]

COVENT GARDEN

Travelling eastwards we reach Covent Garden, originally the property of Westminster Abbey. At the Dissolution of the Monasteries, it was sold to John Russell, 1st Earl of Bedford. His great-grandson, Francis, the 4th Earl, commissioned Inigo Jones to lay out the open space with 'habitacions for gentlemen' in 1631 and Jones, following Italianate examples, retained the spaciousness surrounding the open centre with arcaded terraces of houses and a church, St Paul's, on the western side. It was unlike anything else in London. Licence to hold a fruit and vegetable market there was granted in 1670. Thereafter the whole character of the area changed; it was no longer inhabited by gentlemen, commercial concerns triumphed and taverns, restaurants, hotels and rooming houses flourished. By the early 19th century, the demands of the market were such that the 6th Duke – the title had been elevated – sacrificed the open piazza, allowing it to be filled with Charles Fowler's handsome market buildings erected 1828–36.

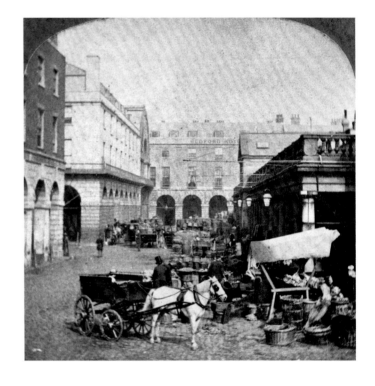

COVENT GARDEN
This stereo image of perhaps 1860–70 looks along the north side of the square bisected by James Street. The portico and balcony of the market are on the right and the foreground is busy with market workers. Someone has spread out an awning to protect the wares and there are baskets, to fill or empty, or possibly for sale. [BB93/06527]
Caption: No. 483. Covent Garden Market, north side
Series: Stereographs of London, by Valentine Blanchard

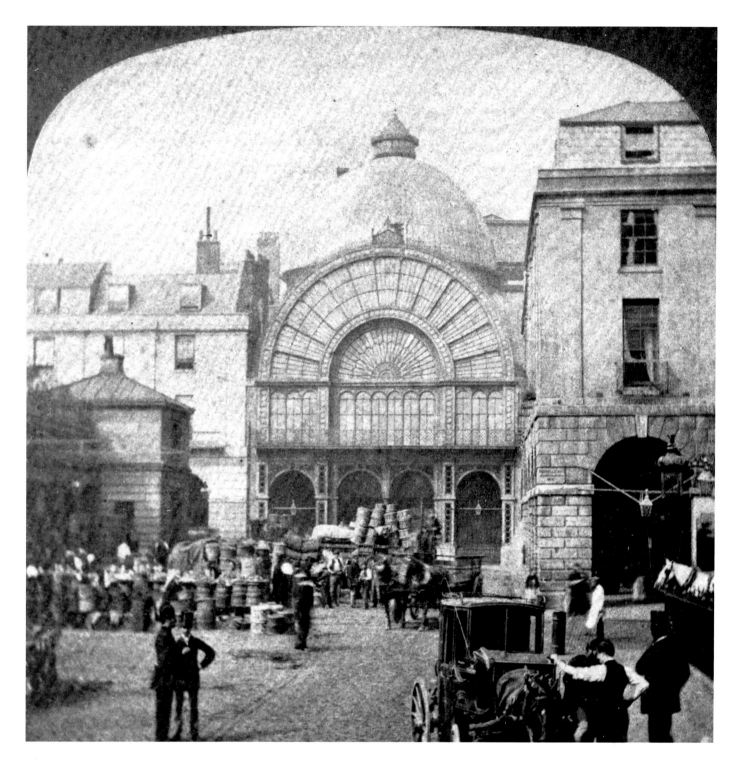

COVENT GARDEN

The eastern end of the north side of Covent Garden was broken into to provide space for the Floral Hall, erected in 1858–60 by E M Barry, Sir Charles Barry's son. It was the beginning of the end for Jones's noble piazza, though in itself it was a pretty building, inspired by the conservatory designs of the day. It only survived until 1887, when it was converted into a foreign fruit exchange. This stereo view of the 1870s shows the intact façade and the dome. [BB93/06528]

Caption: No. 481. The Floral Hall, Covent Garden
Series: Stereographs of London, by Valentine Blanchard. [Printed label of retailer: P E Chappuis, Photographer, Reflector Patentee, Importer and Manufacturer of Amusing and Scientific Novelties, 69 Fleet St., London]

AROUND PICCADILLY

This enclosure [Regent's Park], with the new street leading to it from Carlton House, will give a sort of glory to the Regent's government, which will be more felt by remote posterity than the victories of Trafalgar and Waterloo, glorious as these are.

This is the entry in Henry Crabb Robinson's diary for 15 February 1818, when construction was about to begin on Regent's Park and Regent Street. John Summerson claimed that the architect, John Nash, did more to shape the appearance and character of London than any other, even Sir Christopher Wren. The park, street and Piccadilly Circus, as they were when Nash left them in the late 1830s, had a supreme elegance, unlike anywhere else in the metropolis. Time, redevelopment and garish advertising around the circus have done much to mask the original glory, but those who venture out early before the traffic begins, and who have the eyes to see, can still sense the magic.

PICCADILLY CIRCUS
In this view we are looking north-eastwards along the line of Shaftesbury Avenue, which was cut through a slum area and opened in 1886; it was named after the great social reformer, Lord Shaftesbury, in whose memory Alfred Gilbert's statue of Eros was unveiled in 1893. The junction with Glasshouse Street and Piccadilly is marked by the Bovril advertisement. Horse-drawn vans contend with petrol-driven taxis for road space and a newspaper boy eludes both. The advertisement on the motorbus announces that *The Pink Lady* can be seen at the Globe (now Gielgud) Theatre; the musical ran from April until July 1912 with Hazel Dawn in the title role.

The Swiss restaurant, Café Monico, opened in 1879 and famed for its cuisine, wine list and decor, did not close until after the Second World War. [BB68/08711]

Caption: Piccadilly Circus
Series: The Art Publishing Co. Awarded 5 Gold Medals!

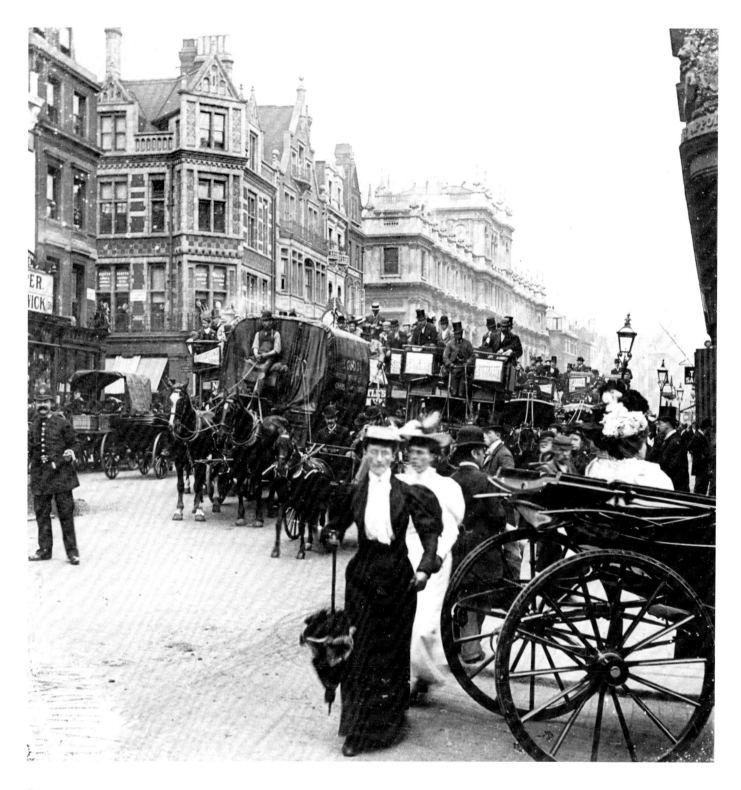

PICCADILLY, NORTH SIDE

A summer afternoon in the early 1900s. A policeman directs the traffic, a lady sits in a smart carriage as it turns the corner, while another, bespectacled and with parasol, crosses warily behind the vehicle. A sizeable dray, pulled by two stout horses, holds up the omnibuses and carriages; Burlington House, home of the Royal Academy and the Society of Antiquaries, fills the distance. [BB82/13469]

Caption: 1181. Piccadilly, with traffic, London
Series: The Fine Art Photographers' Publishing Co, 46 Rydevale Road, London,
S. Gold medal series. Copyright. Varieties sent (by post) to select from

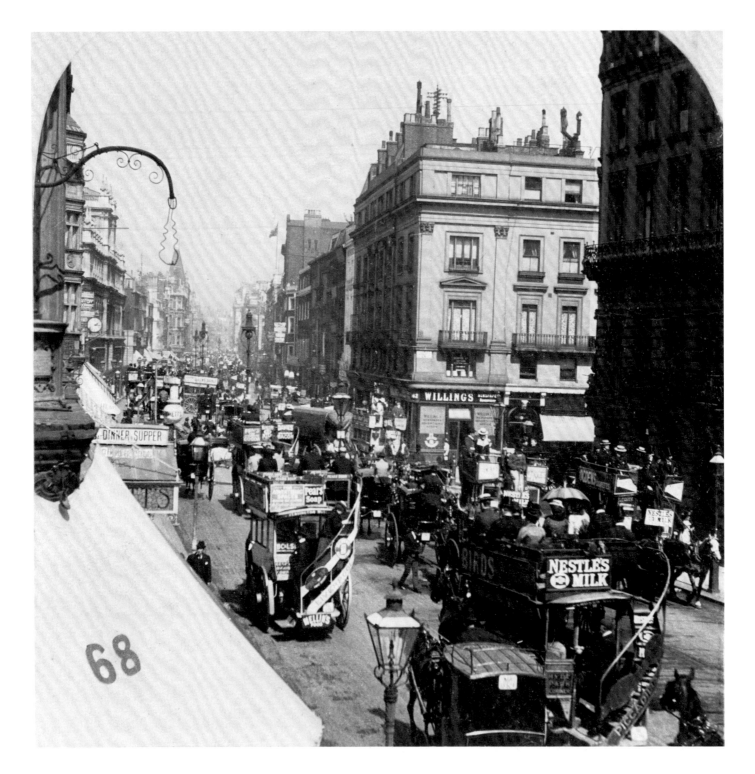

PICCADILLY

A busy day on Piccadilly in 1901. We are looking east, towards Piccadilly Circus with St James's Street turning off to the right. In the distance, to the right-hand side, are Fortnum & Mason and Hatchard & Son, 'Booksellers to the Royal Family'; both are still there today.

All the traffic appears to be horse-drawn. Three spirited ladies have climbed to the top of a 'garden-seat' horse-bus where the pair on the right share a parasol. [BB85/03130]

Caption: 11321. Piccadilly, London, England. [Directions for use, see pp 15–16]
Series: The Fine Art Photographers' Publishing Co, 46 Rydevale Road, London, SW. Gold Medal Series. Copyright, 1901, B L Singley

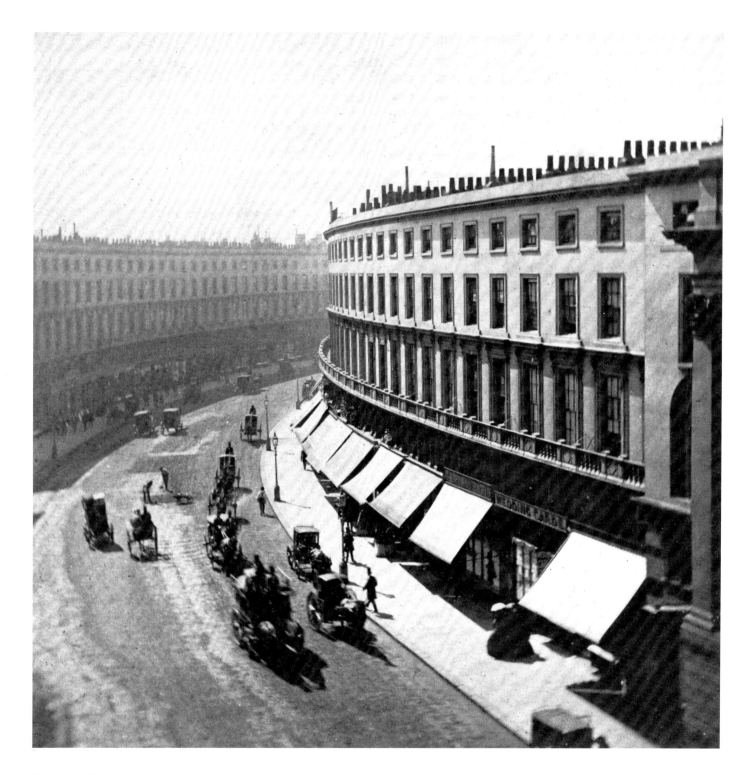

REGENT STREET, LOOKING NORTH

This stereo view, taken perhaps in the late 1860s, emphasises the gracious curve of John Nash's Regent Street. It is a sunny afternoon for the shop awnings are down, protecting the fashionable goods on display in the windows below. Only Henry Dolby at No. 56 dares to expose his wedding cards. One top-hatted gentleman strides out briskly, preparing to cross the road, while another saunters along the pavement. On the extreme right, the edge of the County Fire Office screens the next door adjacent building. [BB85/02196B]

Caption: No. 63. The Quadrant, Regent Street [Cowper quotation, see pp 14–15]

Series: Instantaneous Views of London

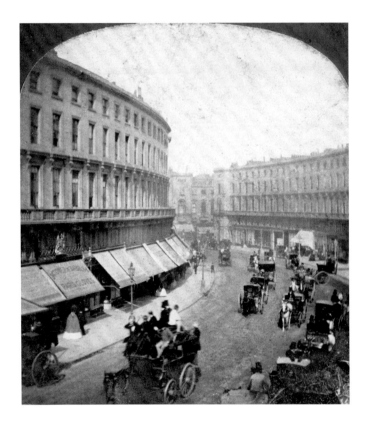

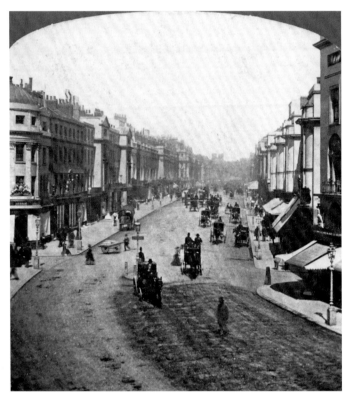

REGENT STREET, LOOKING SOUTH

This view of Regent Street, probably also of the late 1860s, looks south towards Piccadilly Circus. The coat of arms above No. 78, which offers Paris gloves, marks the premises of an old-established firm, Charles Packer, jewellers and goldsmiths. [BB83/05812]

Caption: 108. Regent Quadrant, London

Series: Instantaneous

REGENT STREET

A little further up the street, looking northwards, the corner with Vigo Street is marked with a crest for Scott Adie, court cloakmaker, of the Royal Scotch Warehouse, who owned the premises from 1855–95. A little further along, at No. 129, was Airey & Wheeler, colonial and court tailors; a Prince of Wales crest is above the door. [BB83/01009A]

Caption: No. 605. Regent Street

Series: London and Neighbourhood, by F York – Copyright

LOWER REGENT STREET

This peaceful early morning scene looks southwards towards St James's Park. On the site of Carlton House, George IV's palace in his Regency days, is the granite column supporting a bronze statue of Frederick Augustus, Duke of York, George III's second son; the whole monument is 137ft 9in (42m) high. It was designed by Matthew Digby Wyatt and the figure was sculpted by Richard Westmacott; it was unveiled in 1834.

 Just to the north of it, across the roadway, is a plinth put in position in February 1859; a year later the memorial to the Brigade of Guards for their services during the Crimean War was erected on the plinth, thus providing close dating for the stereo view. Years later, in 1914, figures of Florence Nightingale and Lord Herbert by John Bell were added on either side of the main group. [BB85/02181]

Caption: 879. Place Waterloo, à Londres

ST JAMES'S STREET

This stereo photograph must have been taken in August 1902 when Edward VII, Queen Victoria's eldest son, was at last crowned, the ceremony having been postponed from June of that year owing to the king's illness. The street is thronged; a policeman steps forward authoritatively to help pedestrians cross in safety. [BB82/13468B]

Caption: Coronation decorations, St James's Street, London

Series: Excelsior Stereoscopic Tours, 3 Brooklands Rd, Burnley, M E Wright, Publisher. Copyrighted 1902 by M E Wright

» CHURCHES

Churches are a familiar and much-loved part of the English scene, whether in city, suburb or countryside. In this selection there are shots of 12 churches of various denominations, taken over the second half of the 19th century and the early years of the 20th. Though they are a random collection, they tell us much about the importance of religious worship before the First World War.

TEMPLE CHURCH

This early stereo image of the Temple Church, taken perhaps in the 1860s, looks towards the east side of the porch to the main, north entrance that leads into the older Round Church. Two spectators, leaning on a railing, look towards the camera, with the tomb of Oliver Goldsmith, poet, dramatist and novelist, in the foreground.

The Knights Templar, founded in 1118, was an order of military monks, pledged to the defence of pilgrims on their way to and from the Holy Land. About 1180 they acquired land between Fleet Street and the Thames, and there built the Round Church in commemoration of Christ's tomb, to which was added a second, oblong church to serve as chancel and choir. When the order was dissolved in 1312, the land was made over to the Knights of St John who leased part of it to the lawyers; when the Reformation came, the Benchers of the Inner and Middle Temples purchased the freehold.

The whole Temple precinct was severely bombed during the Second World War, but the church was restored after the war by Walter Godfrey who, as well as being an architect, was director of the National Buildings Record, forerunner of the National Monuments Record. [BB91/18070]

Caption: No. 487. The north side of the Temple Church, looking towards Goldsmith's Grave

Series: Stereographs of London, by Valentine Blanchard

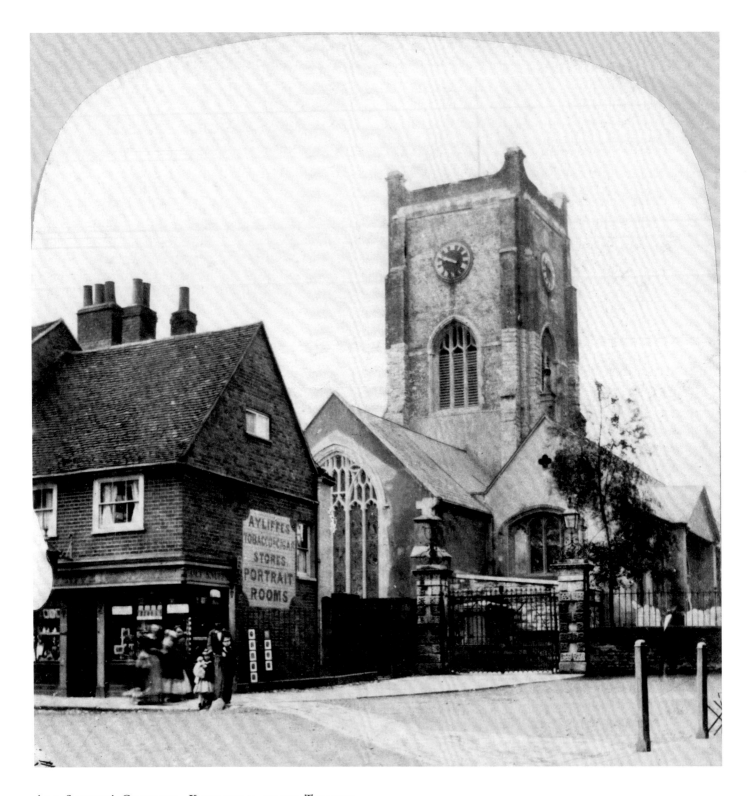

ALL SAINTS' CHURCH, KINGSTON-UPON-THAMES

This imposing church is largely of the 14th and 15th centuries; the foundations of a pre-Conquest chapel – possibly the coronation place of Saxon kings – are found on its south side. The brick upper storey of the tower was added in 1708 by John Yeomans. This shot would have been of particular interest to Howarth-Loomes since it includes the tobacco and cigar shop of Mr Ayliffe; the sign tells us that he could also boast of 'portrait rooms', presumably for portrait photography. [BB72/05891A]

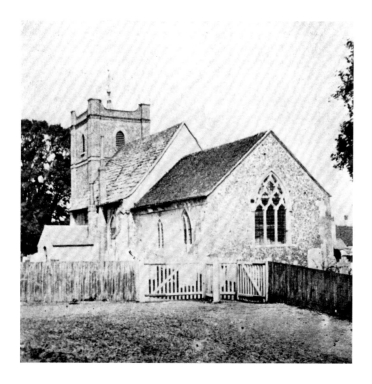

ST NICHOLAS'S CHURCH, SUTTON

Sutton was a village that grew suddenly into a town when its High Street became a staging post on the London to Brighton Road; it grew again with the arrival of the railway in 1847. This stereo view shows the old parish church – it became too small for its congregation and so, being in poor condition, was demolished and rebuilt in flint with a spire by Edwin Nash in 1862–4. [BB70/01550]

ST MARY'S CHURCH, HORNSEY

This stereo photograph of perhaps 1870–80 records much that has now changed. The church is George Smith's 1832 replacement for the body of a medieval building; Smith's church was itself demolished in 1889 and another was built further to the east. Only the medieval tower remains – adopted, restored and maintained by the Friends of Hornsey Church Tower. This zealous and excellent body organises carol singing and a summer festival when teddy bears are 'encouraged' to abseil down the tower. [BB82/13472B]

« St Marylebone Church,
St Marylebone Road
This is the third church to stand on some part of this site.
Built in 1817 to designs by Thomas Hardwick, the dome of
its cupola rests on eight caryatids, modelled and cast by John
Charles Felix Rossi in an artificial stone manufactory among
the open farmland that a decade later became Regent's
Park. The railings shown here have now vanished. Robert
Browning and Elizabeth Barrett were married here in 1846,
thereafter running away together to Italy. [BB88/02292]
Caption: 56. St Marylebone Church, St Marylebone Road
Series: Views of London

St Mary-le-Strand, Westminster »
This exceptionally interesting stereo image focuses on
St-Mary-le-Strand, sitting serenely on its island in the middle
of the road. Cabs and carts edge past it, where now there is a
mill-race of traffic. James Gibbs was one of Wren's disciples
and there is a strong accord between the work of the two
architects. St Mary's has a semicircular porch above which
rises a three-tiered steeple, answering that of Wren's St
Clement Dane's to the east. In the distance we can see the
misty shape of St Dunstan-in-the-West – with an octagonal
crown to its tower – which was built 1829–33 by John Shaw.

There is a lot to notice in this shot. All the buildings and
shops to the left were lost to road development and to the
construction of Bush House in Aldwych, though on the
right we can just see a sliver of Somerset House. The road
in front of the church has been dug up, presumably to be
relaid, and the granite setts are piled up, ready for reuse.
[BB95/10431]
Caption: 22. Church of St Mary-le-Strand
Series: Views of London

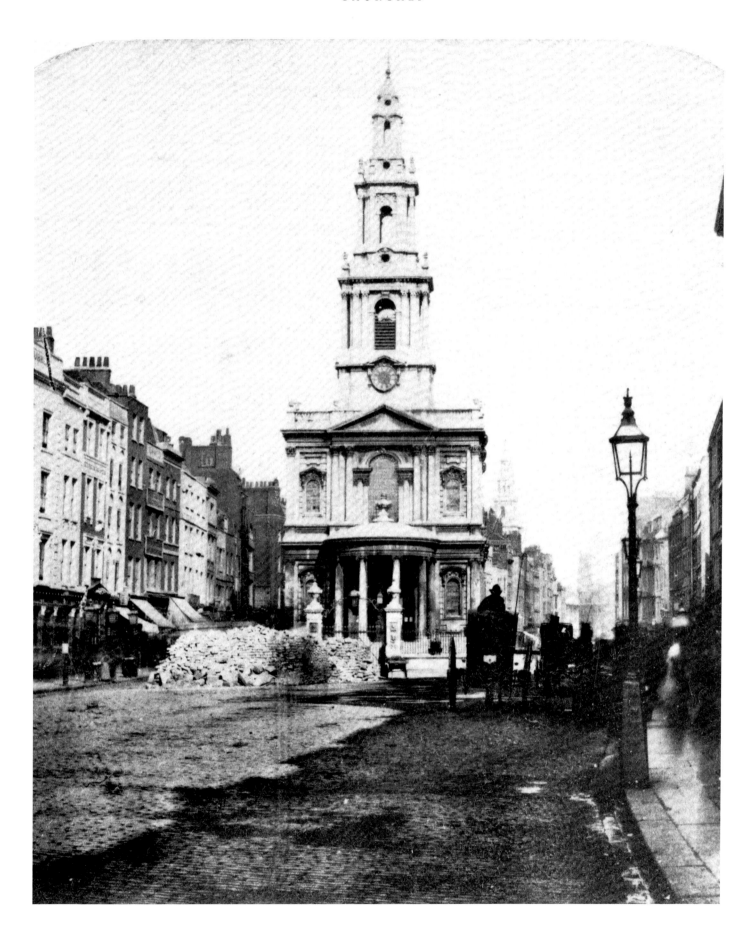

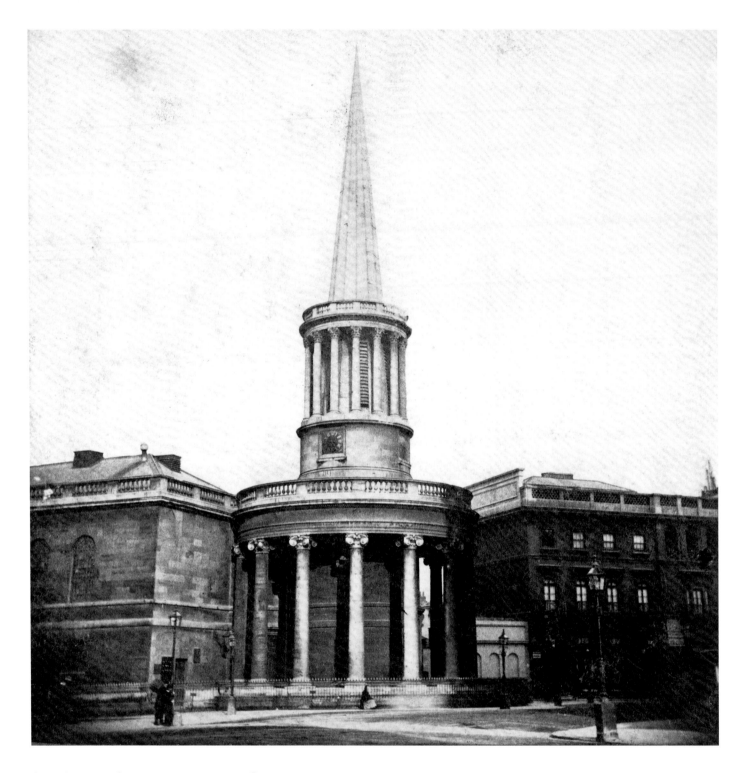

ALL SOULS' CHURCH, LANGHAM PLACE

When John Nash transformed the Crown Estate of Marylebone Park into Regent's Park, he needed to provide a link for the inhabitants of the new villas and terraces with Westminster. He did this with Portland Place and Regent Street, using All Souls' Church as an architectural focus to distract the eye from an otherwise disruptive twist in the road. In this view of perhaps 1870–80, Nash's unconventional façade, with its pillared tower and Gothic spire, enchants the eye. [BB83/05590]

Caption: All Souls, Regent Street

Series: Views of London, photographed and published by Frederic Jones, 146 Oxford St, W. Sold by Dorrell and Son, 15 Charing Cross, SW

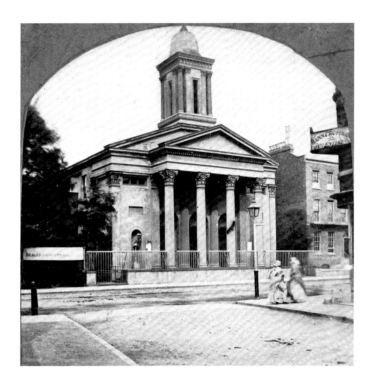

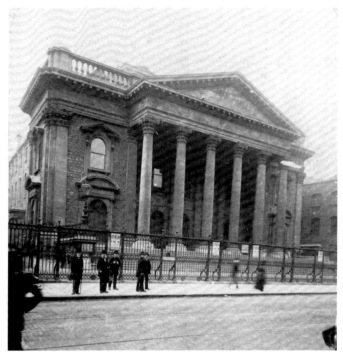

TRINITY CHAPEL, POPLAR, TOWER HAMLETS
Trinity Chapel was built in 1840–1 as an Independent (Congregational) Chapel by William Hosking with funding from George Green, a local philanthropist. This boldly designed place of worship was destroyed by bombs in 1944; only its bell survived. By 1951 the church was replaced on the same site in East India Dock Road, so the bell found a new home. The designs for the church were on view in the Exhibition of Live Architecture at the Festival of Britain. [BB81/07416B]

METROPOLITAN TABERNACLE, NEWINGTON
The congregation of the charismatic Baptist preacher, Charles Haddon Spurgeon, built this chapel with its magnificent portico in order to provide a sufficient space for all who wanted to hear his sermons, which were also published weekly. Erected 1859–61 with W W Pocock as architect, the tabernacle was built at the traffic junction of Elephant and Castle which, even as early as the 17th century, was busy and became even more thronged after the opening of Blackfriars Bridge in 1769. The tabernacle was constructed to hold 6,000 and yet was still judged to be too small.

Bombing in 1941 left only the portico, but the chapel was rebuilt and still dominates the whirl of 21st-century traffic. [BB69/05672B]

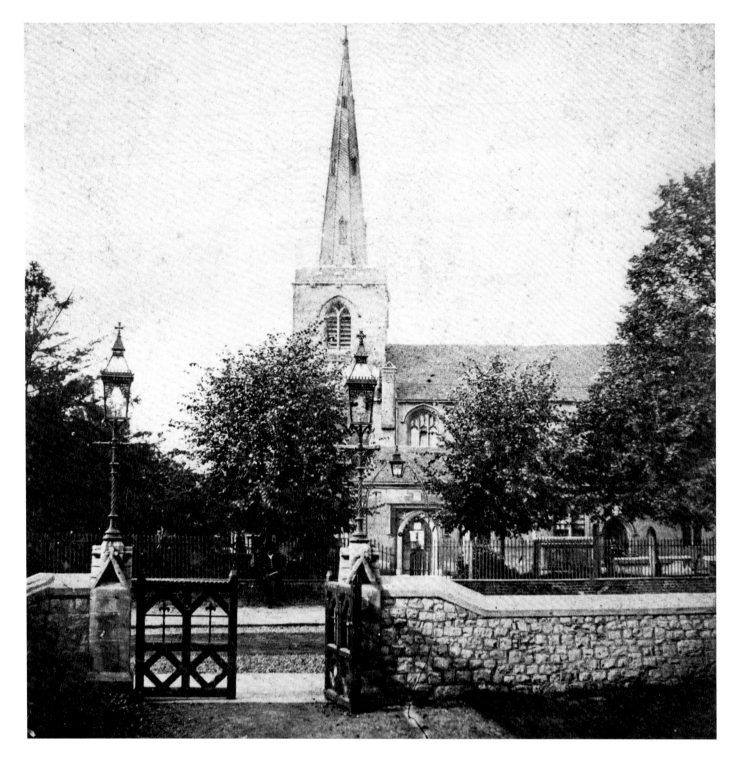

ST MARY'S CHURCH,
STOKE NEWINGTON, HACKNEY

The church that we see in this stereo image stands on the site of the former rectory. It was designed by Sir George Gilbert Scott in 1854–8, its spire being completed by his son, J Oldrid Scott, in 1890. It is a strong, upstanding building and a fine landmark.

Opposite, the open gate in the stone wall leads to Old St Mary's, the medieval parish church which became too small when the neighbourhood suddenly expanded in the mid-19th century. [BB91/14795]

CHRIST CHURCH, LEE PARK

This very early stereo photograph shows Christ Church in
Lee Park while it was being built 1853–4. This was an area
just south of Blackheath that developed rapidly between
1840 and 1860; the houses were small but some had
imaginative features. The church – with Sir George Gilbert
Scott as architect – was intended as a chapel of ease to St
Margaret, Blackheath, and was a gift to the Reverend George
Lock from his parishioners on the 50th anniversary of his
incumbency at St Margaret's. At first it thrived, with seating
for 1,000, but the bombing of 1940 destroyed it. Such an
early use of the stereoscope to record what was clearly a
church built with much local pride tells us a good deal about
the self-confidence of the area and the ability to seize on the
new invention. [BB85/02230B]

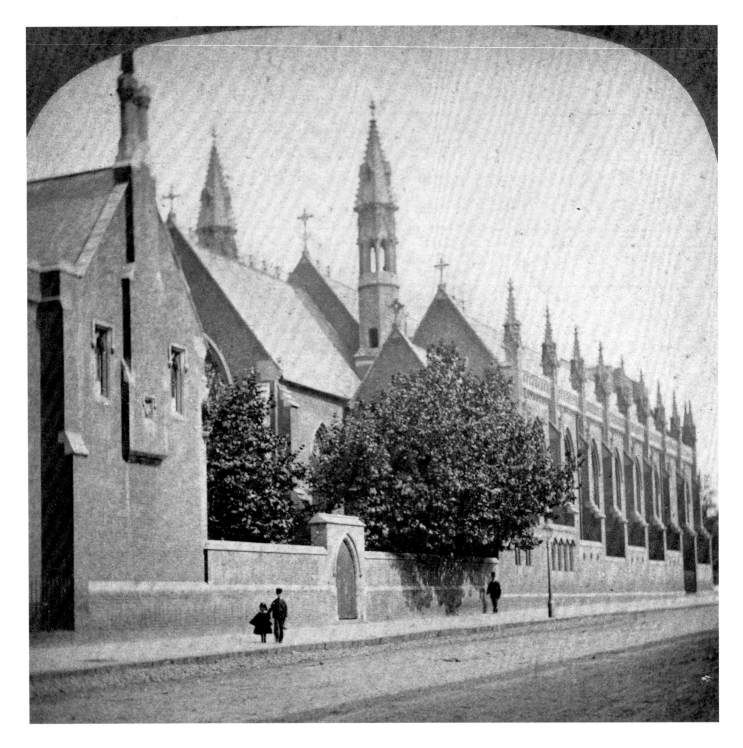

St George's Cathedral, Southwark

This great church, which Augustus Pugin was commissioned to build in 1839, was not originally meant to be a cathedral since the Roman Catholic hierarchy was not readmitted to England until 1850. It was a challenging undertaking since it was intended from the first to hold a congregation of 3,000 and yet funds were severely limited and the site awkward and restricted. [BB83/01623]

Caption: No. 432. St George's Cathedral, Southwark
Series: Stereographs of London, by Valentine Blanchard

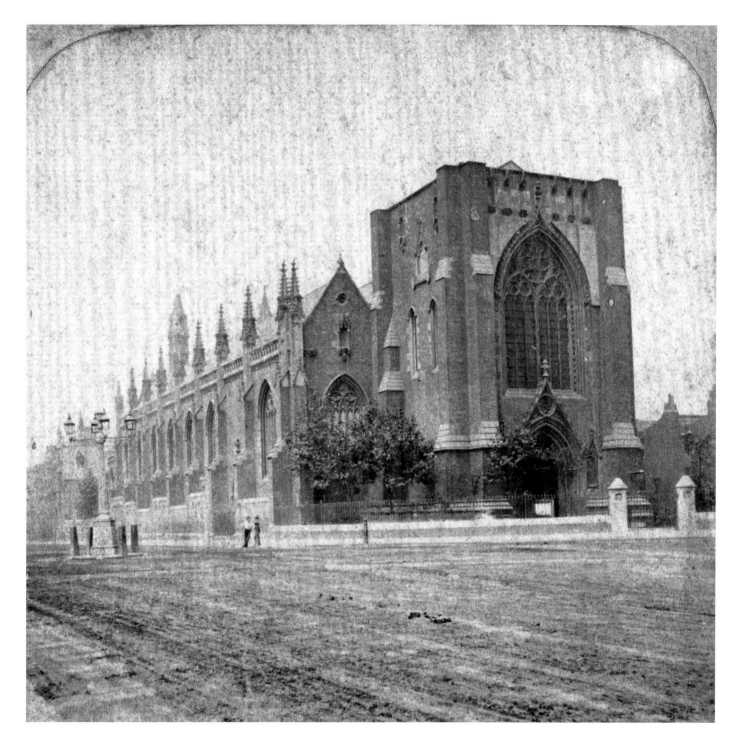

ST GEORGE'S CATHEDRAL, SOUTHWARK

Despite the difficulties, Pugin planned the church nobly and, though the west tower never got beyond its first storey, the entrance to the long nave is triumphant. Seriously damaged by bombing, the cathedral was restored during the 1950s. These two stereo images, probably of the 1850s, reveal the majesty of Pugin's most important London church. [BB83/04809]

Caption: 67. St George's Catholic Chapel

Series: Views of London

» PALACES

Everyone enjoys looking at other people's houses. It is human nature to be curious about the settings in which other people live, and palaces – the residences of monarchs, bishops and, sometimes, dukes – arouse a particular curiosity. This section covers six palaces: some old, some new, and others rebuilt and now serving different purposes.

BUCKINGHAM PALACE

The London residence of the monarch began life in the early 1700s as Buckingham House, the property of the Duke of Buckingham. George III, newly crowned and married, bought it in 1761 as a home for his bride, Charlotte of Mecklenburg-Strelitz, and in this domesticated palace 14 of their 15 children were born. George IV wanted something larger and more magnificent, which John Nash duly provided; his budget was £250,000 but over £600,000 was spent and the king died before the work was completed. Queen Victoria was the first monarch to live there.

This early 20th-century shot of the palace – taken from the eastern, St James's Park, side – shows the main façade of Caen stone with which Edward Blore closed Nash's open courtyard in 1847–50. However, the stone crumbled and was replaced after 1901 with a Portland stone frontage, though the central balcony was retained. The now-familiar Victoria Memorial had not yet been built. This series of stereo cards is captioned in French. [BB86/08711]

Caption: 864. Vue dans le parc St-James, à Londres

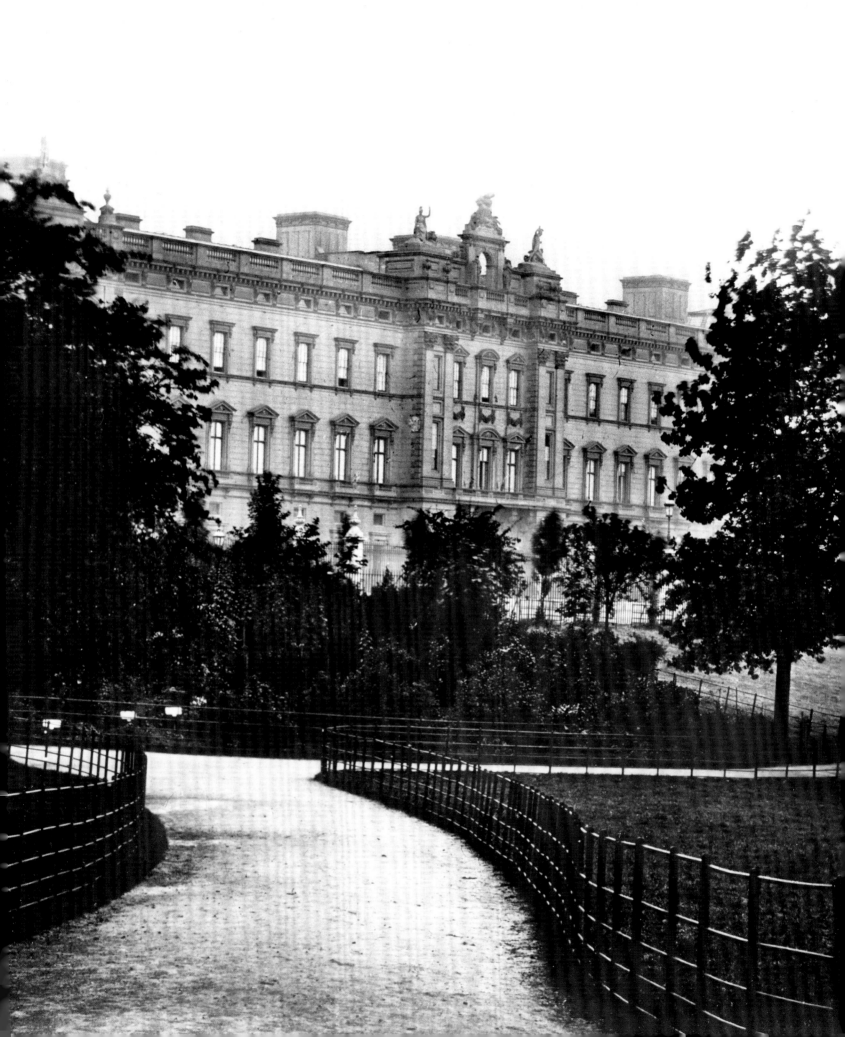

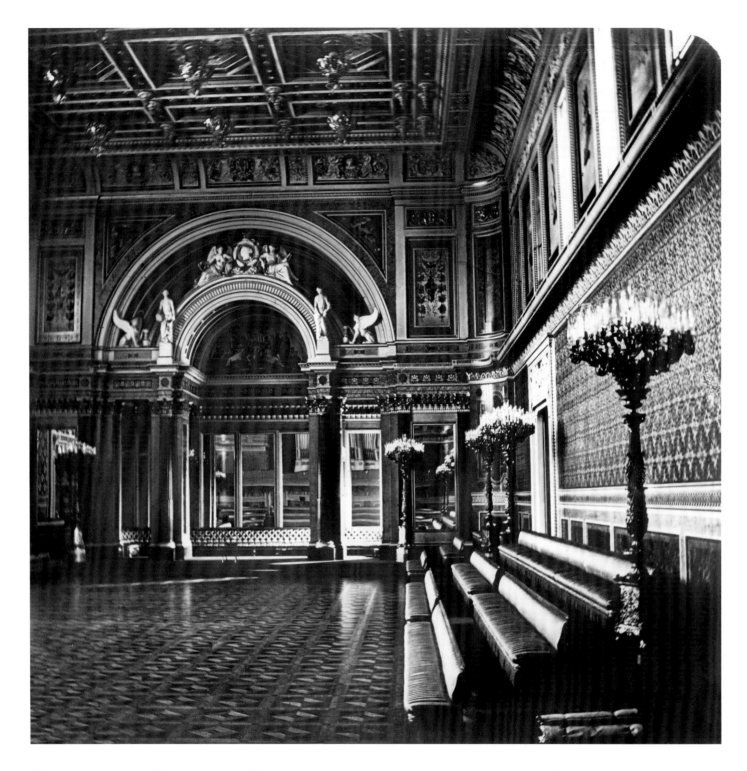

THE BALLROOM AT BUCKINGHAM PALACE

After Prince Albert's death in 1861, Queen Victoria used Buckingham Palace as little as possible so her son, Edward VII, had every reason for a thorough refurbishment and redecoration. However, the ballroom with its elaborate coffered ceiling – decorated by the queen's favourite architect, Sir James Pennethorne – remained unaltered.

Tiers of seating were provided for those watching the dancers. Though the central sculptures with their flanking sphinxes were retained, the opening (still seen here) was closed in by Lutyens to provide a throne under a canopy, which was based on the one that was used at the Coronation Durbar of 1911 in Delhi. [BB86/08712]

122

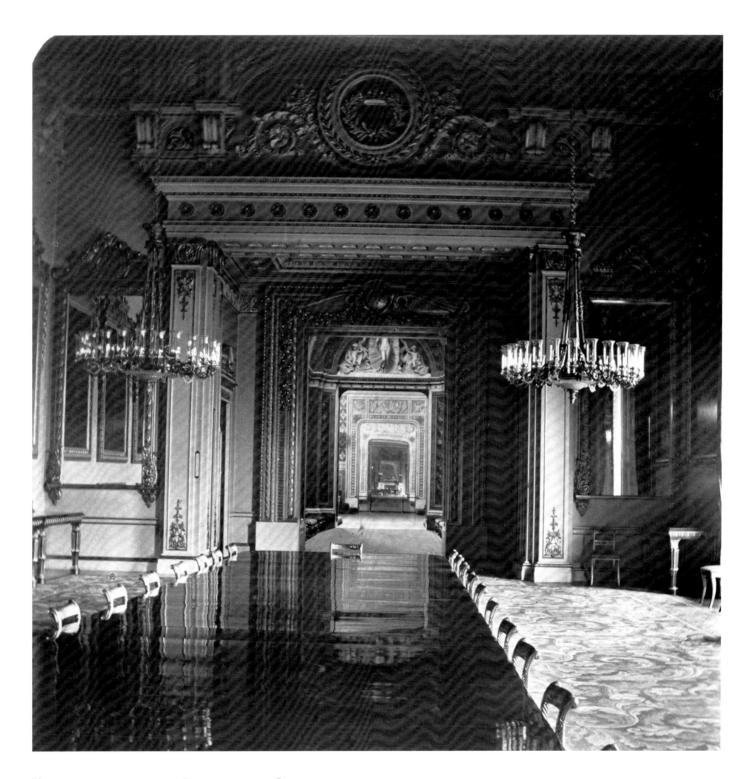

THE DINING ROOM AT BUCKINGHAM PALACE
About 1903 a record was made (and presumably published) of the king's refurbishments. Edward told a friend that, though he was not an expert on art, 'I do know something about *arrangement*' – and rearrange he did. The dining room at the south end of the western front, with its seemingly endless long table, looks through into the White Saloon, a regal enfilade of formal apartments. [BB86/08704]

Caption: 844: La salle à manger no. 2 (Palais de Buckingham), à Londres

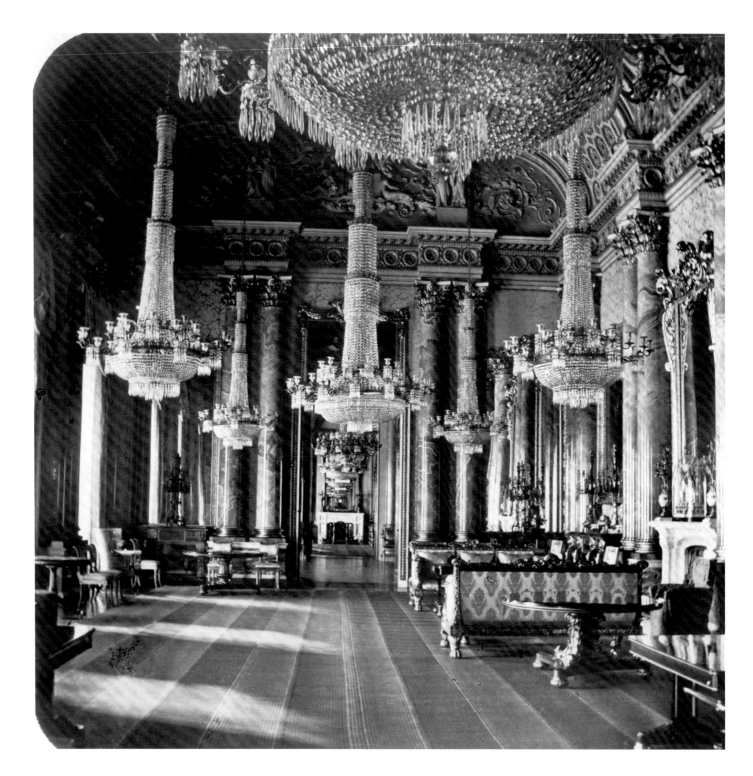

THE BLUE DRAWING ROOM AT BUCKINGHAM PALACE

Until 1854, when Pennethorne added the ballroom to the south wing, this room was used as the ballroom of the palace. Just visible above the fireplace to the right is an elaborate astronomical clock; as well as the minutes and hours, it shows the passing of the days, weeks and months along with the lunar changes. The apartment looks through to the White Drawing Room where today the royal family often assemble before a state function. [BB86/08705]

Caption: 832. Le salon bleu. (Palais de Buckingham), à Londres

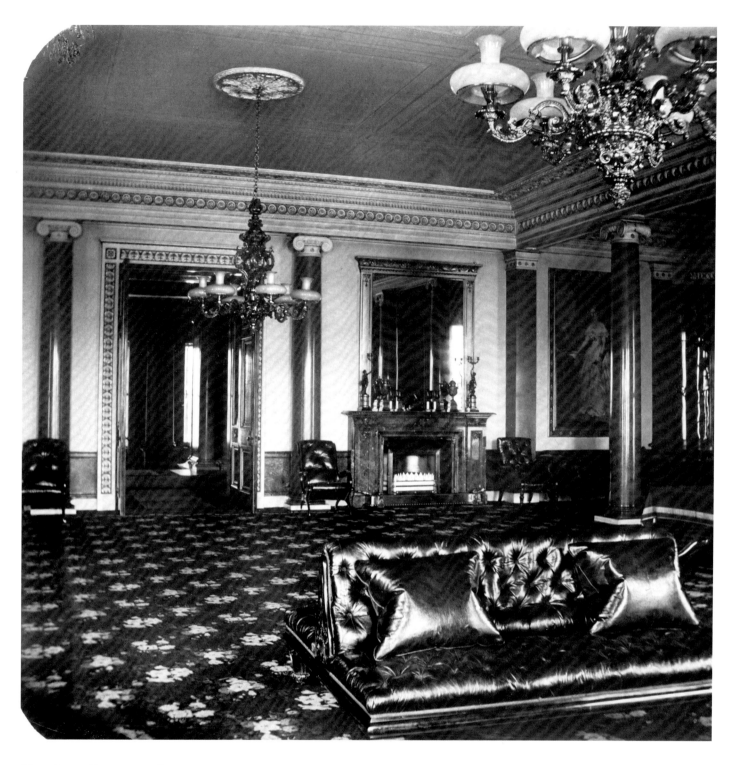

THE BOW ROOM AT BUCKINGHAM PALACE

This room is the inside of the wide bow on the garden front through which those invited to the annual garden parties must pass to reach the terraces and lawns beyond, so it is familiar to all those who come as guests. It is a large, open apartment, easily able to accommodate such gatherings. [BB86/08708]

Caption: 848. La chamber en arc (Palais de Buckingham), à Londres

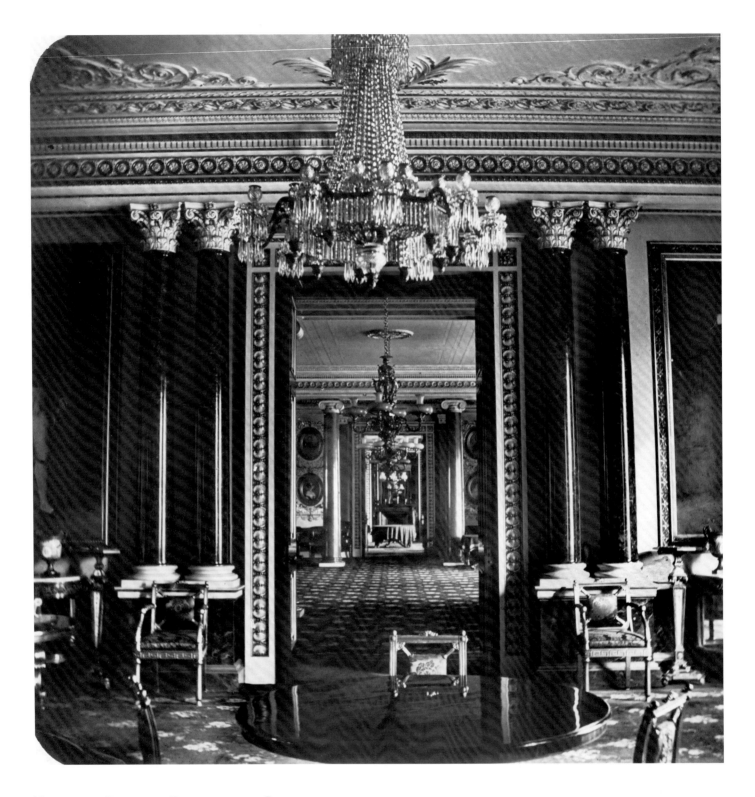

THE 1844 ROOM AT BUCKINGHAM PALACE

This room received its name from the visit by Nicholas, Tsar of Russia, to Queen Victoria in that year. The enfilade of formal rooms shows especially clearly in this stereo photograph – these are spaces in which to entertain foreign dignitaries. [BB86/08710]

Caption: 847. La chamber de 1844 (Palais de Buckingham), à Londres

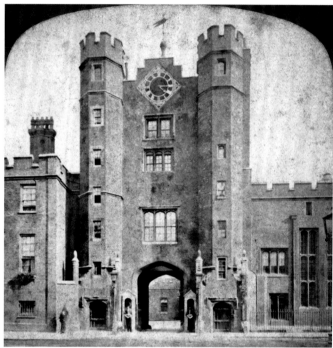

LAMBETH PALACE

Palaces are not only for monarchs. Princes of the Church live in them too and Lambeth has belonged to the See of Canterbury since the 12th century. This is the London residence of the Archbishop of Canterbury with convenient access via the river to Westminster, the City or Hampton Court.

In this stereo image of about 1870 we can see the great hall of the palace, which now houses Lambeth Palace Library, open to scholars since 1610. This hall was built by Archbishop William Juxon during his short episcopate following the restoration of Charles II in 1660. By then Juxon was an old man, for he had stood beside Charles I on the scaffold to support his king as he faced death in 1649.

The small building to the left, begun in the 15th century, had a third storey added in the 16th, apparently equipped to serve as a prison for heretics; it is known as the Lollards' Tower. The handsome riverside railing no longer exists. [BB91/27504]

Caption: 366. Lambeth Palace

ST JAMES'S PALACE

When in London Elizabeth II lives at Buckingham Palace, but the official seat of the Court is still St James's Palace, built for Henry VIII between 1531 and 1540, following his appropriation of the Leper Hospital of St James at the Reformation. The gatehouse, leading through into the Colour Court, remains largely unaltered and today has become a symbol of London. The clock face is dated 1832. Sentries such as those standing guard in this stereo image, taken perhaps in the 1870s, are still on duty today. [BB88/05908]

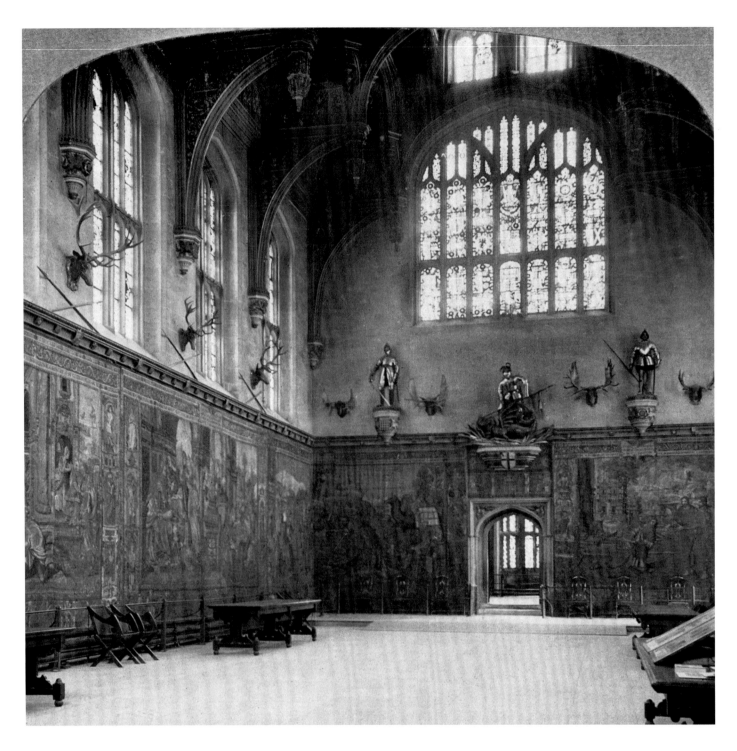

THE GREAT HALL AT HAMPTON COURT

Hampton Court, begun in 1514 for Cardinal Wolsey as his private palace, passed abruptly into Henry VIII's possession in 1529. The king began at once to aggrandise the already magnificent dwelling, creating an even larger, truly royal great hall. Since Catherine of Aragon visited Hampton Court in Wolsey's heyday, all six of Henry's queens knew the palace.

When the young Queen Victoria opened the palace to the public in 1838, it at once became a popular excursion. This stereo image, taken in 1903, conveys the spaciousness of the great hall. The walls are hung with tapestries for warmth, stag head trophies line the walls and two suits of armour stand guard above the doorway leading through to the inner rooms. [BB85/03133]

Caption: 1186. The Great Hall, Hampton Court, London, England
Series: Griffith & Griffith, Philadelphia, Pa etc. Copyright 1903

QUEEN ANNE'S BEDCHAMBER AT HAMPTON COURT
The state rooms on the first floor of Hampton Court were all displayed to retain,
as far as possible, their original splendour. A sturdy rail keeps the public at a safe
distance. [BB85/03135]

Caption: 1188. Queen Anne's Bedchamber, Hampton Court, London, England
Series: Griffith & Griffith, Philadelphia, Pa etc. Copyright 1903, by George W Griffith

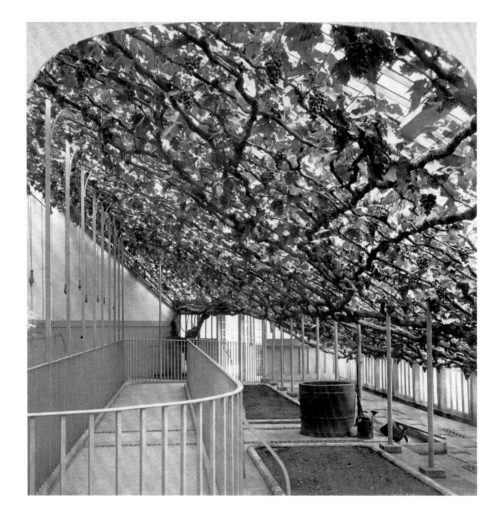

The Great Vine at Hampton Court

On the east side of Hampton Court is a hothouse in which grows an enormous vine. It was planted in 1769 from a slip taken from its parent stock in Ilford, Essex. It has grown and grown to its present magnificence and still delights visitors. [BB85/03134]

Caption: The famous old grapevine at Hampton Court, England

Series: Griffith & Griffith, Philadelphia, Pa etc. Copyright 1903, by George W Griffith

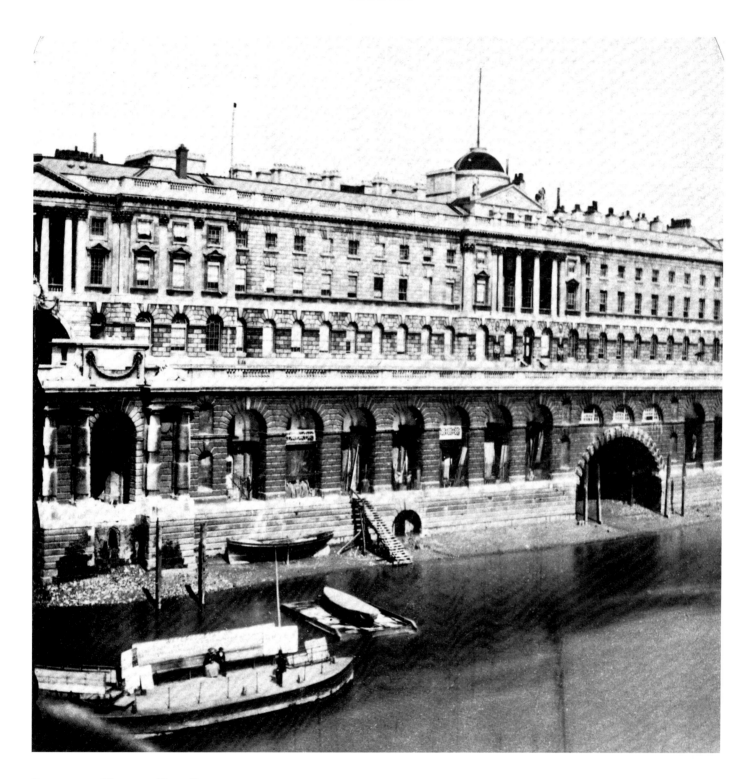

SOMERSET HOUSE, THE STRAND

The original mansion, built 1547–50, provided the Duke of Somerset with a London residence. In the next century, it became home to three queens consort – Anne of Denmark (James I), Henrietta Maria of France (Charles I) and Catherine of Braganza (Charles II); Inigo Jones added a chapel for Henrietta Maria. Early in George III's reign, the site was cleared to house Europe's first, enormous, block of government offices designed by Sir William Chambers. His is the building in this *c* 1870s stereo image; the yet-unembanked Thames laps against its walls, the riverside entrance clearly visible on the right. [BB81/01594]

THE CRYSTAL PALACE AT SYDENHAM

The 1851 Great Exhibition in Hyde Park was one of the most significant events of Queen Victoria's reign. The Howarth-Loomes Collection has no photographs of Sir Joseph Paxton's astonishing glass-and-iron building, but includes a fair number of its successor, the Crystal Palace at Sydenham, which opened on 10 June 1854. A serious fire on 30 December 1866 ravaged the Fine Arts Courts causing the loss of some popular exhibits, but the building was repaired and new attractions were introduced. The structure survived until its destruction by fire on 30 November 1936.

THE CRYSTAL PALACE
Paxton formed a public company that purchased land in Norwood to the south-west of London and built another Crystal Palace there after the 1851 Great Exhibition. This clear view of the amazing building and its surroundings reveals the nobility of Paxton's enterprise. [BB92/03914A]
Caption: South Tower, CP

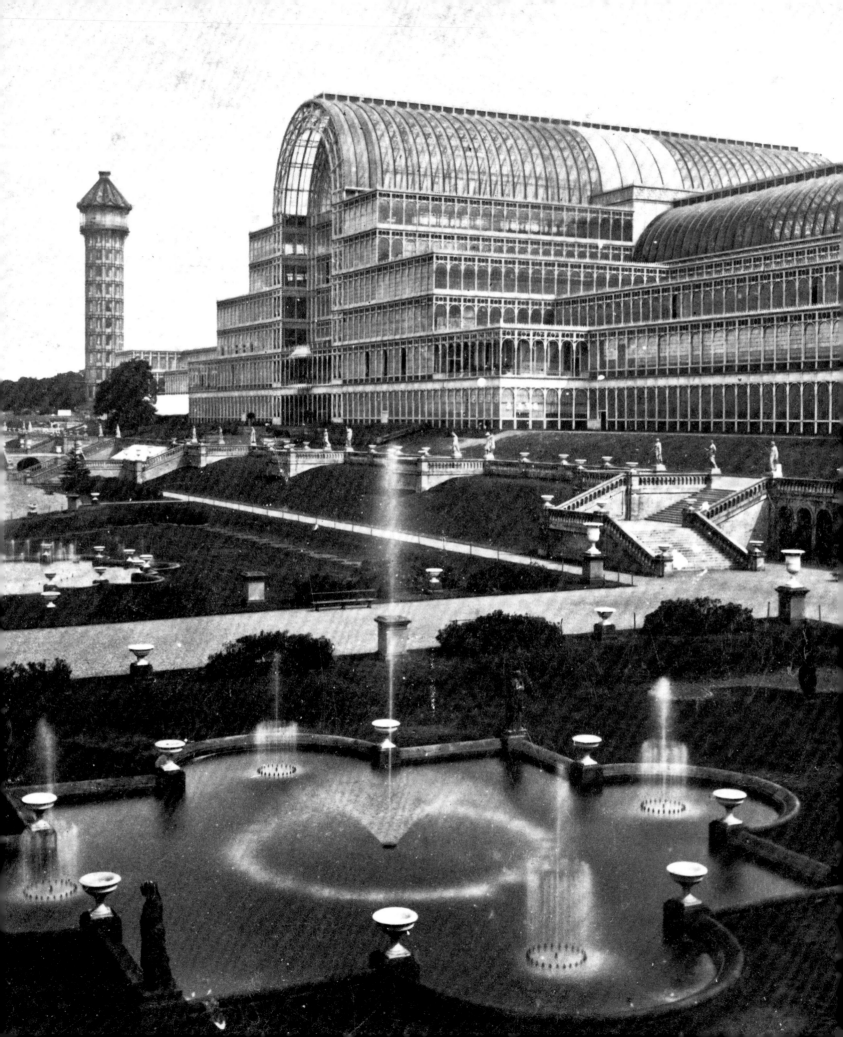

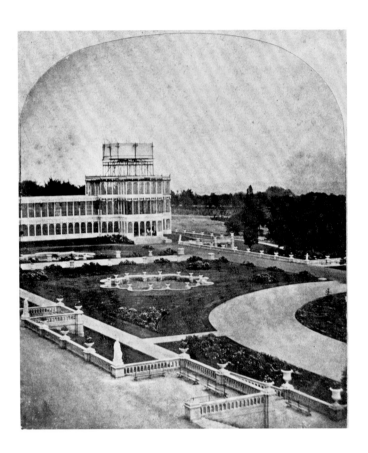

« THE CRYSTAL PALACE

This early stereo view of the terraces, facing north-east, was probably taken in 1854 since three plinths and their statues were not yet installed along the curved Broad Walk. It must certainly be before February 1861, when the north-eastern gallery and tower were blown down in a storm. [BB68/03045A]

Caption: 44. Portion of the North Wing

This portion of the Crystal Palace, intended eventually to be devoted to the exhibition of raw materials and agricultural implements, is still incomplete. The water-tank over the extreme entrance is now removed, but the Italian terraces with the vases and statues, the flowerbeds and fish-ponds convey a general idea of a part of the grounds with which, when the whole is matured, no other pleasure-ground will bear any comparison.

Label: C W Dixey, Opticians to the Queen, New Bond Street [retailer]

THE GARDENS OF THE CRYSTAL PALACE »

This view of the gardens looking north-west shows one of the two water towers supplying the fountains that Paxton intended – many thought successfully – to rival those of Versailles. [BB81/07416A]

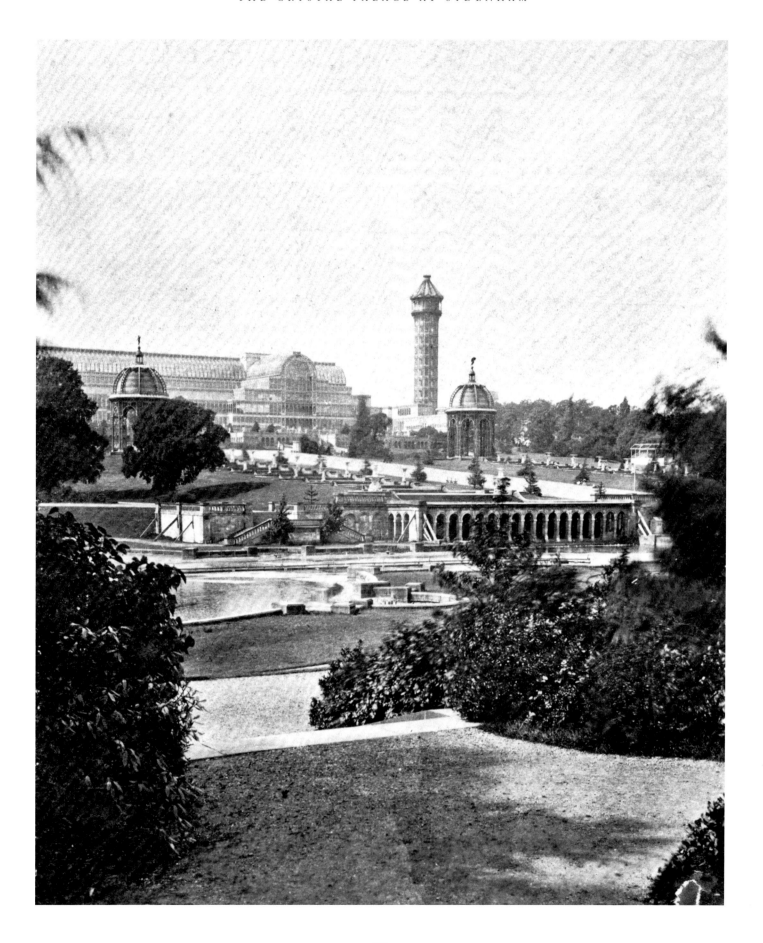

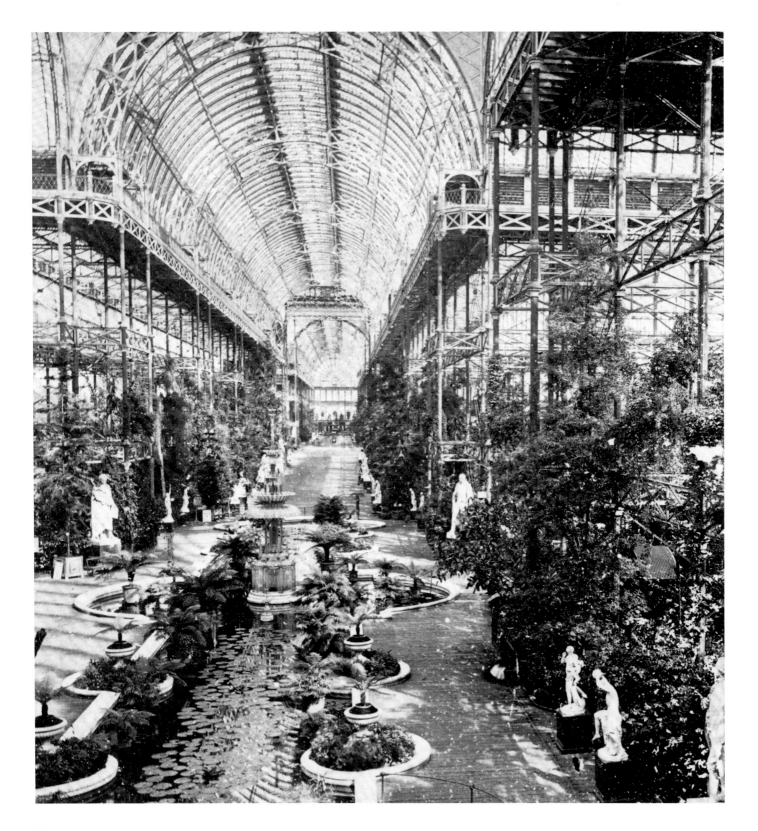

THE NAVE LOOKING SOUTH

This long shot of the nave, taken from the north, reveals the majesty of the building and the ingenuity of its construction. The interior seems light and airy, with a skillful use of greenery to soften the starkness of the structure and to a give a background to the statuary. [BB80/03248]

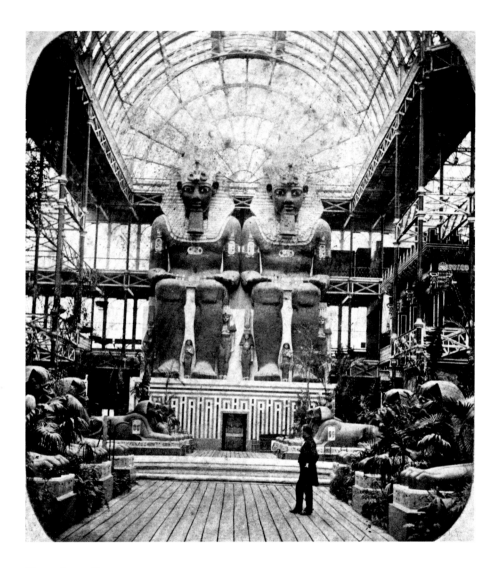

THE ABU SIMBEL FIGURES

After some deliberation about their placement, replicas of two full-size figures from Abu Simbel were stationed in a dominating position at the back of the north transept. Standing 51ft (15.5m) high and built around a brick core, they were made from blocks of plaster, sculpted by Joseph Bonomi using French craftsmen; Bonomi later became curator of the Sir John Soane's Museum. The figures were vividly painted – according to Lady Eastlake, wife of the Director of the National Gallery, they were 'covered in red, yellow and blue house-paint ordered by the hogshead'. They were approached through an avenue of sphinxes, but unfortunately were destroyed in the 1866 fire. [BB69/01078]

« THE ENTRANCE TO THE EGYPTIAN COURT

The aim of the first Crystal Palace had been essentially commercial; however, the second had a strong bias towards education. The 10 Fine Arts Courts were the work of Owen Jones and Matthew Digby Wyatt. When young, Jones had spent months drawing and measuring in Egypt and at the Alhambra in Spain, while Wyatt had travelled in Italy and Sicily, recording buildings as he went. Experts were consulted such as Henry Layard, excavator of Nineveh, who gave his advice for the Assyrian Court. The architects intended to provide visitors with a 'complete history of civilisation', three-dimensional and in full colour. This stereo shows the entrance to the Egyptian Court. [BB85/02132A]

Caption: 5. The Egyptian Court. The Façade of the Hall of Columns. The figures are reproduced from those in the ruins of the Ramesseum, at Thebes.
Series: Crystal Palace

UNA AND THE LION »

John Bell's *Una and the Lion* was one of the most admired sculptures in the whole exhibition and is a realisation of a story in Edmund Spenser's *Faerie Queen* (1590), written for Elizabeth I. Una, symbolising True Religion, is protected from various perils by a lion until she can be reunited with her true love, the Redcrosse Knight, who represents the Anglican Church. Bell's *Andromeda* can be seen to the left and the entrance to the Musical Instruments Court is behind the sculptures. [BB82/12129]

Caption: [Quotation from Spenser's Faerie Queene *(sic)]*
Series: London Stereoscopic Company, 54 Cheapside

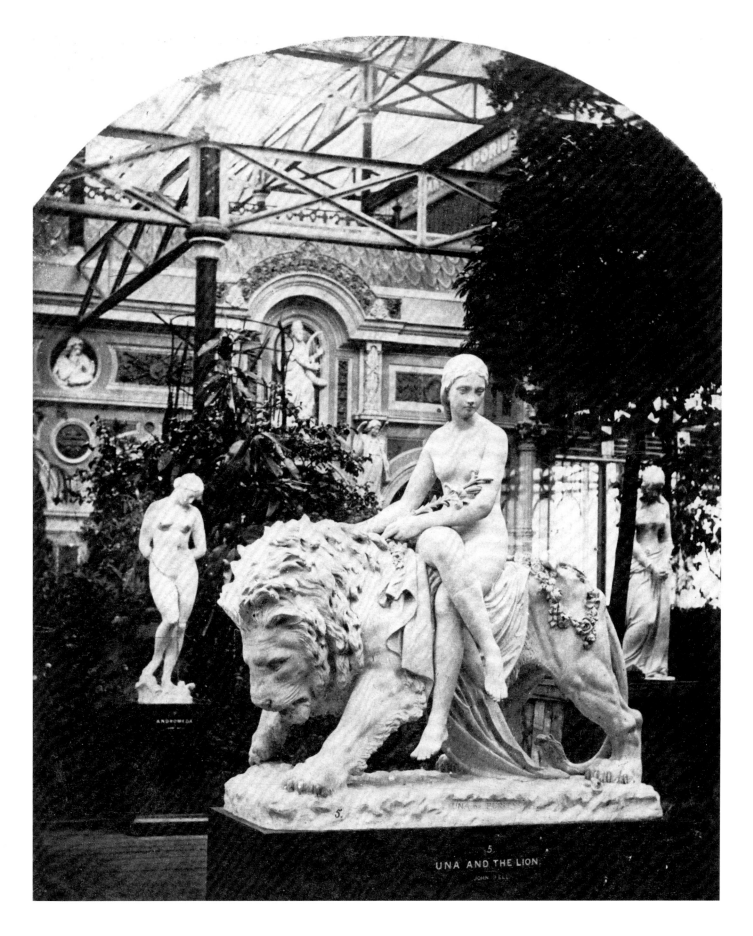

5.
UNA AND THE LION.
JOHN BELL

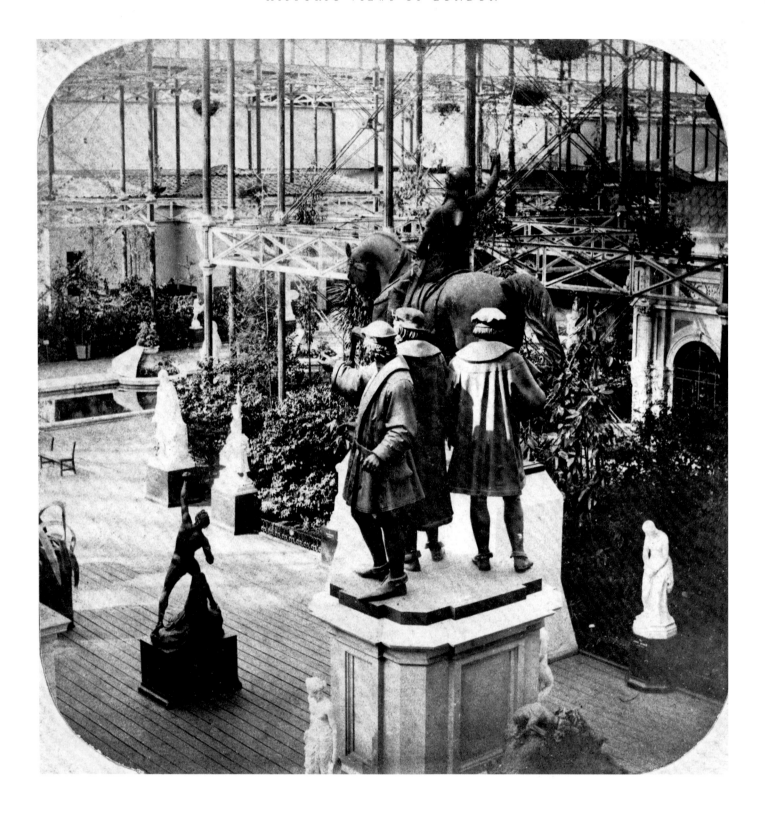

« THE SOUTH-EAST TRANSEPT

This stereo looks across the south-east transept, which is
dominated by casts of Carlo Marochetti's *Richard I* (the
actual monument is today outside the Houses of Parliament,
see p 86) and Baron Schmidt von der Launitz's memorial
to Johannes Gutenberg, the inventor of printing, and his
assistants and companions, Johann Fust and Peter Schoeffer.
John Bell's *Eagle Slayer* aims his arrow just in front of
the larger sculpture; it had been exhibited in 1851 at the
original exhibition in Hyde Park and today is in the Bethnal
Green Museum of Childhood. The same sculptor's *Maid
of Saragossa* urges on other defenders just left of centre.
The organisers of the display had spent in the region of
£60,000 in commissioning and collecting casts of important
sculptures all over Europe. [BB83/03183A]

Caption: 64. General view in the South Transept from the Gallery

Series: Crystal Palace

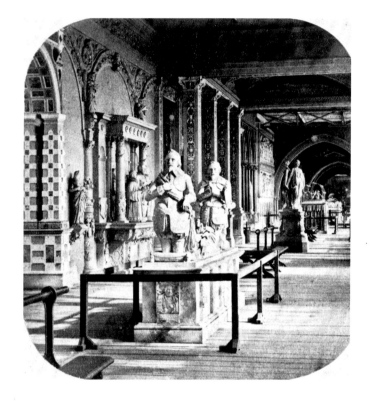

THE RENAISSANCE COURT »

This stereo, possibly taken by Philip Henry Delamotte
about 1859, shows the Garden Gallery of the Renaissance
Court. The first cast in the sequence is taken from the tomb
of Bernward von Gablenz, who died in Mainz, Germany,
in 1570. Against the wall to the left is the memorial to the
Countess of Hertford and her two sons from Salisbury
Cathedral; she was sister to Lady Jane Grey. Further along
the corridor is a replica of the Three Graces by Germain
Pilon; the 16th-century original is made of marble and was
intended to serve as a pedestal for an urn containing the
hearts of Henry II of France and his wife, Catherine de
Medici. In the distance is the Beaufort tomb from St Mary's,
Warwick. [BB83/03192]

*Series: Executed for the Crystal Palace Art Union of 1859 – by Negretti and
Zambra, Photographers to the Crystal Palace Company, Hatton Garden &
Cornhill, London*

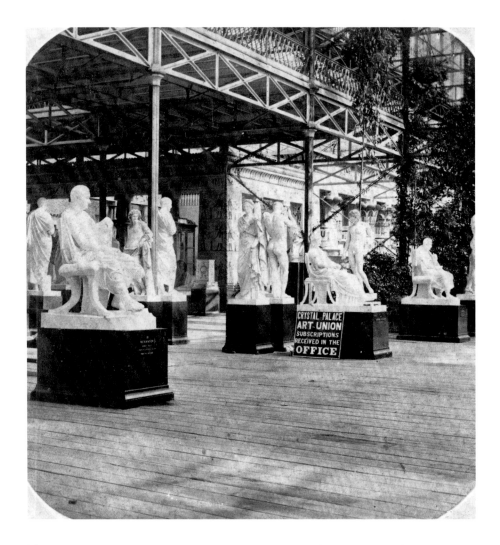

THE ENTRANCE TO THE GREEK AND ROMAN SCULPTURE COURT
Since the aim of the display at Sydenham was particularly directed towards
educating the public, special care had been taken with the Greek and Roman
Sculpture Court situated beside the main entrance. Casts came from all over
Europe. The seated figures – Germanicus from the Louvre, Agrippina from Naples
and Posidippus from the Vatican – just hinted at the excitements within and, in
return for a subscription to the Crystal Palace Art Union, you could hope to win
a set of stereo photographs of the palace, its environs and exhibits, or a replica in
reduced size of one of the sculptures. [BB83/03183B]

Caption: 92. Entrance to the Greek and Roman Sculpture Court. From the Nave
Series: Crystal Palace

THE ALHAMBRA COURT
The Court of the Lions in the Alhambra Palace in Granada
is one of the finest creations of Arab art; in his youth
Owen Jones had spent months studying it. Its recreation in
Sydenham by Raphael Monti was a triumph and it was the

most talked about of all the courts. Washington Irving's *Tales
of the Alhambra*, published in 1832, would have also been
familiar to many of the visitors. [AA83/01336]
(Reproduced from a hand-tinted stereo slide)

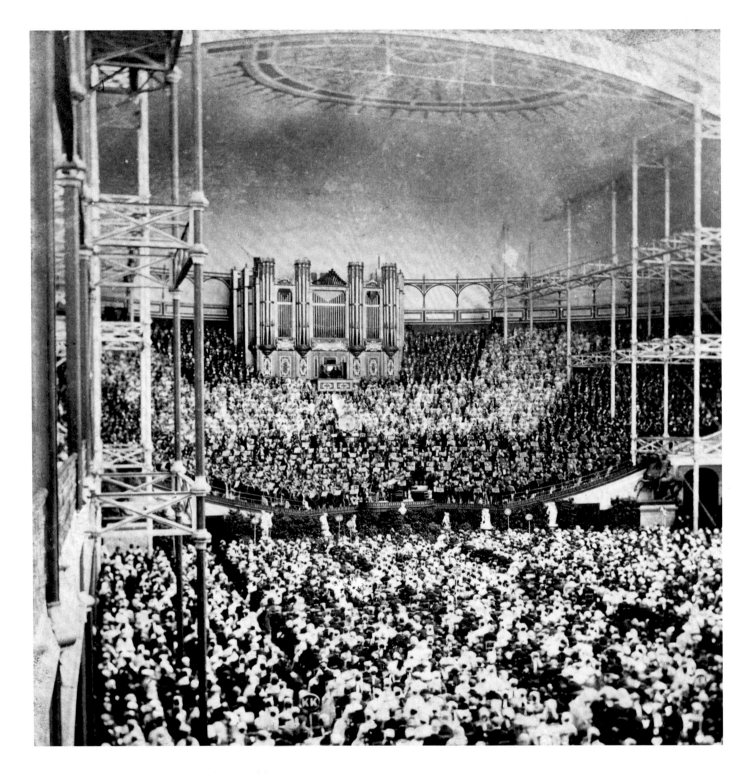

HANDEL FESTIVAL IN THE GREAT TRANSEPT

There had been no thought of provision for music when the Crystal Palace was first planned and the acoustics were notoriously bad; however, the Handel Festivals, held at three-year intervals from 1857, were so popular that they saved the palace from financial failure. A raised stand, 42ft (12.8m) high, was built to accommodate 250 performers and the audience numbered thousands. Later, the orchestra pit was enlarged to a width of 216ft (65.8m) and a depth of 100ft (30.5m). The organ, by Gray and Davison, was the largest in Britain, with 4 manuals and 4,568 pipes. [BB94/00376]

Series: Julius Graife, 27 Warwick Str., c/o Cryst. Palace Coll.

AFTER THE FIRE
A severe fire broke out on 30 December 1866 at the north end of the garden front.
It did much damage, particularly to the Fine Arts Courts inside the building.
A ruined Norman doorway from Romsey Abbey stands forlornly on the right;
Paxton's approach tunnel from the railway marks the foreground. [BB92/15895]

THE INTERNATIONAL
EXHIBITION OF 1862

The International Exhibition of 1862 was the direct successor to the Great Exhibition of 1851. As the decade passed, plans were made for a commemorative celebration that would also act as an encouragement to further progress in the arts, sciences and manufactures. The initial drive came from Sir Henry Cole, Prince Albert's friend, who had also been behind the 1851 undertaking in Hyde Park; he was backed by the Royal Society of Arts, which hoped to gain a permanent building for displays, and – more reluctantly – by the prince, who felt that it was unwise to try to repeat a success. A site, however, was provided free of charge for a temporary structure; the solid main façade ran along the Cromwell Road, from Prince Albert Road (now Queen's Gate) to Exhibition Road, and northwards to Kensington Road.

THE 1862 INTERNATIONAL EXHIBITION SEEN FROM THE CROMWELL ROAD, LOOKING NORTH
The architect of the exhibition building was Captain Francis Fowke of the Royal Engineers, a man in his 30s and exceptionally gifted in recognising the possibilities of new materials and techniques. Using the same modular system with components of timber and brick as well as the glass and iron that had been employed in Hyde Park, he planned an enormous structure with entrances on all sides and domes to emphasise the east–west axis. There were annexes for further displays of machinery and agricultural implements beyond it and, still further northwards, the gardens of the Horticultural Society with the memorial to the 1851 Great Exhibition.

However, the main façade along the Cromwell Road was much criticised as being too heavy and unwelcoming; contemporary engravings usually record the building from the south-western corner where the entrance under the domes gave a more picturesque and exciting aspect. The influential *Art Journal* was especially vehement in its disapproval, declaring that it was 'difficult to imagine anything more daringly ugly than this lamentable specimen ... it is a monstrous outrage upon national forbearance, and doomed to reflect most fatally upon national taste'.

This view shows the main entrance with a queue to buy tickets. The price of entry ranged from £1 to a shilling, depending on the day of the week. [BB86/02157]
Caption: No. 185. International Exhibition. The East Front taken from the Cromwell Road, looking North. [Cowper quotation, see pp 14–15]
Series: Instantaneous Views of London

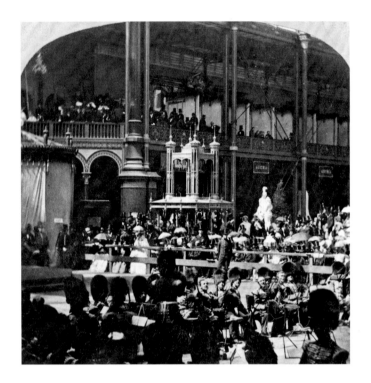

THE OPENING CEREMONY

The opening of the International Exhibition had already been postponed from its original date in 1861 and the death of Prince Albert on 14 December 1861 was a blow from which the whole enterprise never recovered. Not surprisingly, the queen felt incapable of performing the opening ceremony, so the Duke of Cambridge took her place on 1 May 1862. The Band of Guards played and, over the six months the exhibition was open, there were almost as many visitors as in 1851 – 5¼ million as against 6 million – of which a greater proportion were foreign and commercially directed. Nevertheless, when it closed on 1 November, the exhibition was judged a disappointment rather than a glorious success. Since no pertinent use could be found for the building, Captain Fowke and the Royal Engineers demolished his creation. Alfred Waterhouse's Natural History Museum now occupies the site. [BB80/00009]

Caption: [unnumbered] The opening ceremony

Series: The International Exhibition of 1862. London Stereoscopic & Photographic Co

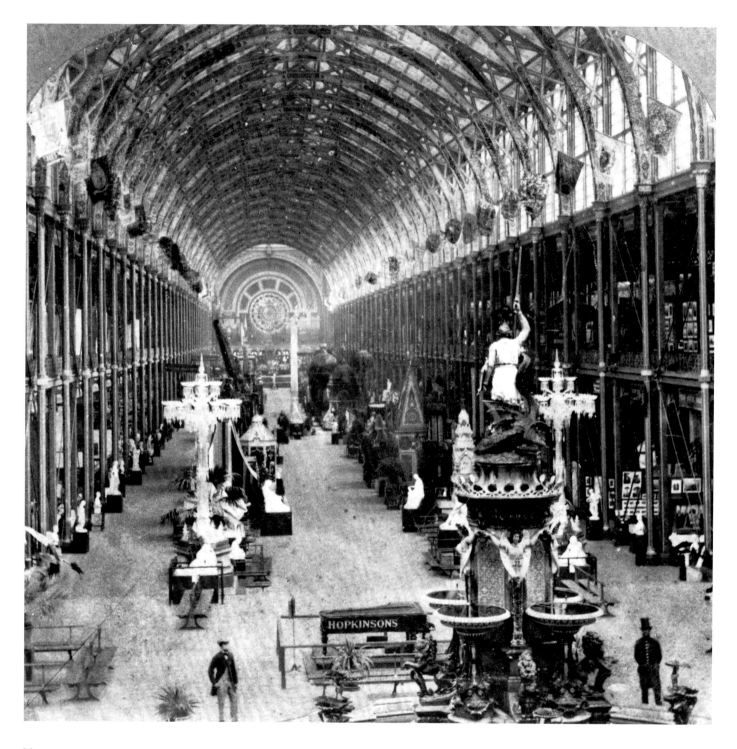

HOPKINSONS

THE NAVE FROM THE EASTERN DOME

The main exhibition space in the nave was filled with an extraordinary mixture of exhibits; the architect Alexander Beresford-Hope spoke of the 'conglomeration of telescopes, organs, lighthouses, fountains, obelisks, pickles, furs, stuffs, porcelain, dolls, rocking-horses, alabasters, stearine, and Lady Godiva', but Sir Henry Cole's 'Cromwellian genius', as his son-in-law said, sorted it all out somehow.

This shot shows the rear of Thomas Minton's Majolica Fountain. To its left is the Grand Glass Candelabrum from Messrs Defries & Sons of Houndsditch. [BB80/00015]

Caption: No. 28. The nave from the eastern dome

Series: The International Exhibition of 1862. London Stereoscopic & Photographic Co

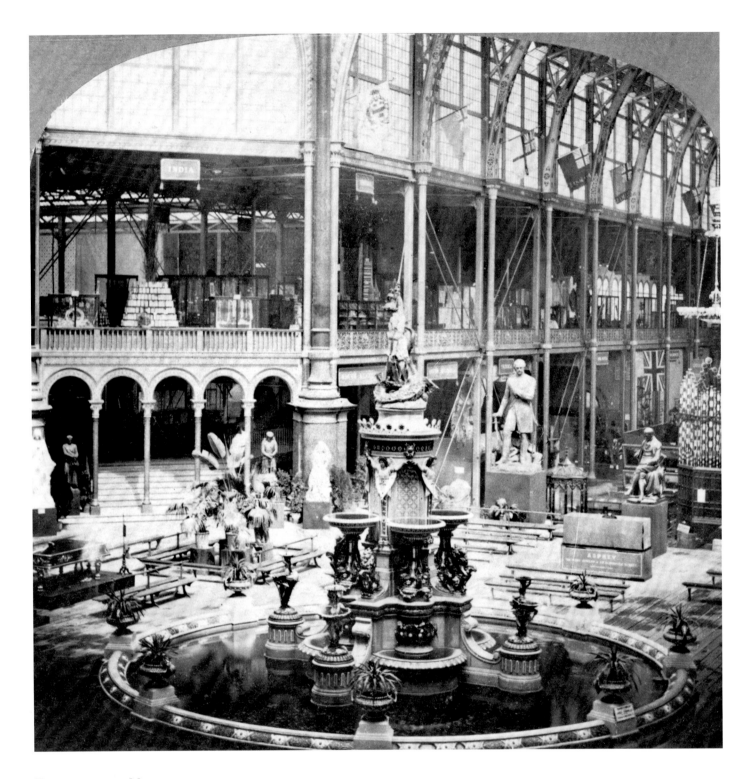

FOUNTAIN IN MAJOLICA WARE

Thomas Minton's Majolica Fountain was 36ft (11m) high and topped by John Thomas' figure of St George, his sword raised aloft. It was one of the special attractions of the International Exhibition and its waters were regularly perfumed throughout the day by Messrs Rimmel. This shot shows the galleried structure of the interior of the exhibition building particularly clearly. [BB80/00019]

Caption: No. 49. Fountain in Majolica Ware. Modelled by Thomas Minton & Co (2)

Series: The International Exhibition of 1862. London Stereoscopic & Photographic Co

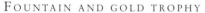

FOUNTAIN AND GOLD TROPHY

A visit to Kensington was an exhausting undertaking due to
its oppressive atmosphere – people collapsed on leaving the
building, the roof being covered with felt and slates meant
a serious reduction in the light and there was not the same
joyous atmosphere of wonder and discovery and innovation
as there had been in the Hyde Park building of 1851. In this
view a weary band takes a rest beside Minton's fountain.
Behind them is an obelisk, nearly 45ft (13.7m) high and
10ft (3m) square at the base, representing the mass of gold
ore excavated over a 10-year period from around Victoria in
Australia. [BB80/00012]

*Series: The International Exhibition of 1862. London Stereoscopic &
Photographic Co*

THE FRENCH EXHIBIT

The French delegation to the exhibition showed what could
be done with the rather awkward display carrels. By building
screens and balustrades – ignoring the instructions laid
down for exhibitors – they made sure that their exhibits
would be displayed advantageously, as the *Art Journal* noted
approvingly. Though the outcome of the Franco-Austrian
war was as yet undecided, Napoleon III sent his cousin
Prince Jerome with his wife, Princess Clothilde, daughter of
Victor Emanuel II, King of Italy, as his representatives. They
are seen here, surrounded by their exhibition team. Behind
them hang Gobelin tapestries, woven copies of Titian's
Assumption of the Blessed Virgin, and Hyacinthe Rigaud's
magnificent portrait of Louis XIV. [BB90/03165]

*Caption: No. 334. Prince Napoleon and the Princess Clothilde. The Gobelin
Tapestry etc*

*Series: The International Exhibition of 1862. London Stereoscopic &
Photographic Co*

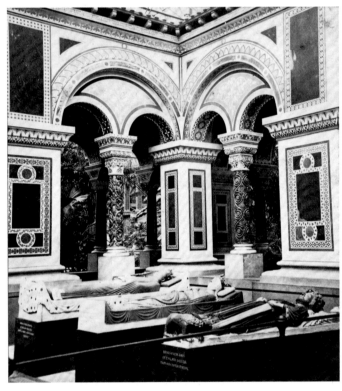

THE NOVA SCOTIA COURT

The Canadian display concentrated on the natural resources of the country, in particular its minerals (including gold, iron and copper) and its superb timber. A trophy was built, three storeys high, under the north transept, with baulks of white oak and black walnut, 12ft (3.7m) and 15ft (4.6m) in girth. The Nova Scotia Court, its arms displayed aloft, also proudly exhibited a stuffed moose. [BB83/01535]

ROYAL EFFIGIES

This view shows casts of the royal effigies from Fontevrault in France, where the Norman Angevin kings were buried. Here we have Henry II and his tempestuous wife, Eleanor of Aquitaine, and their son, Richard Coeur de Lion. Richard's wife Berengaria was there too. The casts can now be seen in the Victoria & Albert Museum where they are highly prized, both as superb works of art and as records almost more faithful than the originals. Salviati's mosaics decorate the walls and the pillars are adorned with terracotta mouldings. [BB91/27457]

Series: This is not one of the official series taken by the London Stereoscopic & Photographic Co.

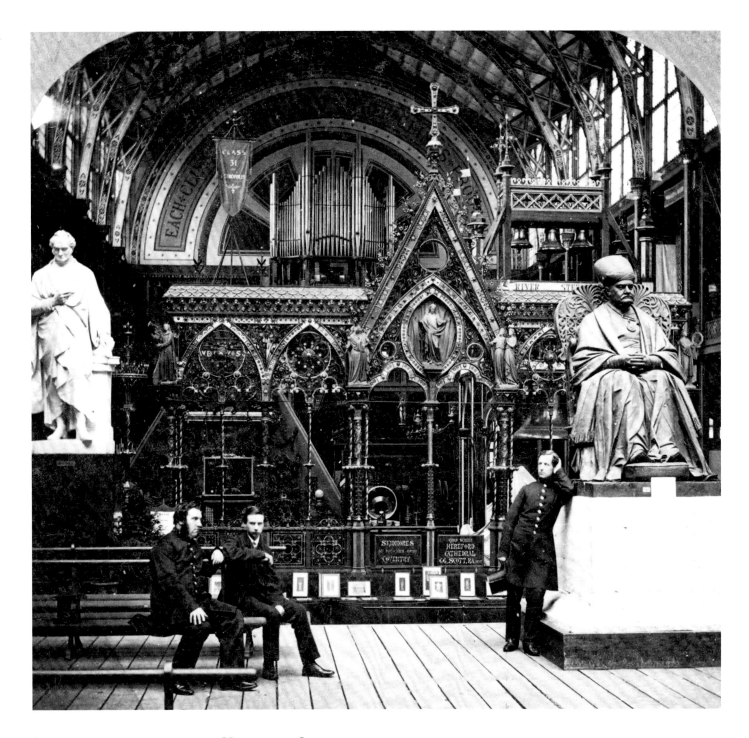

SOUTH-EAST TRANSEPT: THE HEREFORD SCREEN

This magnificent screen was made for Hereford Cathedral by Messrs Skidmore of Coventry from designs by Sir George Gilbert Scott. John Timbs praised it as 'the largest piece of architectural metalwork ever executed', noting mournfully that it was 'seen to great disadvantage'. This was not surprising since 9,862 applicants had demanded display space; it would have required a building seven times larger than Fowke's design to accommodate them all. The screen is now displayed in the Victoria & Albert Museum.

Exhausted warders rest by the exhibits. On the right is a cast of Carlo Marochetti's imposing statue of Sir Jamsetjee Jejeebhoy, the leader of the Parsee community and a respected philanthropist. [BB85/02141B]

Caption: No. 48. South East Transept

Series: The International Exhibition of 1862. London Stereoscopic & Photographic Co

THE NAVAL COURT

John Timbs' fat little volume on the International Exhibition gives considerable space to the naval and military models, weapons and appliances. Pride of place went to the new gun recently introduced by Sir William Armstrong, 'a rifled breech-loading 70-pounder'. [BB91/27444]

Caption: No. 120. Armstrong Guns &c. Naval Court (1)
Series: The International Exhibition of 1862. London Stereoscopic & Photographic Co

NORTHERN LIGHTHOUSE BOARD DISPLAY

This view shows a model of the Skerryvore Lighthouse off Tiree, Western Isles, with a display of other equipment from the Northern Lighthouse Board. Skerryvore was built in 1838–44 by Alan Stevenson, uncle of the novelist Robert Louis Stevenson who worked for a time as an engineer in the family office. Behind it, we can see the ominous Armstrong guns. [BB80/00008]

Caption: No. 133. The Armstrong Trophy and Naval Court

Series: The International Exhibition of 1862. London Stereoscopic & Photographic Co

VIEW IN THE HARDWARE COURT

One of the main objectives of the 1862 International Exhibition was to display the manufacturing capabilities of the various nations. Two long annexes were needed at the rear of the main building to house these displays. Here we have Exhibit 6336, Brewing and Distilling Equipment from Henry Pontifex & Sons of 55 Shoe Lane, Holborn, London;

the firm, established in 1796, continues today in Pepper Lane, Leeds. Perhaps the top-hatted gentleman is a younger Mr Pontifex. [BB91/27450]

Caption: No. 161. View in the Hardware Court

Series: The International Exhibition of 1862. London Stereoscopic & Photographic Co

THE KIRKSTALL FORGE STEAM HAMMER
The steam hammer from the Kirkstall Forge Company received particular mention by John Timbs, its rapidity of action being one of its 'principal qualifications'. [BB80/00018]

Caption: No. 341. Machinery (Kirkstall Forge & Co's steam hammer)
Series: The International Exhibition of 1862. London Stereoscopic & Photographic Co

FRENCH MACHINERY

The excellent precision and finish of the French exhibit was especially praised by John Timbs in his invaluable volume on the International Exhibition, which was published in 1863. Here, a smartly waistcoated representative chats instructively to a visitor. [BB91/27452]

Caption: No. 199. French Machinery. Western Annexe. (3)
Series: The International Exhibition of 1862. London Stereoscopic &
Photographic Co

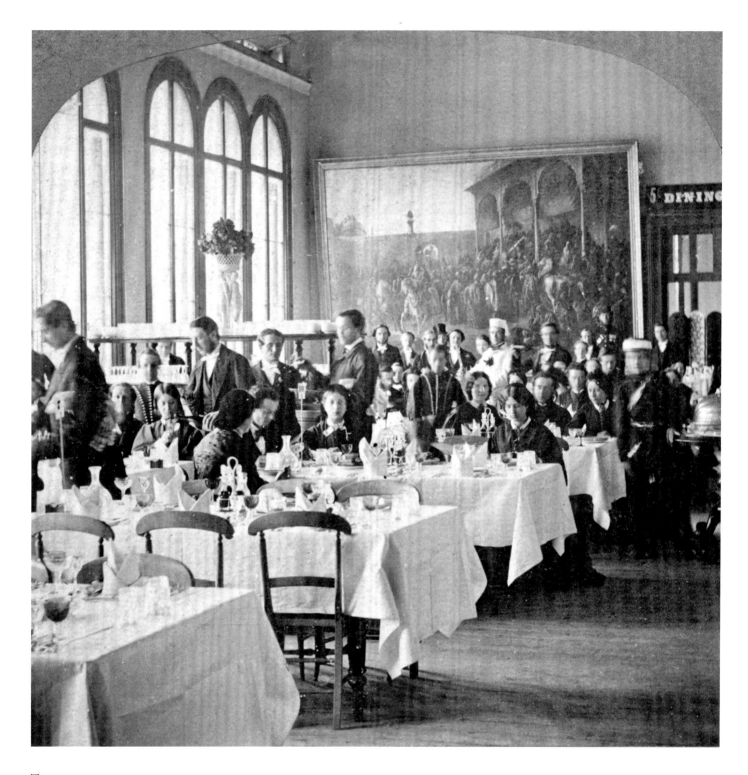

THE DINING ROOM

The International Exhibition had a dining room on the north side of the building, looking out onto the gardens of the Horticultural Society. This stereo, presumably taken before the exhibition opened, shows the staff posing as diners. The soberly dressed ladies are those in attendance in the female retiring rooms. Waiters pretend to take orders and the chef, presumably the *maître d'hôtel* and a uniformed commissionaire are behind them. But what is the large painting of an oriental scene, which seems to be propped against the wall? [BB80/00007]

Caption: No. 14. The dining room

Series: The International Exhibition of 1862. London Stereoscopic & Photographic Co

» RAILWAY STATIONS

The railway stations stand in a watchful ring around London, ready to serve those arriving and those setting out on a journey. Like Paris, the capital has no Grand Central Station since its streets and buildings were already too developed to permit any insertion.

The railways meant change. For the first time, people could travel at a greater speed than their legs could carry them or a horse could gallop. Now they could be miles away in minutes. Where before there had been limits on the weight that could be transported by pack mules or stout wagons, heavy loads could now be carried easily wherever the rails might run. The railways arrived and, suddenly, there was no turning back.

EUSTON STATION
The world's first main line railway station opened at Euston on 20 July 1837, just as Queen Victoria came to the throne. The first train to make the 112-mile journey between London and Birmingham ran on 17 September 1838, covering the distance in just over five hours.

The terminus was given the approach that it deserved. The entrance was under a gigantic Doric Arch surmounted by a pediment. It was designed by Philip Hardwick and stood 72ft (22m) high with lodges attached to either side. Behind it, between 1845 and 1849, the younger Hardwick added a pillared Great Hall 125ft (38.1m) long, with a statue of the railway engineer George Stephenson at the foot of the grand staircase.

Despite wartime bombing, all this survived until 1961 when Euston began to be systematically redeveloped. In spite of passionate opposition, the Doric Arch and Great Hall were wantonly sacrificed; the only relic is George Stephenson's statue, standing forlorn on the forecourt.

This early stereo image of the 1860s shows the arch in all its glory, a proper tribute to Victorian engineering skills. [BB72/05884B]

Caption: 537. Euston Station

Series: London and Neighbourhood. G R & Co

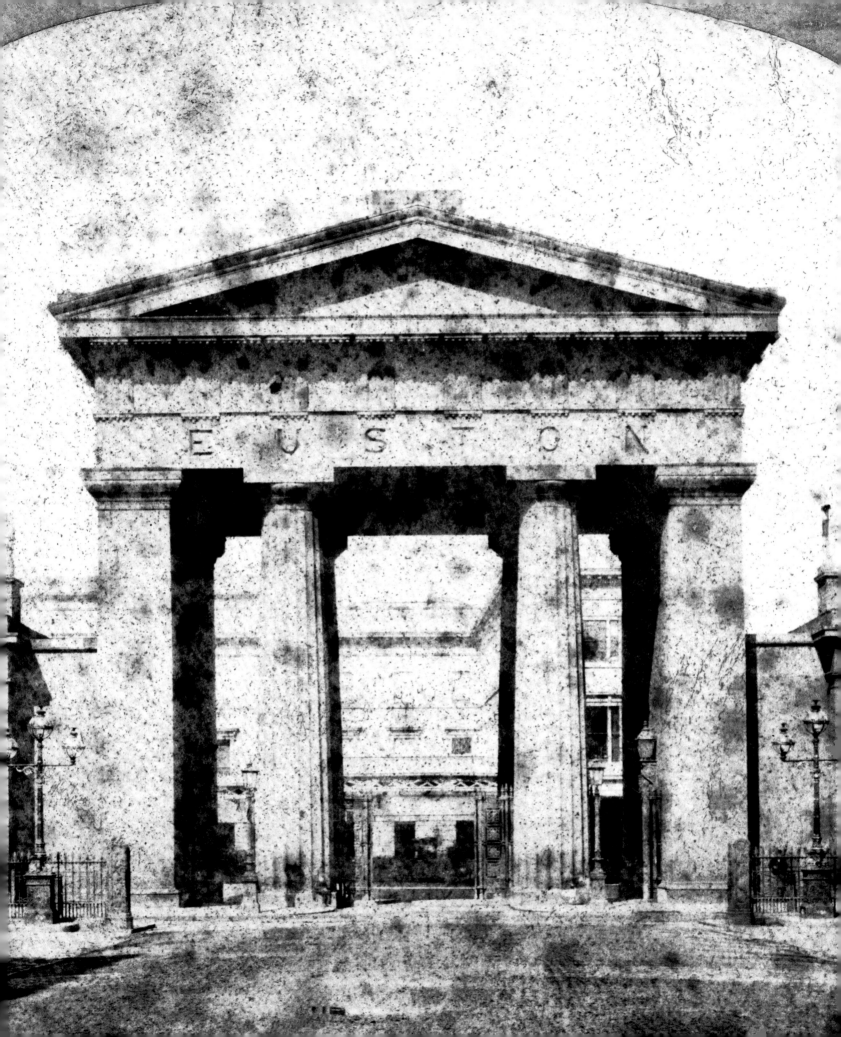

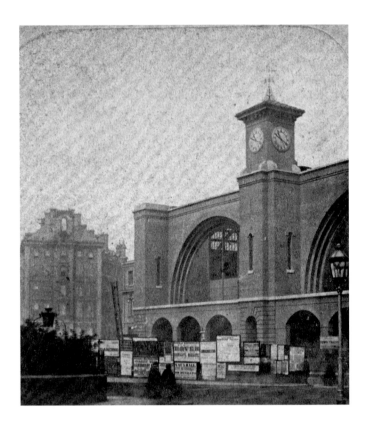

KING'S CROSS STATION

King's Cross Station is just half a mile eastwards of Euston, facing onto the Euston Road. It serves the Great Northern Railway, bearing passengers between London and York and then on to Edinburgh and further north. The line was opened on 7 August 1850 from a temporary station on what is now York Way; the sparse accommodation of two bare wooden platforms – an example of classic functional simplicity – had to cope with the excursion trains coming in and out for the Great Exhibition of 1851 and with Queen Victoria and Prince Albert setting off for Scotland in August. The existing station opened on 14 August 1852, designed by Lewis Cubitt with his brother, Sir William, and nephew, Joseph Cubitt, as engineers.

To the left of this stereo photograph, taken perhaps in the 1870s or 1880s, is the eastern side of St Pancras Station, the third of the trio of termini facing onto the Euston Road; it was built to serve the Midlands. Opening on 1 February 1857, it was designed by William Barlow, the railway's own engineer, but is best known for its hotel, designed in awe-inspiring Gothic manner by Sir George Gilbert Scott in 1865 and built 1868–73; however, the hotel is out of sight in this view. [BB92/15896]

Caption: 63. Great Northern Railway Station, King's Cross
Series: Views of London

LONDON BRIDGE STATION

Properly speaking, London Bridge, beside the Southwark approach to the river crossing, should have pride of place in any recital of the glories of London's termini. Each day 2,000 people tramped between Greenwich and London, and the first passenger railway – the London & Greenwich – opened on 8 February 1836 in temporary accommodation in Bermondsey to serve them. The permanent station at London Bridge formally opened on 14 December 1836; this event was attended by the Lord Mayor, sheriffs, the Common Council and 2,000 guests, who travelled 3½ miles to Greenwich with musicians, dressed as Beefeaters, serenading them from a perch on the roof of one of the carriages.

The railway itself was ingenious. In 1831 a retired Royal Engineer, Lieutenant Colonel G T Landmann, proposed that the track should be laid on a brick viaduct supported on 878 arches. The station itself was unpretentious and frequently altered when the London & Greenwich Railway was joined by others serving Croydon and then Brighton and Dover.

This stereo photograph of the 1850s shows the road approach to the station. A double file of cabs waits patiently for passengers. With the enlargement of train services, there were several rebuildings, described more fully in Alan A Jackson's admirable *London's Termini* (1985). This shot shows Samuel Beazley's 1850s replacement of William Cubitt's original design; *The Illustrated London News* (15 February 1851) did not admire it, describing it as 'of less merit than its predecessor' and commenting sharply on the cement decorations round the clock. [BB85/02230A]

Caption: 6. South Eastern Railway, London Bridge
Series: Views of London

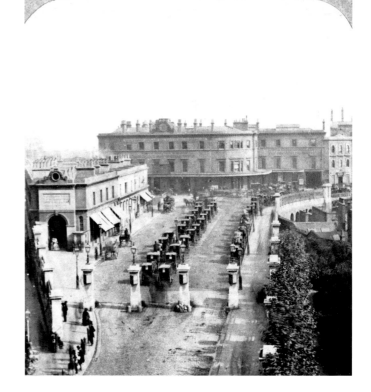

PADDINGTON STATION

Paddington Station is the terminus for the western approach into London, connecting the capital to Bristol and the south-west. Various sites were considered for the station, including a sharing of the London & Birmingham Railway's facilities at Euston, but at last the site was settled upon at Paddington. There Isambard Kingdom Brunel built his station, wide and airy enough to accommodate his broad-gauge track – 7ft ¼in wide as against the more usual 4ft 8½in – though both widths were in use from the early 1850s to 1892.

A provisional terminus opened on 4 June 1838 and the line to Bristol was completed on 30 June 1841. It was to this early Paddington that Queen Victoria made her first railway journey on 13 June 1842; Prince Albert felt that the speed was a little too swift, and said so. The average speed was 44mph and the driver was Daniel Gooch, who had become the first Great Western Railway superintendent of locomotives six years earlier at the age of 20.

This daguerreotype, which seems to be as early as 1853, appears to record the demolition of Brunel's original station before the building of a more permanent structure on the south-eastern side of Bishop's Bridge Road. The work is in full progress; the first goods shed can be seen, glimpsed on the far side of the bridge. It is a very different scene from that shown in William Powell Frith's painting, *The Railway Station*, completed in 1862, which is all colour, glamour and drama. [BB72/00450B]

A ROYAL VISIT, PADDINGTON STATION

No. 1 Platform is decked out and carefully attired gentlemen await the arrival of the Shah of Persia on a state visit in 1899. Which of them is the stationmaster? A shield with a crescent hangs below the central window with more heraldry on either side. [BB82/12079]

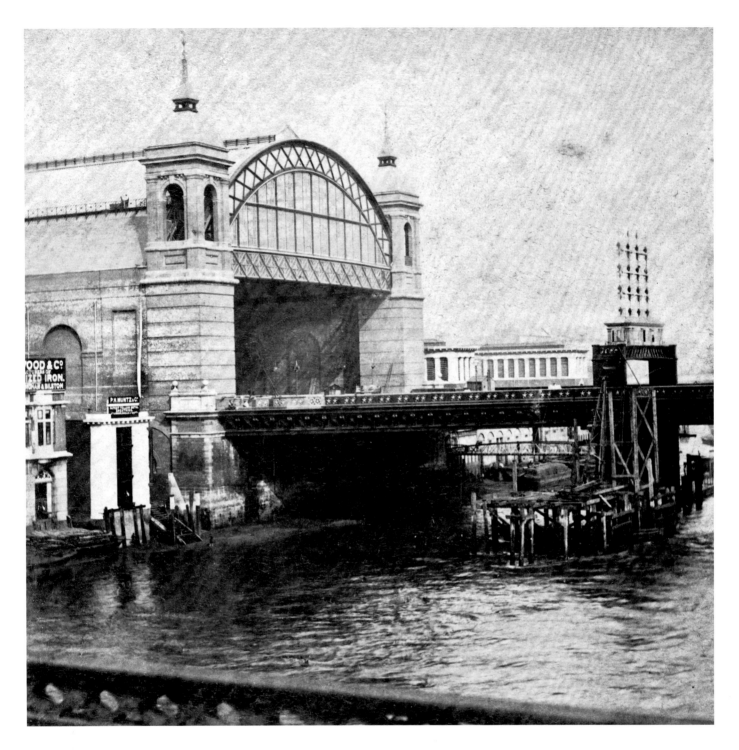

CHARING CROSS STATION

Charing Cross Station lies nearest to the heart of Westminster. Constructed on the site of Hungerford Market (*see also* Hungerford Bridge on p 44) – demolished to make way for this newcomer – the station was designed by John Hawkshaw, consulting engineer to the South-Eastern Railway. The first main line train ran on 1 May 1864, though local services had been operating since the January of that year. Today it is probably the busiest of all London termini as many people find it easy to walk to work in Westminster, the Strand or Whitehall from here. [BB88/04282]

Caption: No. 123. South-Eastern railway bridge, Charing Cross
Series: Views of London and its Vicinity, by The London Stereoscopic & Photographic Co

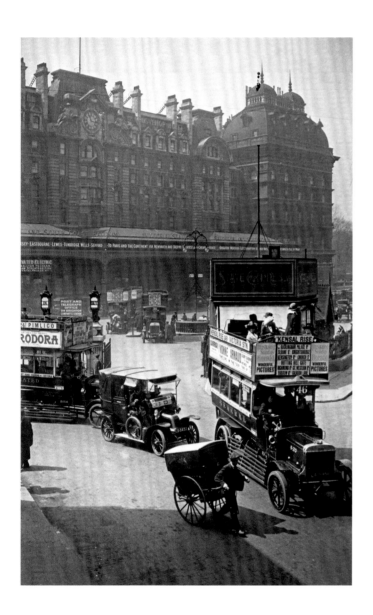

VICTORIA STATION

Victoria Station began as two stations in one, the result of an alliance between the London, Brighton & South Coast Railway and the West End of London & Crystal Palace Railway. The resulting terminus has two distinct characters – from the suave, intercontinental and international to the more domesticated southern counties and the slightly racier approach of those travelling in from Brighton. Services began on 28 March 1858.

In this photograph we can see the forecourt of the station and the frontage of the Grosvenor Hotel, with small pavilions on its roofline, designed by J T Knowles in 1861. The No. 46 bus (now Route 52) sets out for Kensal Rise with an advertisement for Yvonne Arnaud's appearance at the Garrick Theatre in *The Girl in the Taxi* and another bus comes into view with a notice for the musical *Florodora*, probably at the Aldwych; both entertainments were revivals, but the only time when they were running simultaneously was in the first half of 1915.

Most of the vehicles are motorised though there is one substantial barrow dragged along steadily behind its owner. [BB88/04126]

» TRAFFIC

London has always been a place of jostle and noise. By 1830 an otherwise unknown J Shakespeare was lamenting:

> It is really impossible to suffer the Annoyances we complain of without remonstrance. At this moment there are three large Shut carts blocking up the Passage entirely across Oxford Street & surrounded by a mob of Vagabonds – One fellow ringing a Bell, another blowing a Trumpet, and a third beating a large Gong or Drum that may be heard to Charing Cross.
> (Quoted in Saunders 1981, 170, ftn 33)

From pedestrians, horses, carts and carriages; to the early 19th-century unsuccessful option of steam-driven vehicles, the more hospitable horse-drawn omnibus and the late 19th-century successful development of motor cars and buses; to the trams, trolley-buses and bendy-buses of the 20th century – London has seen them all.

ROTTEN ROW, HYDE PARK
After the restoration of Charles II in 1660 it became fashionable to ride or drive around Hyde Park in order to see and be seen. When William III made Kensington Palace his chief London residence, the main route through the park was hung with 300 lanterns in an unsuccessful attempt to deter highwaymen; it later became popularly known as Rotten Row from the *route du roi*. The park remained fashionable and this stereo shows us the scene on a fine afternoon in summer *c* 1900. Horse-drawn carriages parade slowly around the centre, pausing so that friends and acquaintances may converse; parasols are much in evidence. [BB83/04732]
Caption: 876. Rotten Row – Hyde Park
Series: London and Neighbourhood by York & Son

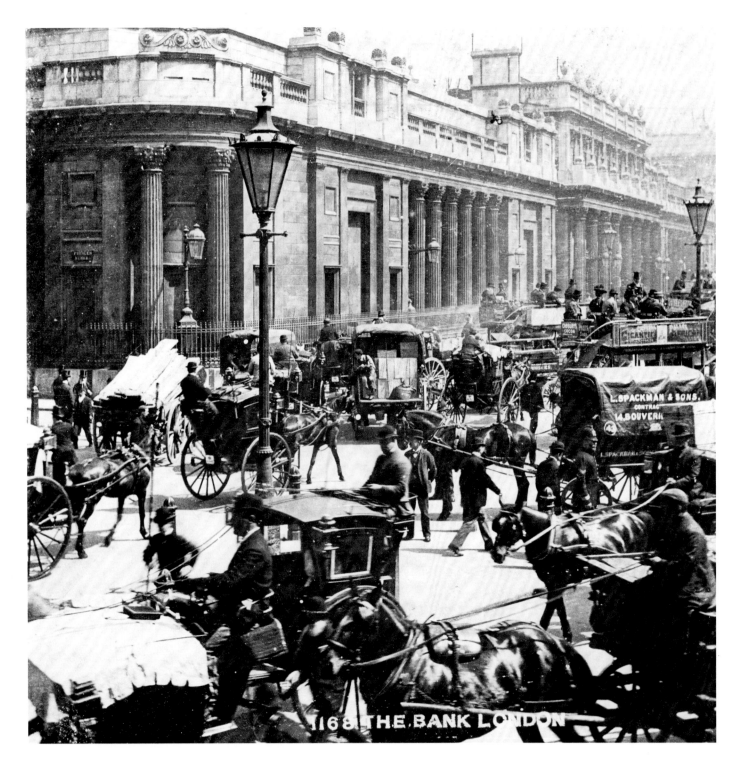

1168 THE BANK LONDON

THE BANK OF ENGLAND

The Bank of England was established in 1694. In this stereo, we are looking at Sir John Soane's building, developed from 1788 onwards, before it was changed and extended by Sir Herbert Baker and his nephew in the 1920s and 1930s. Vehicles of all kinds throng the space in front of the Bank of England and the Royal Exchange, which lies at an angle to the bank and is just off to the right of this image. The view emphasises the dignity of Soane's façade with its colonnade; working carts and smart cabs crowd in together and someone is dragging along a load of planks. [BB72/05883A]

Caption: 1168. The Bank, London [Directions for use, see pp 15–16]
Series: The Fine Art Photographers' Publishing Co. Gold Medal Series.

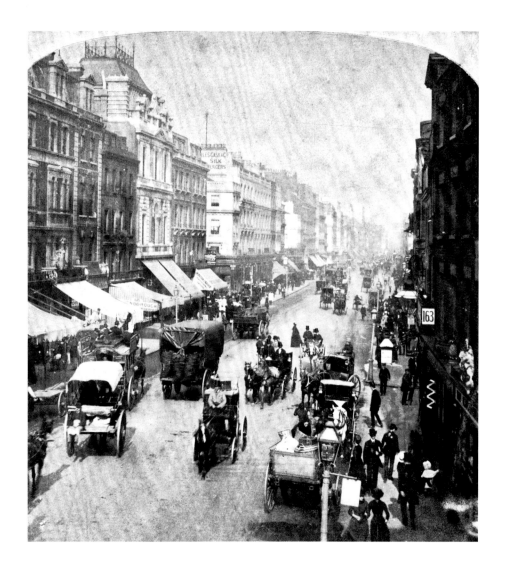

OXFORD STREET

A steady procession of traffic moves eastwards along Oxford Street one morning in 1887. Two ladies, arm in arm, walk towards us, almost out of frame. Another stereo card, with an identical scene, is labelled in German as well as English. [BB67/08241]

Caption: Oxford Street, London, England (Also given in German)

Series: J F Jarvis, Publisher, Washington, DC. Sold by Underwood & Underwood, Baltimore, Ma etc.

Copyright J F Jarvis 1887

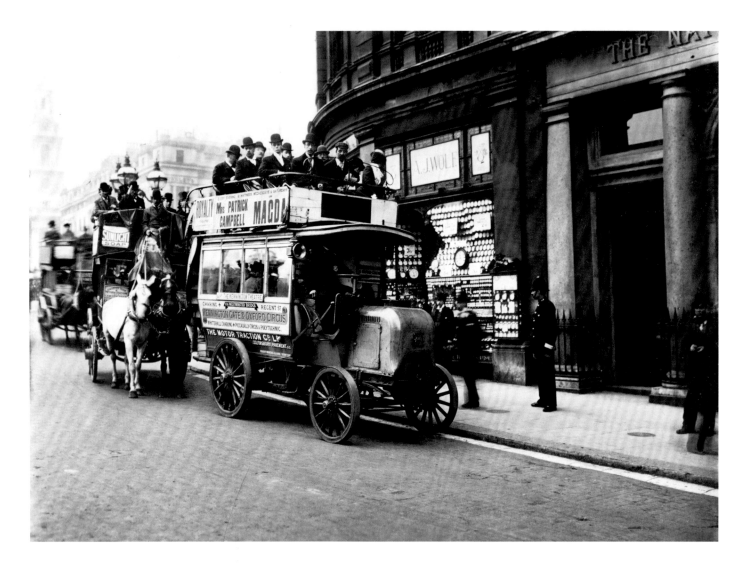

CHARING CROSS

The past overtakes the future. In this photograph a Motor Traction Company's omnibus, powered by a 12-horsepower German Daimler engine, draws up in Charing Cross. A policeman looks on with interest. The fleet consisted of two vehicles, which ran between Kennington and Victoria Stations via Westminster Bridge from 9 October 1899, though they were withdrawn in December 1900. Since *Magda*, starring Mrs Patrick Campbell, ran at the Royalty Theatre between February and July 1900, we can date this photograph reasonably closely from the poster advertising the play's run. A horse-bus pulls out behind the omnibus, striving to overtake. Horse-drawn transport was, in fact, more reliable since the early motorbuses' engines were sorely tried with frequent stopping and starting. [BB90/14585]

TOTTENHAM COURT ROAD

A purposeful motorised omnibus dominates this early 20th-century photograph of the junction of Tottenham Court Road and Oxford Street. The road layout remains surprisingly unchanged, save for the volume of traffic. The Young Men's Christian Association (YMCA) still occupies the site on the corner of Tottenham Court Road and Great Russell Street, though now in a new building of 1930–2. Opposite the majestic dome of the YMCA is another building surmounted by an elegant ironwork cupola. It is still there, like a tiny aerial bandstand. When the photograph was taken, it was a public house; today, it provides for the Central School of English with a burger bar at pavement level. [BB88/04127]

» MEDICAL LONDON

Humanity with all its ills has always sought out medicine and its practitioners. A Fellowship of Surgeons had developed by 1324, becoming a City Livery Company in 1462; at the same time London barbers performed bloodletting and minor surgery. In 1540 the two groups were merged by Henry VIII to become the Barber-Surgeons, with a hall in Monkwell Square where a large painting of the monarch presenting the officers with a charter still hangs. In 1745 the surgeons broke away to become a separate company.

ROYAL COLLEGE OF SURGEONS
In 1797 the surgeons purchased a house on the south side of Lincoln's Inn Fields and it was from these premises that they received a royal charter in 1800, thus becoming the Royal College of Surgeons. The property was rebuilt by George Dance the Younger and James Lewis with a handsome portico, which has survived rebuilding and enlargement by Sir Charles Barry, heavy bombing in 1941 and post-war reconstruction with further extensions. This stereo view, probably of 1870–80, shows the façade of Barry's building. [BB88/05913]

Caption: 258. London College of Surgeons

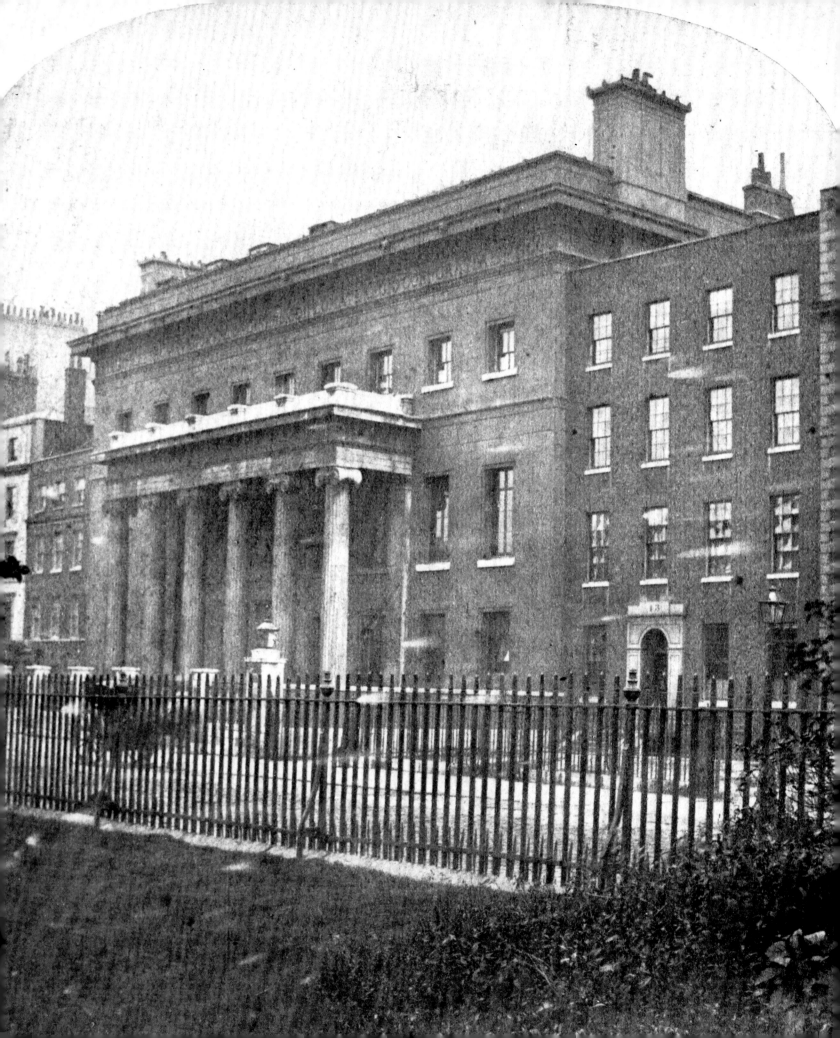

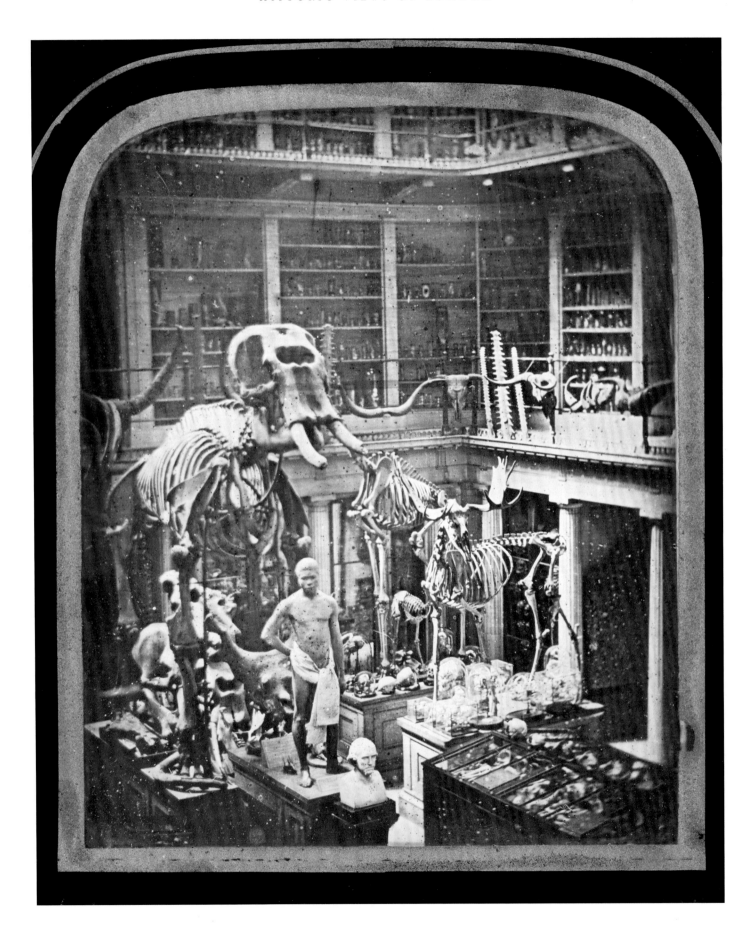

« HUNTERIAN COLLECTION, ROYAL COLLEGE OF SURGEONS

The vast anatomy and physiology collection amassed by the surgeon-scientist John Hunter was presented to the college in 1806 by the prime minister, William Pitt. This early daguerreotype, taken in the summer of 1852 by Timothy Le Beau, shows the gallery of Barry's building with skeletons of an elephant, an Irish elk and a giraffe, as well as a cast of an African by Antonio Santorini. The elephant, known as Chunee, was displayed in a menagerie at Exeter Change in the Strand where, in 1826, he went mad and had to be put down. Judging from the other daguerrotypes held by the college, a detailed photographic record of Hunter's collection must have been made at this early date. Howarth-Loomes so prized this daguerreotype, a photographic incunabulum, that he reproduced it in his *Victorian Photography*. [BB72/05026]

MIDDLESEX HOSPITAL, MORTIMER STREET, WESTMINSTER »

The middle years of the 18th century saw much philanthropic hospital building. The Middlesex Hospital opened in 1745 in a house in Windmill Street, but soon moved to the present site in Mortimer Street, the foundation stone being laid in 1755. Both David Garrick and George Frideric Handel organised benefit performances to raise money for the new buildings and Samuel Whitbread gave £3,000 to endow a cancer ward; oncology remained a speciality of the hospital through more than two succeeding centuries.

This stereo image shows the hospital in about 1861. Extended and rebuilt at intervals, the Middlesex set up its own medical school and in 1890 added a chapel designed by J L Pearson with inspiring art nouveau decoration; this is now a listed building. It was merged with University College Hospital Trust, finally closing in 2005, and the site is being developed as shops, offices and flats. [BB83/03174A]

Caption: 59. Middlesex Hospital

Series: Views of London

» STATUES

The outdoor statues of London are the capital's own open-air art gallery. There they stand, in main thoroughfares and in byways, in parks and in gardens – some human figures, recognisable portraits, and others symbolic abstracts. They punctuate the traffic and provide silent companionship on our daily walks; they commemorate the still famous and the now forgotten. The traffic rumbles past while pigeons perch on crowns, helmets and unadorned heads alike. London would be a duller place without its statues.

CHARLES I, CHARING CROSS

One of the earliest, and finest, of London's statues is the mounted figure of Charles I, cast in bronze in 1633 for Lord Weston, later Earl of Portland. Holding a marshal's baton, the king looks confidently down Whitehall towards Parliament, the body which condemned him to death on a scaffold outside his Banqueting House on a cold January day in 1649. During the Commonwealth, the figure was given to a brazier, John Rivet of Seven Dials, with instructions to melt it down. Somehow it survived and, at Charles II's restoration in 1660, the figure emerged in triumph and was set up in its present position, the site of one of the original Eleanor Crosses. The king's master mason, Joshua Marshall, re-erected it, providing it with a plinth at a cost of £668 6s 1d.

Only horse-drawn vehicles are apparent in this early stereo image. It was taken at the upper end of Whitehall, looking along the Strand. Immediately on the right is Northumberland House, built in the early 17th century but demolished, amidst protests, in 1874. The Percy Lion, today safely installed at Syon House, Isleworth, dominates the Strand frontage in this view. Further along is the site of Charing Cross Station, opened in 1864 but here still covered in shops and houses, with Hungerford Market out of sight behind them. Opposite them, on the left, one 'pepperpot' corner of John Nash's Lowther Arcade is just visible; today the inwardly converted and renovated building provides Coutts's Bank with a headquarters, designed by Sir Frederick Gibberd & Partners. [BB68/05588]

Caption: 117. Charing Cross, London

Series: Instantaneous

ALBERT MEMORIAL, HYDE PARK

Another royal statue was that of Albert of Saxe-Coburg, Queen Victoria's intelligent, cultured and much beloved husband, who died on 14 December 1861 aged only 42. He had been one of the prime movers behind the Great Exhibition of 1851 and within a month of his death an appeal was opened to raise a memorial for the man who had done so much for his adopted country. To shelter a statue of the prince, George Gilbert Scott designed an immense Gothic reliquary, 175ft (53.3m) high. The main structure was finished by 1872 and this stereo image shows it complete save that J H Foley's figure of Prince Albert is not yet in place; the prince's statue was finally installed in 1876. The dome of the Albert Hall seems to fill the space behind the memorial. [BB85/02121A]

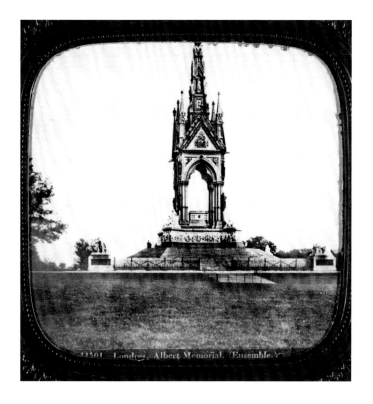

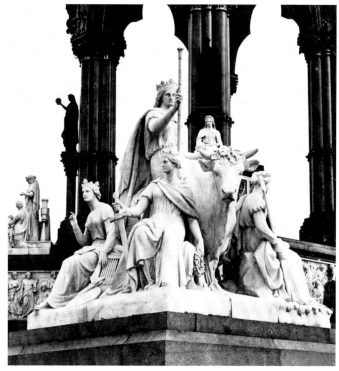

ALBERT MEMORIAL, HYDE PARK
This stereo view of the memorial was prepared for the
French market. Here, the dome of the Albert Hall is out of
sight; the empty plinth awaits the statue of Prince Albert.
[BB83/01529]

Caption: 11501. Londres, Albert Memorial. 'Ensemble'

ALBERT MEMORIAL, HYDE PARK
At each corner of the shrine is a group of figures
symbolising a continent. This stereo image is of Europe,
sculpted by Patrick MacDowell. [BB67/08243]

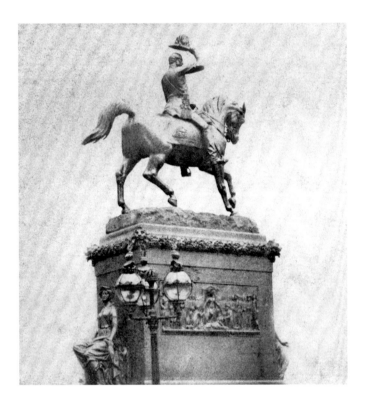

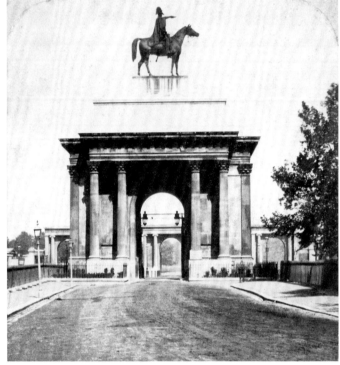

PRINCE ALBERT, HOLBORN CIRCUS

A jovial representation of Prince Albert stands at Holborn Circus. Funded by Charles Oppenheim at a cost of £2,000 and provided with a pedestal by the Corporation of London, the equestrian figure of the prince wears a field marshal's uniform and doffs his hat courteously in the direction of the City. At either end of the plinth sit figures of Peace and Commerce; plaques show Albert opening the third Royal Exchange in 1842 and Britannia handing out awards to prize winners at the Great Exhibition of 1851. The artist responsible for the statue was Charles Bacon, one of a family of sculptors of that name; it was unveiled in 1874. [BB82/13467B]

THE DUKE OF WELLINGTON, HYDE PARK CORNER

The Wellington Arch, designed by Decimus Burton in 1826, was originally intended to provide Buckingham Palace with a triumphal approach along Constitution Hill. It was topped by a figure of the duke – created by Matthew Cotes Wyatt and his son, James – 20 years later. The story goes that, when completed, a dinner for eight people was given inside the 40-ton figure.

In 1883 the arch was resited. Wellington and his mount, Copenhagen, were dismantled and eventually resurrected in a secluded position at Aldershot. In 1912 the top of the arch was reoccupied by Adrian Jones's *Quadriga* or *Peace Descending into the Chariot of War*. [BB88/02293]

Caption: 57. Wellington statue, Hyde Park Corner

Series: Views of London

SIR HUGH MYDDELTON, ISLINGTON GREEN
London's water supply shortage was remedied by the
goldsmith and entrepreneur, Sir Hugh Myddelton; between
1609 and 1613 he financed the digging of the New River
through Hertfordshire to Islington. The statue, by John
Thomas, was unveiled on 26 July 1862. Highbury Barn had
opened as a cakes and ale house by 1740, obtaining a licence
for dancing in 1854. The poster against the railings advertises
a display of art photography by J F and J P Hasset on view
in Upper Street nearby. John Frederick Hasset also traded
under the name of Blennerhasset and it is his studio and
shop which can be seen to the right of Myddelton's statue.
[BB013749]

PARKS, GARDENS, BUILDINGS AND LODGES

The parks of London are the capital's very lungs, the freedom spaces, the places where the Londoner can be alone or walk with friends. London needs and loves its parks and open spaces, and rejoices in them – the spaciousness of Holland Park, the variety of Hyde Park, the countryside-come-to-town character of Regent's Park or the orderly nature of Peckham Rye, the site where the poet William Blake saw a host of angels sitting in an oak tree when he was a child.

MARBLE ARCH, HYDE PARK
Marble Arch, modelled on the Arch of Constantine in Rome, was originally intended to provide a grand approach to George IV's Buckingham Palace but, when that building was altered to accommodate Queen Victoria's increasing family, the arch was found to be inconvenient. Moved to its present site in 1851, it now stands almost where the Tyburn scaffold and gallows stood from 1388 to 1783.

This stereo photograph shows the arch from the south, looking towards the western end of Oxford Street. The reliefs on this side were carved by E H Baily, those on the north by Sir Richard Westmacott. The heavy iron gates that close the main entrance are only opened for the passage of royalty or the King's Troop Royal Horse Artillery. [BB88/02304]
Caption. No. 402. The Marble Arch, from Hyde Park
Series: Stereographs of London, by Valentine Blanchard

<< Hanover Gate, Regent's Park

The polygonal lodge on the western side of Regent's Park is one of John Nash's most attractive and distinctive conceits. The keeper is clearly proud of his responsibilities. Traffic lights rather than gates now regulate the vehicles swirling around the little building. [BB83/05701B]

Caption: Regent's Park

Series: Views in London. [In red:] 'The shilling slide' sold at the London School of Photography etc

The Colosseum, Regent's Park »

This amazing building stood on the eastern side of Regent's Park; it was replaced in 1875 by Cambridge Gate. It was built 1824–7 by Decimus Burton to house a panorama of London painted by E T Parris; this enormous work was based on sketches made by Thomas Horner, a surveyor who, throughout 1822, had worked from a cabin on the dome of St Paul's while the Ball and Cross were being replaced. He made 2,000 drawings and then, determined to display them to the public, commissioned a 16-sided building 130ft (39.6m) in diameter with a huge portico, set in acres of gardens all leased from the Crown. Parris, who was required to paint 40,000sq ft (3,716.1sq m) of canvas, fell behind with his work and Horner and his principal backer decamped, leaving debts of £60,000. However, the Colosseum opened at last on 10 January 1829 and was visited by the young Victoria in 1835 and again, with Albert, in 1845.

The Colosseum, however, was never a financial success because it was so large and costly to maintain, and also on the less accessible side of the park. This stereo image shows the building standing forlorn, probably just prior to its demolition in 1875. [BB83/05738A]

Caption: No. 133. The Collosseum [sic], Regent's Park

Series: Views of London and its Vicinity, by the London Stereoscopic & Photographic Co

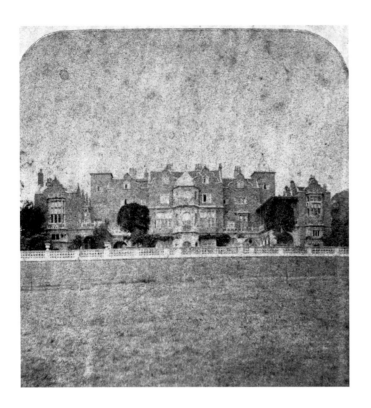

HOLLAND HOUSE, KENSINGTON

Very little remains of this magnificent house begun about 1605 for Sir Walter Cope, Chamberlain of the Exchequer and Keeper of Hyde Park; the architect John Thorpe was responsible for at least part of the design. After Cope's death in 1614, the mansion was completed for his daughter Isabel and her husband, Sir Henry Rich, later Lord Holland; Inigo Jones designed the gate piers, which survive. In the mid-18th century the house and surrounding park were sold to the Fox family – Charles James Fox, the Whig politician and leader spent his childhood here – and they later succeeded to the Holland title. Under the 3rd and 4th Lords Holland – and their wives – the house became a centre for liberal thought, the anti-slavery movement and music, literature and painting.

This early stereo photograph of perhaps the late 1850s reveals the E-shaped south front and wings of the Jacobean mansion. Little remains today for it was heavily bombed in 1941 and then mostly demolished by the LCC, which had taken over the property, turning the private grounds into a public park. Fragments of the south front remain, serving as a backdrop for open-air performances, and the east wing is now an international youth hostel, its accommodation enlarged by unsympathetic additional buildings.
[BB86/08764]

Caption: 51. Holland House, Kensington
Series: Views of London

HOLLAND HOUSE GARDENS

The 4th Lord Holland spent much time and money in Italianising the gardens. This stereo view was presumably taken soon after Lord Holland's death in 1859 since permission to photograph was given by Lady Holland. It shows the garden with formal flowerbeds, a cloister and a small building with a pyramid-shaped roof. [BB83/04746]

Caption: Holland House – The Italian Garden and Lodge

Series: Photographed by W England. By Permission of Lady Holland

KENSINGTON GARDENS

The Italian water gardens, laid out in 1861 close to Marlborough Gate, were intended to provide filter beds for the waters of the Serpentine. This square building with a central chimney serves jointly as pumping house and shelter for visitors. This stereo image, probably taken in the 1860s, may show a late phase in the building works, judging from the tools and pieces of wood propped up against the little house. [BB91/00667]

Caption: No. 484. The New Fountains, Kensington Gardens
Series: Stereographs of London, by Valentine Blanchard

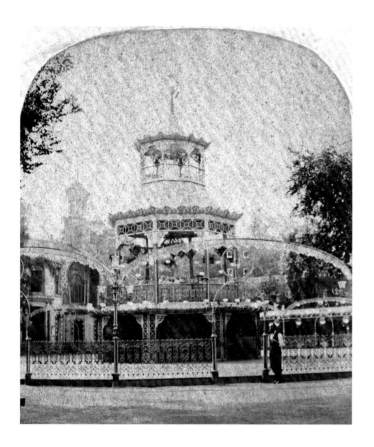

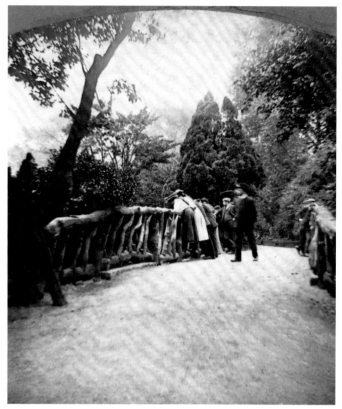

CREMORNE PLEASURE GARDENS, CHELSEA

Cremorne House, built around 1740, was one of the Chelsea
riverside estates. Passing through the hands of various
owners, it became a club for sporting gentlemen and then,
in 1845, the grounds were opened as Cremorne Pleasure
Gardens. In 1857 a delicate iron pagoda was constructed
with a bandstand inside and a dancing platform around it;
it was all hung with Chinese lanterns and lamp standards
supported arches adorned with 'devices in emerald and
garnet glass drops'. It must have seemed a fairyland.
This stereo view, taken perhaps *c* 1860, gives a shadowy
impression of the magic that was Cremorne. The gardens
are also famous due to James McNeill Whistler's painting
of fireworks at Cremorne in his *Nocturne in Black and Gold*
(*see* p 43). They closed in 1877. [BB86/02147]

Caption: 264. Dancing Platform, Cremorne Gardens

BATTERSEA PARK

Although the northern half of the metropolis was well
provided with parks and gardens – Hyde, St James's,
Regent's and Kensington Gardens to name only the
royal areas – the South Bank lacked well-laid out and
well-regulated spaces for relaxation, and much remained
soggy and waterlogged. Queen Victoria's Commission for
Improving the Metropolis was set up early in her reign
and in 1846 an act was passed to enable Battersea Fields to
become Battersea Park at a cost not to exceed £200,000. The
fields were drained and Sir James Pennethorne undertook the
landscaping. In 1864 a large convoluted pond was created,
with the Rustic Bridge as one of its features. A fairly recent
replacement occupies the same position today and passers-by
lean over it with the same interest and contemplation shown
by this group, photographed in 1906. [BB83/04731]

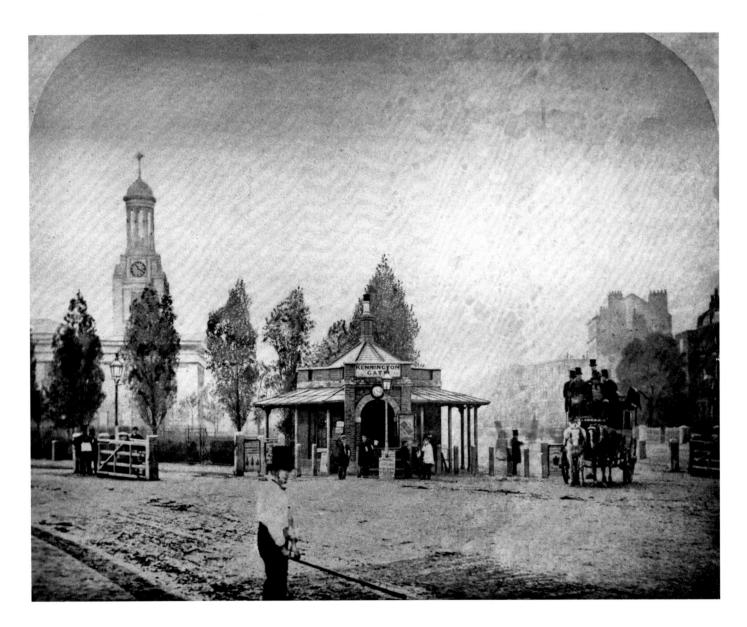

KENNINGTON GATE, SOUTH LAMBETH

This large early view shows Kennington Gate at the intersection of Kennington Park and Camberwell New Roads. The photograph was probably taken about 1853 to record the resiting of the gate; the toll was abolished on 18 November 1865 and the little house no longer exists. Here, the gate swings wide for the passage of a coach with a driver and several top-hatted gentlemen perched aloft.

The church in the background is St Mark's, designed in 1824 by D R Roper and A B Clayton. Today the traffic swirls around St Mark's but the church is well used; the crypt, having been cleared, is now a venue for community activities. [BB79/08403]

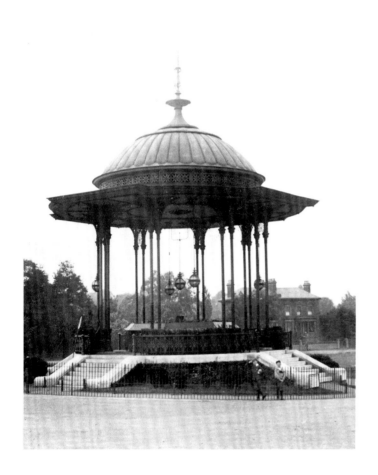

BANDSTAND, PECKHAM RYE
The central area of the International Exhibition of 1862 was a garden, maintained by the Royal Horticultural Society, within which were two bandstands. These were eventually sold to the newly established LCC when the exhibition closed. One of them went to Southwark Park, another to Peckham Rye and a third, a replica of the other two, was erected on Clapham Common. Unfortunately the bombs of the last war destroyed the Peckham Rye bandstand and it was not replaced. [BB91/21536A]

KEEPER'S LODGE, GREENWICH PARK
This lodge stands adjacent to the Blackheath Gate into Greenwich Park, alongside the junction of Blackheath Avenue and Charlton Way. Built about 1860, it is still in use for the maintenance of the park. [BB91/21619]

» LONDON'S SUBURBS

The years spanned by this collection of photographs coincide with the period of London's most rapid suburban growth. These shots from seven villages, now subsumed into boroughs, give a suggestion of the changes taking place in the second half of the 19th century. They also show how determinedly each particular area retained its identity and individuality.

ST PAUL'S NATIONAL SCHOOL, KILBURN, BRENT
The little school with its belfry opened in 1847 on the Edgware Road with 180 pupils, both boys and girls. It became the boys' half of Holy Trinity Schools 20 years later, with the girls and infants moving away to Canterbury Road. The original school survived until 1940.

This stereo image, probably taken in the 1860s, shows the building clearly. Three workmen gaze stolidly at the camera. There is, however, a problem. The board above the entrance clearly reads 'J Felgate, veterinary surgeon', but no such professional appears in local directories. Was this some temporary arrangement in school holidays? Perhaps a local historian will solve the riddle. [BB88/06021]
Caption: HSCI National & Sunday Schools – Kilburn
Series: [blind stamp] Bowen & Carpenter Photo, Kilburn

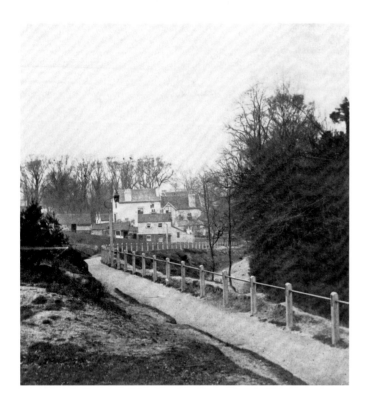

NORTH END, HAMPSTEAD, CAMDEN
The photographer of this view stood halfway up the path above North End Road, looking north towards the cluster of houses in Sandy Lane. These were severely damaged by bombing in the Second World War, but the tallest house remains and has recently been refurbished. Out of sight behind the saplings on the right are two public houses – the Bull and Bush of Marie Lloyd fame, still flourishing today, and the Hare and Hounds, which closed recently, its site now developed into a small block of flats. The colouring of the earth on the left suggests that this view was taken after a light fall of snow. This image provides no clue to the date, but possibly it is 1880–90. [BB70/01559]

HAMPSTEAD, CAMDEN
A manuscript note in ink tells us that this stereo image shows Heathside Cottage in 1886. The cottage still stands in North End near the Bull and Bush public house. The glass-covered porchways have gone, but the distinctive bay belonging to neighbouring North End Lodge remains. [BB89/00459]

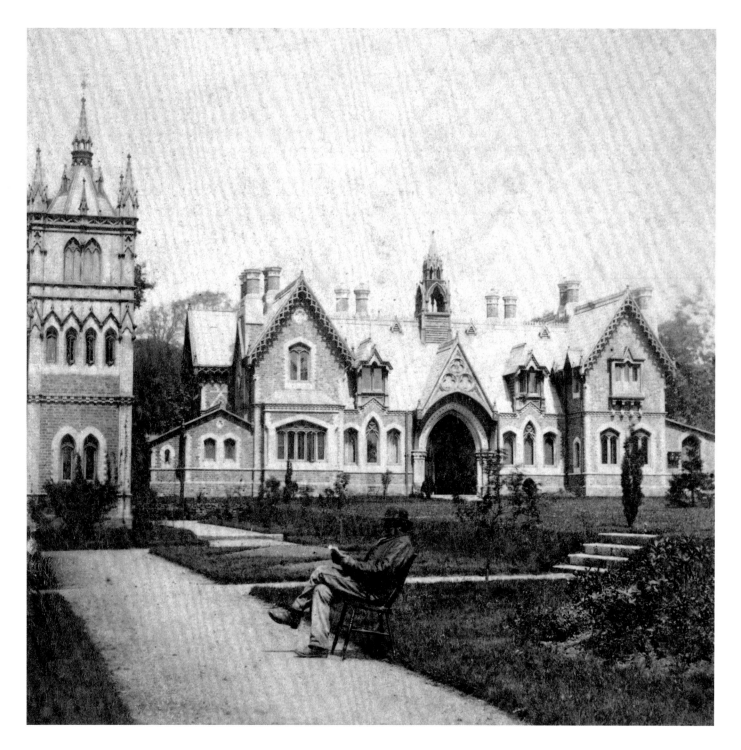

HOLLY VILLAGE, HIGHGATE, CAMDEN

On the corner of her Highgate estate, at the foot of Swain's Lane, the extraordinary philanthropist Baroness Angela Burdett-Coutts built a cluster of Gothic cottages and called it Holly Village. This garden village was intended to be let as family homes to city clerks and commercial travellers.

The houses were designed in 1865 by Henry Darbishire, the baroness's favourite architect, and are as picturesque as any of those created by John Nash a generation earlier on the east side of Regent's Park. [BB89/00463]

Series: Robt. Edwards, Photo., Hornsey, near London

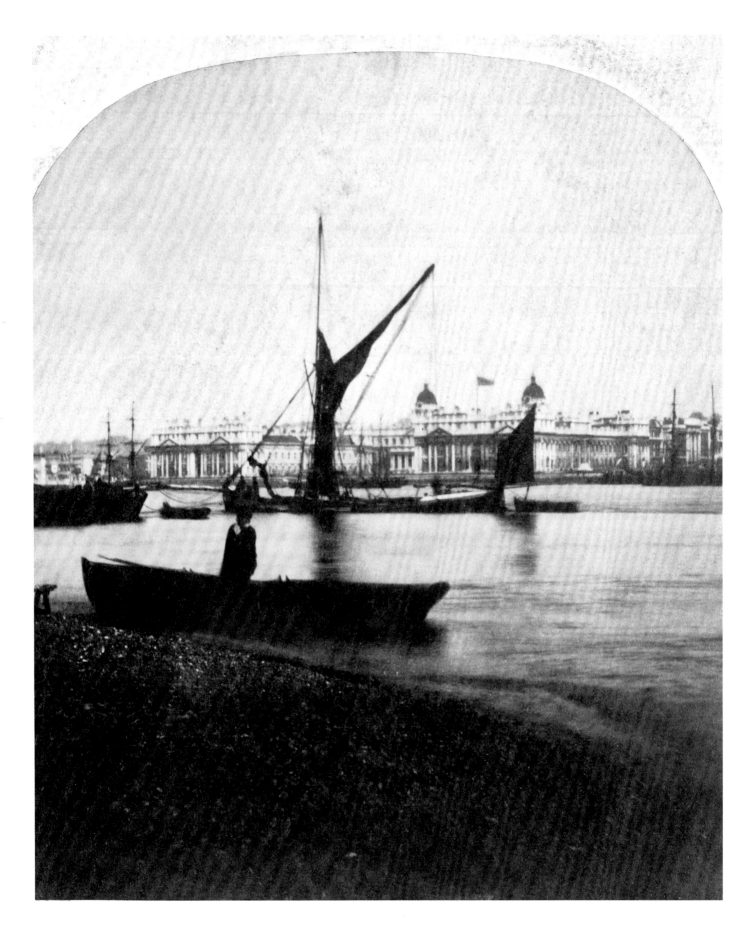

« GREENWICH
The Thames at Greenwich with Greenwich Hospital (originally built as a royal palace) in the distance – one of the noblest prospects in Europe. In the middle distance, a typical Thames sailing barge rides at anchor, her sail weatherproofed with red ochre. A rowing boat is beached on the foreshore. [BB83/05814]

BLACKHEATH, GREENWICH »
A dog pauses contemplatively on the edge of Blackheath. Behind him, the newly made Morden Road stretches away. In the centre is the lodge to Morden College, founded in 1695 by Sir John Morden as a place of refuge for 'decayed Turkey merchants'. He himself had suffered the vicissitudes of fortune so, when his ships at last came safely home, he decided to succour those more unlucky than he had been; the college is still a home for the elderly.

Behind the lodge are the first houses in Morden Road, probably Nos 1 and 3 of 1853–4, which were demolished as a result of war damage. The big house with double chimneystacks is 4 Morden Road, built 1858–9, and for many years home to the McDougall flour-milling family. On the extreme right is East Lodge House built in 1794 to the designs of Michael Searles as part of the Paragon, an elegant crescent of seven houses linked by colonnades. Though much war-damaged, the house was restored in 1948 by Charles Bernard Brown. This photograph was taken around 1870. [BB91/27498]

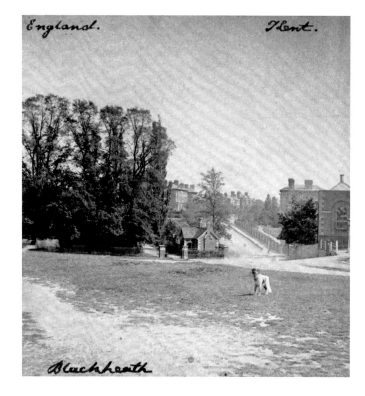

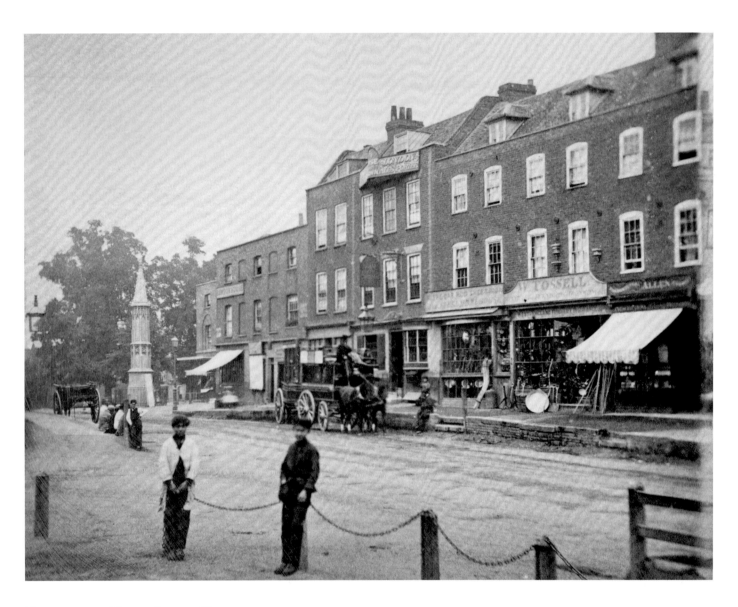

TOTTENHAM HIGH ROAD, HARINGEY
This photograph, taken in the early 20th century, shows
Tottenham High Cross and High Road. The cross was once
a wayside cross, recorded as early as 1409, though rebuilt in
brick in the 17th century and coated with plaster with thin
Gothic details in the 19th. The road appears unmade with a
raised pavement and shops, one of them a junk shop with
a glorious mixture of items for sale outside its windows.
A horse-drawn omnibus pauses to pick up a passenger.
[BB91/27399]

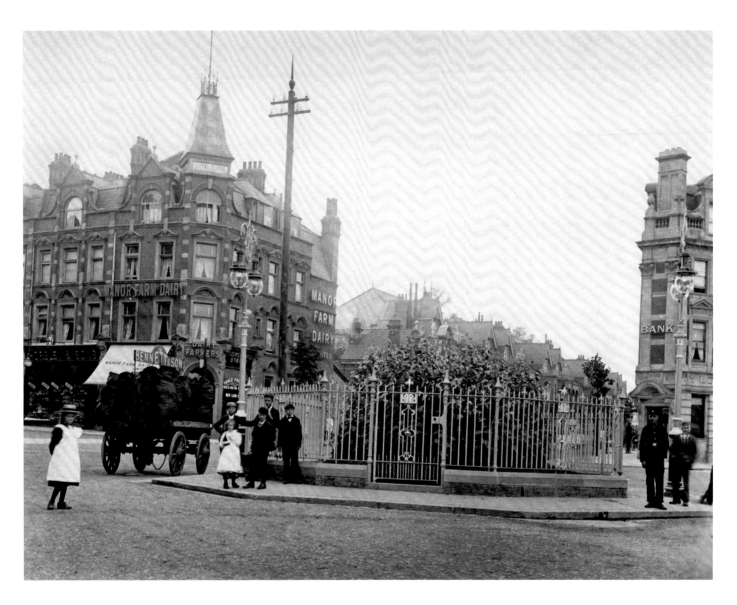

MUSWELL HILL, HARINGEY

This early 20th-century photograph, probably taken for a postcard, shows the junction of Muswell Hill Broadway with Queen's Avenue. The roundabout with its railings is still there, though now it serves as a halt for bus drivers to change shifts and has a shelter in the centre for their convenience. The shopping parades with flats and offices above remain unaltered.

The coal cart of Bennett & Son, presumably horse-drawn, pauses with its load, while passers-by stand and turn to stare at the cameraman. The little girls' pinafores look immaculate. Manor Farm Dairy no longer advertises its supplies, but the building on the opposite corner is still a bank. [BB91/27398]

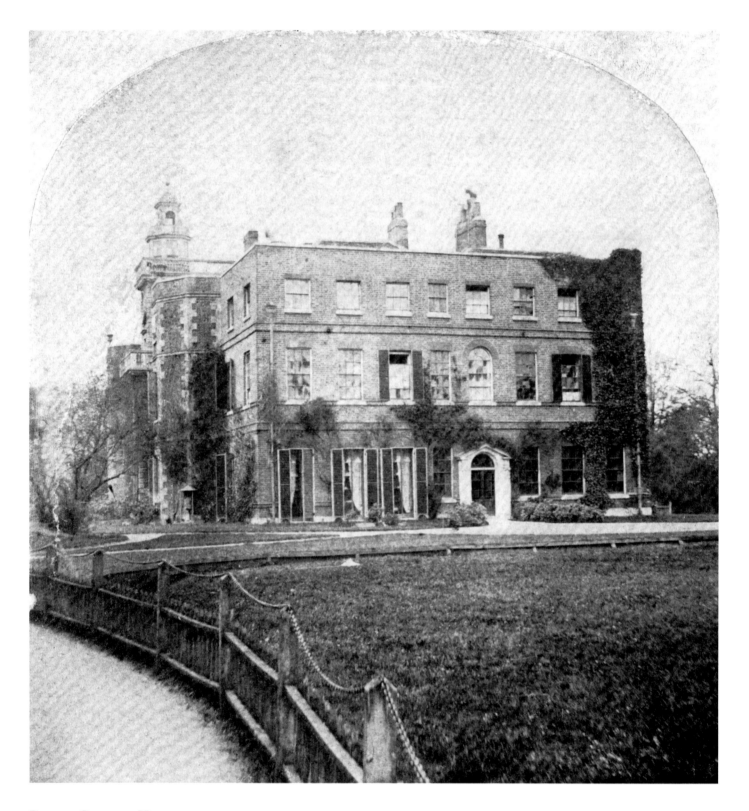

BRUCE CASTLE, HARINGEY

This attractive house today provides Haringey with a park, a museum and an archive centre. This was the site of a 14th-century manor house, the property of Robert Bruce who claimed and held the throne of Scotland. The Crown repossessed the manor and in 1514 it passed into the hands of Sir Walter Compton, who built an amiable south-facing dwelling. Later owners adapted and added to it until in 1892 it became Tottenham's first public park. [BB83/05848]

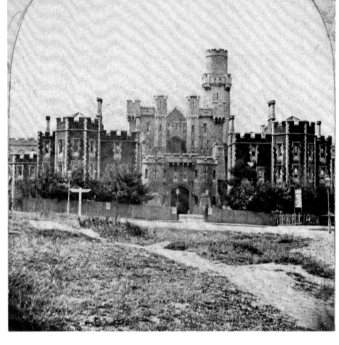

CANONBURY TOWER, ISLINGTON

An unexpected survivor from the 16th century. Originally this was a property belonging to the priors of St Bartholomew. After the Dissolution of the Monasteries it was acquired by Sir John Spencer – Lord Mayor of London and a man of great wealth – who enlarged it; the house may have been visited by Elizabeth I. This beautiful stereo image shows the house and tower from the south. A cart trundles along the quiet road. By the 19th century the tower was being let out as lodgings, until in 1907 it became a community centre; in 1952 it became the headquarters of the Tavistock Repertory Company and an auditorium was built in the garden. Amateur in status, professional in quality of performance, the company now performs in the City and elsewhere until a new home is found. [BB83/05851]

Caption: No. 431. Canonbury Tower, once the residence of Queen Elizabeth
Series: Stereographs of London, by Valentine Blanchard

HOLLOWAY PRISON, ISLINGTON

This stereo photograph shows the original prison, designed in 1849–51 by the City architect J B Bunning as the City House of Correction; we may guess that the shot was taken not long after it was built. The gatehouse was copied from Caesar's Tower at Warwick Castle. It became a women's prison in 1903 and was rebuilt, less dramatically but equally forbiddingly, in brick by Robert Matthew, Johnson-Marshall & Partners (1970–7). [BB67/08240]

Caption: New Prison at Holloway

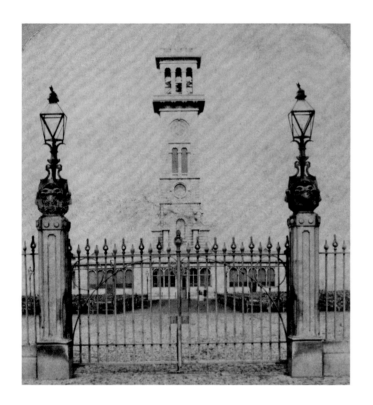

« CALEDONIAN MARKET, ISLINGTON

The Metropolitan Cattle Market in Smithfield closed in 1852 and was transferred to 30 acres of open land in Islington. Proximity to the Caledonian Road gave it a name and livestock were sold on Mondays and Thursdays with a general pedlars' market on Fridays. This gradually developed into an antiques market and many were the tales told of amazing purchases. The cattle market closed in 1939, with the meat market finally closing in 1963, and the site was redeveloped.

J B Bunning's superb flourish to his market was the clock tower, seen here in all its glory. It still survives, now surrounded by a bleak municipal estate. Perhaps, one day, the clock tower will receive the landscaping that it deserves. It stands 160ft (48.8m) high with a balcony, a clock and aedicules. The railings are still there, too, though now without their lamps. This stereo image of 1860–70 shows the timber-built telegraph and banking offices around the base of the tower. [BB85/01102B]

Caption: New Cattle Market, Islington

Series: Views of London

ST MARY'S CHURCH, ISLINGTON »

The medieval parish church was replaced in 1751–4 with a stalwart structure designed by Lancelot Dowbiggin. This stereo image of perhaps 1865–75 shows the steeple, which is all that remains since the body of the church – having been destroyed by bombs – was replaced by a spacious, light-filled interior from Seely and Paget (1954–6). To the left, the terrace north of the church was later shorn of its front gardens for road-widening and thus looks more humble today; the ground-floor rooms have been converted into shops and bistros. South of the church is the bulk of the former dispensary and soup kitchen, constructed in 1881, though both had been founded 60 years earlier. Note the rough condition of the roadway in Upper Street; the elegant lamp-posts have since given way to concrete-supported lighting. [BB85/02231A]

Caption: Islington Church

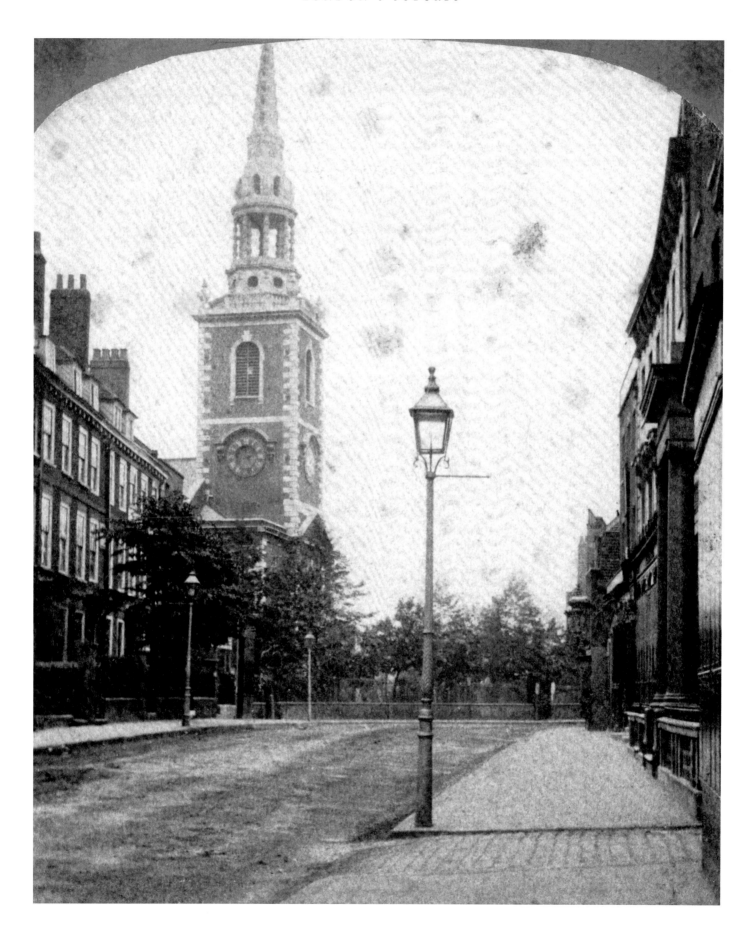

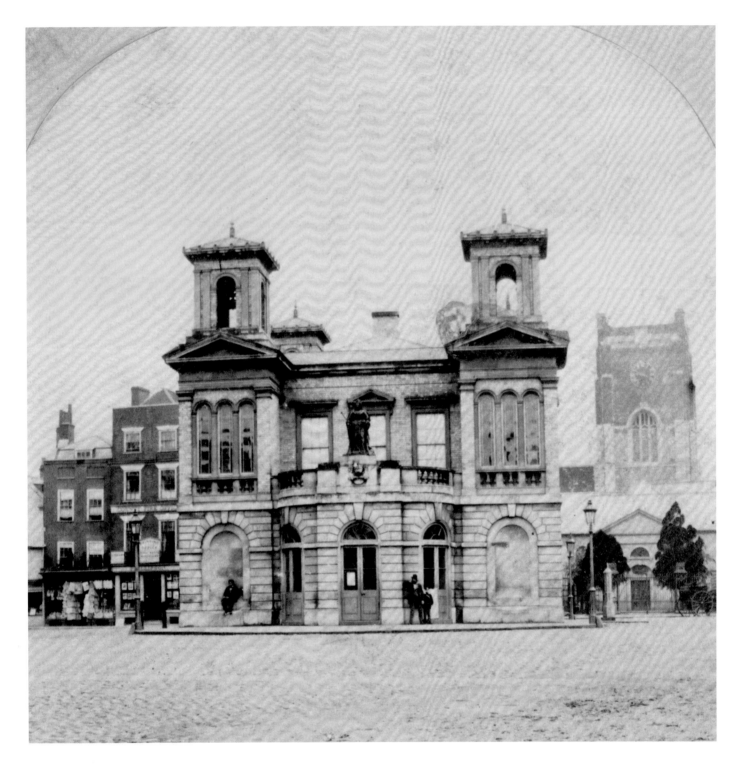

TOWN HALL, KINGSTON-UPON-THAMES

The building recorded in this stereo view was erected as the town hall, but its administrative functions have moved to more modern premises nearby. Designed by the elder Charles Henman and built 1838–40, this town hall is a proper expression of civic pride. After all, no fewer than seven Anglo-Saxon monarchs had been acclaimed here, standing on the King's Stone, and the town hosted the most important market on the south side of the Thames. The building has four neat little Italianate corner towers and, at first-floor level, there is a statue of Queen Anne by Francis Bird. The tower on the right belongs to All Saints' Church (*see* p 110). [BB72/05890B]

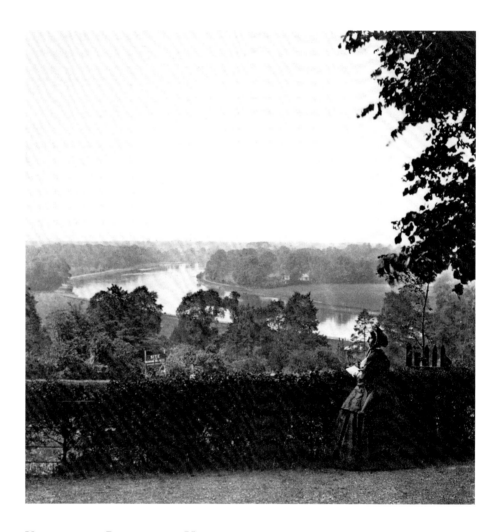

VIEW FROM RICHMOND HILL

Richmond can make a fair claim to being the loveliest and most varied of all the boroughs of Greater London. The view from the top of Richmond Hill towards the curve in the Thames has changed surprisingly little since Joshua Reynolds painted it. This stereo view from the summit across to Petersham Meadows captures one summer afternoon in perhaps the 1860s; a becrinolined lady, possibly carefully posed, holds a book and surveys the picturesque scene. The building to the left, half-hidden among trees, is the Petersham Hotel. [BB85/03128]

« POPE'S VILLA, TWICKENHAM
The poet Alexander Pope became famous when very youthful for *The Rape of the Lock* and made a fortune from his translation of *The Iliad*. In 1719 he came to live at Twickenham with his widowed mother and old nurse to look after him, for his constitution was delicate. His home and garden were the centre of his world, where he delighted to entertain his friends. The villa was demolished in 1840 and replaced with another, shown in this stereo photograph. It became St Catherine's Convent, a school for girls; St James's Independent School today uses the premises. [BB89/07891]
Caption: Cottage at Twickenham
Series: London Stereoscopic Company, 54 Cheapside

THE RIVER AT BRENTFORD »
This stereo view has most probably been taken from the north bank of the Thames, looking west. To the left is Brentford Ait; the main channel flows on the further side. On the right, just behind the top-hatted gentleman, is a boathouse with characteristic double doors and a viewing gallery above with a flagpole to give position to competing oarsmen. The chimneys in the distance are probably those of Hounslow Gas Works. The shot may well have come from the studio of George Hilditch, an eminent painter and one of the earliest photographers to exhibit his work at the Royal Academy. [BB70/01580]

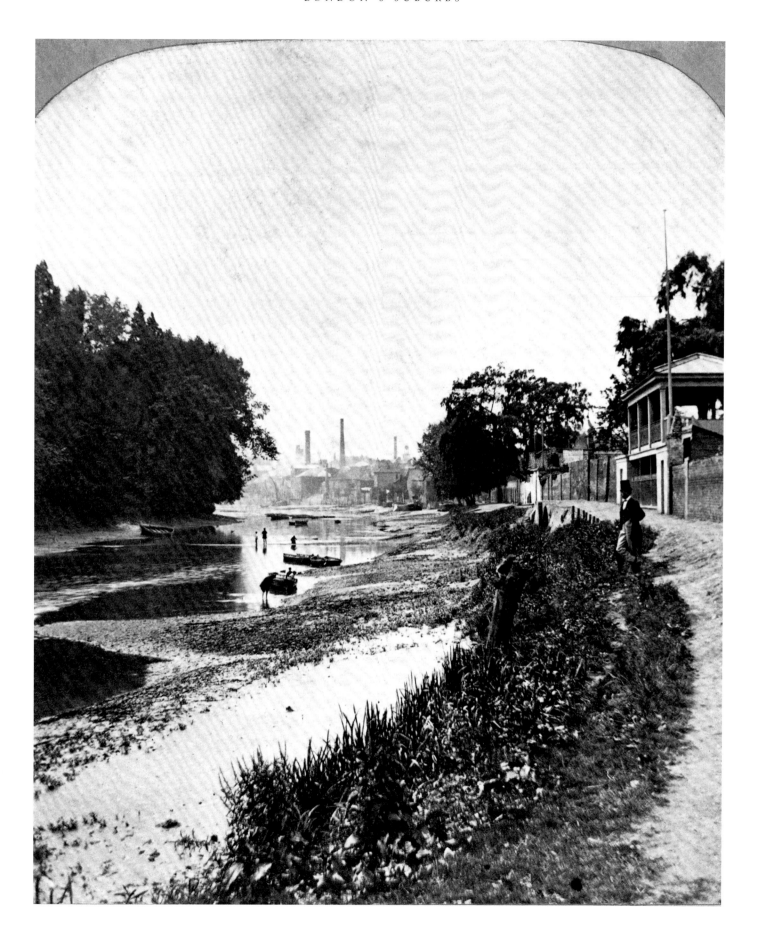

STRAWBERRY HILL, RICHMOND

In 1747 Horace Walpole – the 30-year-old youngest son of Sir Robert Walpole, prime minister to George I and George II – decided to buy a tiny cottage at Twickenham, which he proceeded to adorn and enlarge. 'It is a little play-thing-house ... the prettiest bauble you ever saw', he wrote to a friend. He built on a long gallery – fan-vaulted like Henry VII's Lady Chapel in Westminster Abbey – along with other delights and conceits. He called the house Strawberry Hill and lived there until 1797, when he died in his townhouse in Berkeley Square. He left Strawberry Hill to his cousin, the sculptress Anne Damer, and after her to his great-niece, the Countess of Waldegrave who, needing more space, had the good taste not to alter Walpole's Gothic dwelling but to build a handsome extension at the side. In 1923 the house was bought by the Catholic Education Council; it is occasionally open to the public. [BB88/02305]

Caption: 247. Strawberry Hill, Horace Walpole's residence
Series: London and Neighbourhood, G R & Co

PEMBROKE LODGE, RICHMOND PARK

There are a number of buildings in Richmond Park; one of them is Pembroke Lodge, today a hospitality venue available for weddings and other gatherings. It first appears on a map of 1754, where it is marked as 'the Mole Catcher's'. Towards the end of the 18th century, the modest house was acquired and enlarged by the Countess of Pembroke, by whose name it is still known. In 1847 it was granted to Lord John Russell, the champion of the Reform Bill, soon after he became prime minister and his family continued to live there until the early 20th century. The philosopher Bertrand Russell, orphaned at the age of four, was brought up here by his severe grandmother.

The stereo image shows a small summer house in the grounds. It appears on early Ordnance Survey maps but no longer exists. A curved bench runs round the inner wall with a small tea or writing table before it; it seems a particularly inviting spot with flowering shrubs around it. It may even have been the seat of poets – the legend on the stereo card reads, 'Here Thompson sang *The Seasons* and their change'; that is, the poet James Thompson who lived in Richmond in 1730–44 and had a key to the park. [BB80/03245]

Caption: Here Thompson sang The Seasons *and their change*

» KODAK IN LONDON

In 1877 an enterprising young American, George Eastman of Rochester, New York, took up photography as a hobby, using the collodion wet-plate method. This involved lugging around 'a pack-horse load' for coating and developing the plates as exposures were made. In Europe the gelatine dry plate was being developed, so in 1881 he gave up his secure job as a bookkeeper in a bank and, with a local businessman as a partner, set up the Eastman Dry Plate Company. In May 1885 he exhibited his work at the International Inventions Exhibition in the Albert Hall and was awarded a silver medal; later that summer, he opened his first English office and work premises at 13 Soho Square. In 1886 photography took big steps towards becoming a popular hobby with Eastman's development of stripping film, followed by the first Kodak box camera in 1888.

KODAK FACTORY, HARROW
When Eastman decided to set up manufacturing premises in England, he acquired a 7-acre site in open countryside at Harrow; a factory was in production by mid-1891. The photographs of the factory and the Kodak shops, taken around the first decade of the 20th century, were presumably intended to provide a record of Eastman's impressive achievement.

The factory building was, in itself, a striking advertisement. The company name stood proudly on the summit and the names of the international capitals in which the company operated were spelled out to form a frieze. Across the main façade, the relationship with the original Eastman Photographic Materials Company was clearly defined. The angled glass roof provided daylight for printing customers' negatives. [BB91/19771]

FACTORY ENTRANCE
In front of the main building was the Reception Department. Later, this became the Medical Department. [BB91/19772]

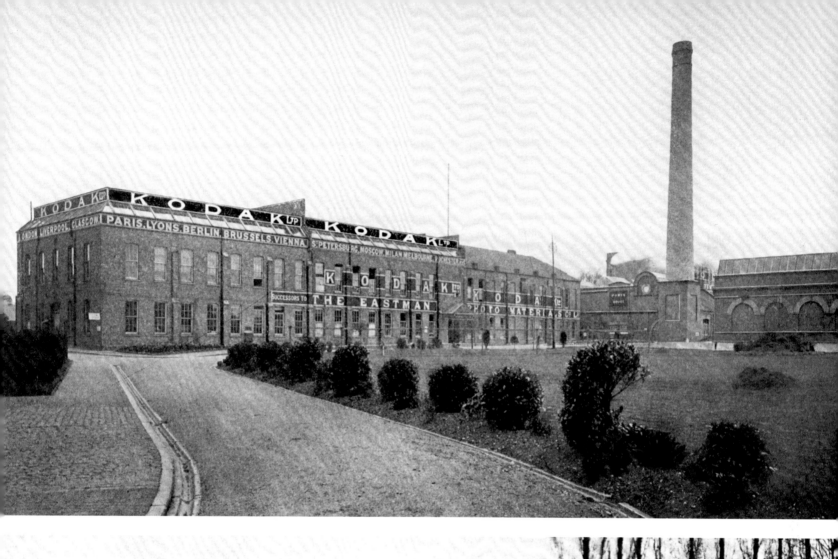

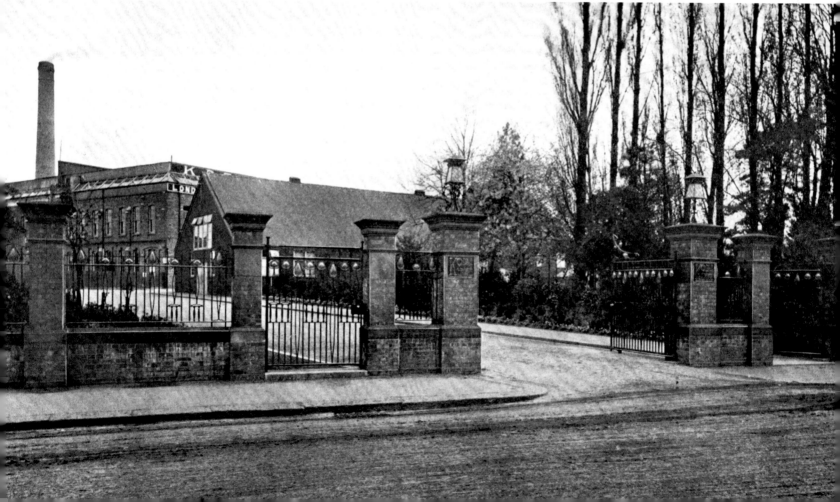

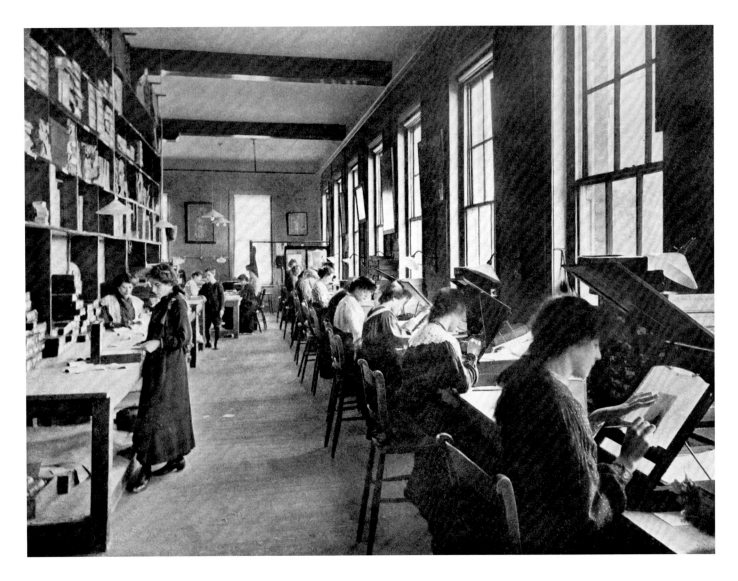

DEVELOPING AND PRINTING DEPARTMENT
These women are retouching glass negatives. Their clothes
are those of the first decade of the 20th century. On the
left, towards the back of the room, is a young boy in a
knickerbocker suit – is he just starting work as a messenger?
[BB91/19776]

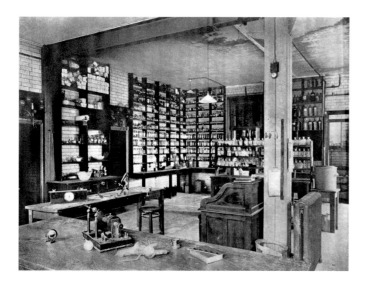

CHEMICAL LABORATORY
The Chemical Laboratory became part of the Works
Laboratory, established in 1902, which was concerned
with quality control. Later, it was known as the Standards
Laboratory. [BB91/19778]

PHYSICAL LABORATORY
The Physical Laboratory also became part of the Works
Laboratory. The equipment seen here was used to calibrate
lamps and to test film or paper. [BB91/19781]

DRYING AREA
This room was part of the baryta-coating track. Long rolls
of paper were coated with baryta – that is, barium sulphate
– used in the manufacture of photographic printing paper.
Here they are, hung in loops that then move through the
drying area. [BB91/19775]

FITTERS' SHOP
Pipe-fitters at work – overalls and cloth caps were the usual
clothing for hands-on jobs. In the early years, every trade
needed was available on the factory premises. [BB91/19779]

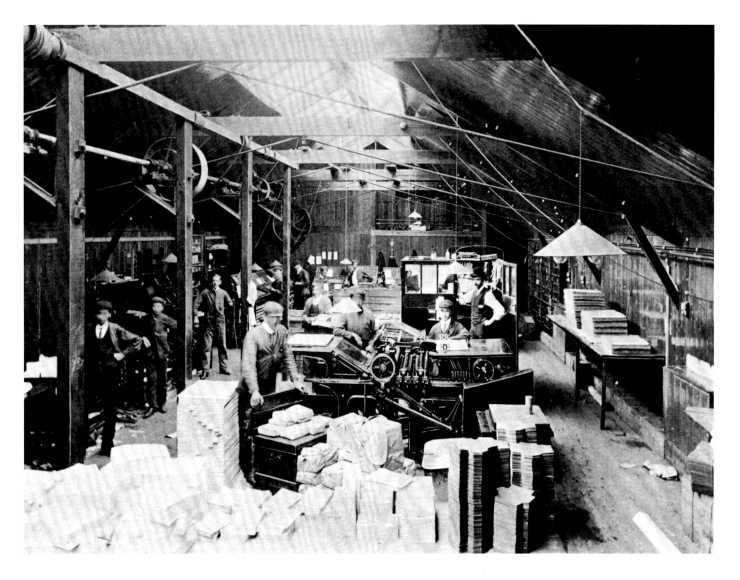

LETTER PRESS, PRINTING AND BOX-MAKING
DEPARTMENT
The Letter Press, Printing and Box-Making Department,
later known as Box and Print, produced packaging and
promotional literature. [BB91/19780]

KODAK SHOPS

The first Kodak shop – at 115 Oxford Street
– opened in 1888. Through his acquaintance
with George Davison, an original board
member of the Eastman Kodak Company,
George Walton was employed as architect
for the Kodak shops in Britain and on the
Continent. His designs were highly distinctive
and had considerable influence. Nikolaus
Pevsner described Walton as a pioneer of the
modernist movement and Charles Rennie
Mackintosh, who worked with him in the
late 1890s on the refurbishment of Miss
Cranston's Tea Rooms in Glasgow, absorbed
much of Walton's style. Later, both architects
moved to London.

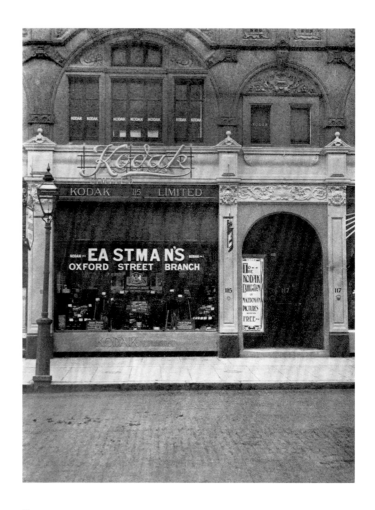

SHOP EXTERIOR AND INTERIOR,
115 OXFORD STREET
Kodak's first retail shop was also the London head office
until 57–61 Clerkenwell Road opened in 1897. The names
Kodak and Eastman continued to be used in parallel, even
after Kodak Ltd became a registered company in 1898.
[BB91/19799; BB91/19800]

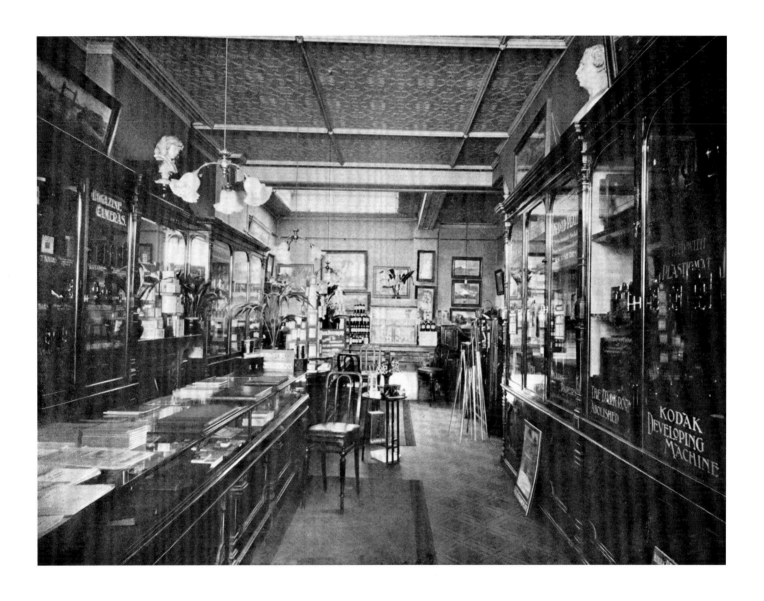

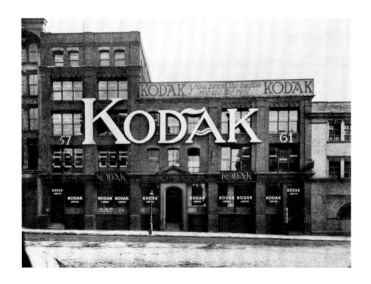

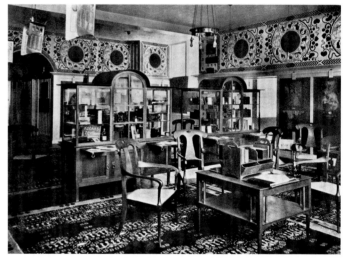

57–61 CLERKENWELL ROAD,
SHOP EXTERIOR AND INTERIORS, C 1898
This shop opened the previous year, and also served as the
London head office until a new one was opened in Kingsway
in 1911. [BB91/19785; BB91/19787; BB91/19788]

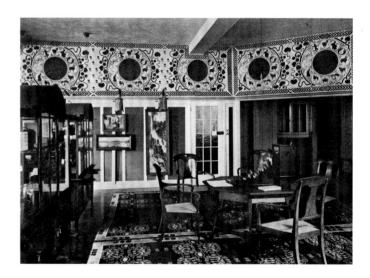

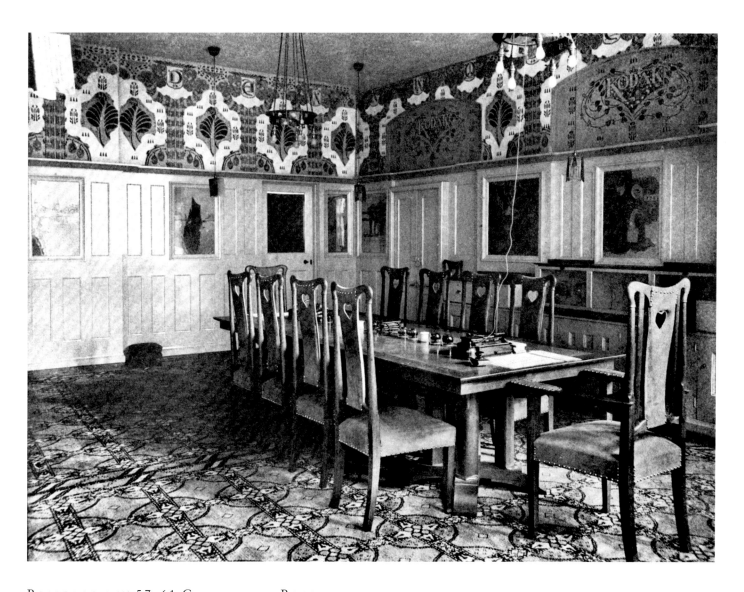

BOARDROOM AT 57–61 CLERKENWELL ROAD,
C 1898
This is the boardroom of Kodak's London head office at
57–61 Clerkenwell Road. [BB91/19786]

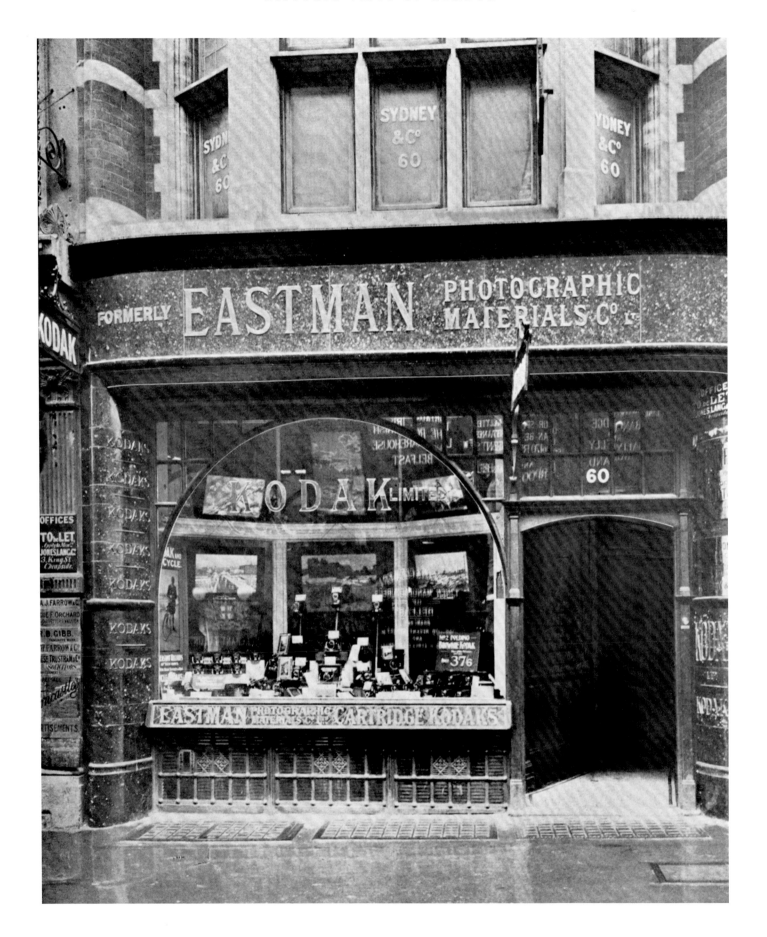

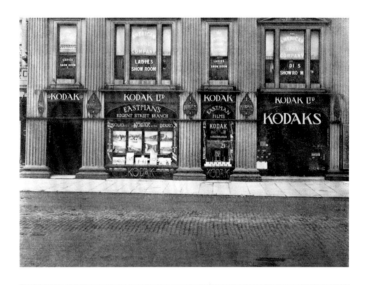

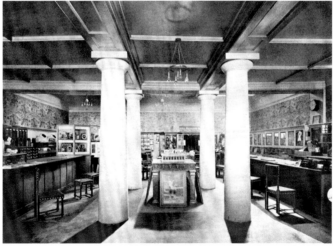

SHOP EXTERIOR AND INTERIOR,
171–173 REGENT STREET, C 1898
This shop was photographed soon after opening.
[BB91/19789; BB91/19790]

« SHOP EXTERIOR, 60 CHEAPSIDE
[BB91/19802]

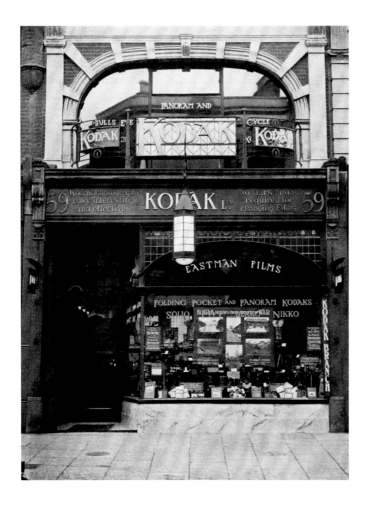

SHOP EXTERIOR C 1905 AND INTERIOR C 1903,
59 BROMPTON ROAD
[BB91/19801; BB91/19803]

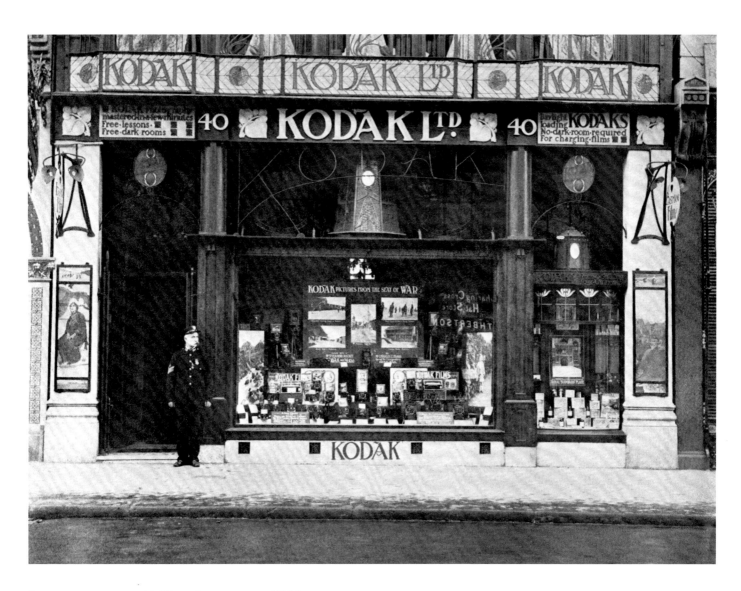

SHOP EXTERIOR, 40 THE STRAND, C 1903
[BB91/19791]

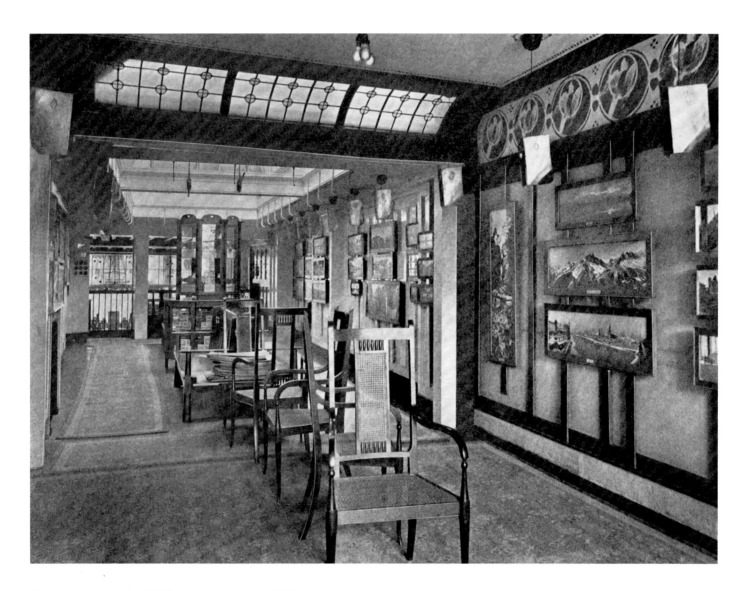

SHOP INTERIOR, 40 THE STRAND, C 1901
[BB91/19793]

SHOP INTERIORS, 40 THE STRAND, C 1903
[BB91/19794; BB91/19792]

» THE NATIONAL
MONUMENTS RECORD

Unless otherwise stated, the photographs in this book are all taken from copy negatives in the collection of the National Monuments Record (NMR); the reference numbers for the images are noted in square brackets after the captions. The original stereo cards are held as part of the Howarth-Loomes Collection by National Museums Scotland, Edinburgh (contact the Department of Science and Technology, 0131 2257534). The NMR is one of the largest publicly accessible archives in Britain and is the biggest dedicated to the historic environment. It is an unparalleled collection of images, old and new, which has been growing for 60 years. Set up as the National Buildings Record in 1941 in response to the threat to historic buildings from aerial bombardment

during the Second World War, it immediately began its own recording programme as well as collecting historic negatives and prints. In 1963 it came under the auspices of the Royal Commission on the Historical Monuments of England and in 1999 was transferred to English Heritage. Today the collection comprises more than 10 million photographs and other archive items (including measured drawings and survey reports) relating to England's architecture and archaeology. It continues to accept major collections of national importance and is a repository for material created by English Heritage's staff photographers. The collection may be consulted at the National Monuments Record offices in Swindon (telephone 01793 414600 for details).

» FURTHER READING

Betjeman, J 1969 *Victorian and Edwardian London from Old Photographs*. London: Portman

Briggs, A 1988 *Victorian Things*. London: Batsford

Fisher, J 1976 *City of London Past and Present*. Oxford: Oxford University Press

Grynberg, W 2005 *Images of the City of London*. Derby: Breedon

Hobhouse, H 1971 *Lost London*. New York: Weathervane

Howarth-Loomes, B E C 1974 *Victorian Photography: A collector's guide*. London: Ward Lock Limited

Howgego, J 1977 *The Victorian and Edwardian City of London from Old Photographs*. London: Batsford

Jackson, A A 1985 *London's Termini*, 2 edn. Newton Abbot: David & Charles

Saunders, A 1981 *Regent's Park: A study in the development of the area from 1086 to the present day*, 2 edn. London: Bedford College

Saunders, A 1988 *The Art and Architecture of London: An illustrated guide*, 2 edn. Oxford: Phaidon

Seaborne, M 1995 *Photographers' London 1839–1994*. London: Museum of London

Stamp, G 1984 *Changing Metropolis: Earliest photographs of London 1839–1879*. Harmondsworth: Viking

Timbs, J 1863 *The International Exhibition. The industry, science and art of the age: or the International Exhibition of 1862 popularly described from its origin to its close, etc.* London

Ward-Jackson, P 2003 *Public Sculpture of the City of London.* Liverpool: Liverpool University Press

Whitehouse, R 1980 *A London Album*. London: Secker & Warburg

THE BUILDINGS OF ENGLAND SERIES:
Bradley, S and Pevsner, N 1997 *London 1: The City of London*. London: Penguin

Cherry, B and Pevsner, N 1983 *London 2: South*. Harmondsworth: Penguin

Cherry, B and Pevsner, N 1991 *London 3: North West*. London: Penguin

Cherry, B and Pevsner, N 1998 *London 4: North*. London: Penguin

Cherry, B, O'Brien, C and Pevsner, N 2005. *London 5: East*. London: Yale University Press

Bradley, S and Pevsner, N 2003 *London 6: The City of Westminster*. London: Yale University Press

» INDEX TO MANUFACTURERS, PUBLISHERS, PHOTOGRAPHERS AND SERIES REPRESENTED IN THE BOOK

The following photographers, manufacturers, publishers, retailers and series are recorded on the stereo cards and prints selected for this book. Various forms of the proper names are sometimes recorded; where captions and series information have been provided at the end of the image captions, names and information have been transcribed exactly as originally written.[1] While some figures and companies are well known nationally or even internationally, others are little known. Stereo production was intensely competitive, so some producers may have been short-lived. Some of the names recorded may be of retailers rather than publishers or photographers.

[1] English Heritage and the author would like to acknowledge the assistance of Dr Alison Morrison-Low of National Museums Scotland, who kindly transcribed this information from original stereo cards in the museum's possession.

The Art Publishing Co is presumably the business at 48 King Street, Glasgow, though other Artistic Publishing Companies are known.
102

Billikin & Lawley, 165 The Strand – possibly a retailer.
39

Valentine Blanchard (fl 1859–84) had various London addresses, settling in 1876 at 289 Regent Street. He published the series *Stereographs of London* and was a pioneer of 'instantaneous views'.
58, 79, 95, 100, 101, 109, 118, 185, 190, 203

Bowen & Carpenter, Photo, Kilburn. The photographer John Bowen of Edgware Road, Paddington, and 161 High Road, Kilburn, was active between 1868 and 1895.
195

The British Houses of Parliament (photographed by special permission). (*See also Houses of Parliament*).
82, 85

P E Chappuis, 69 Fleet Street – retailer specialising in 'scientific novelties'.
101

Crystal Palace (see also Negretti & Zambra).
138, 140, 142

James Davis Burton of 194 Oxford Street acquired permission to sell stereo views of the Tower of London in 1864.
67, 68, 69, 70, 71, 72

C W Dixey, Opticians to the Queen, New Bond Street – possibly a retailer.
134

Dorrell and Son, 15 Charing Cross, SW – retailer. The firm is only known as a book publisher and stationer.
114

Robt Edwards, photographer, Hornsey, London.
197

J Elliot, possibly James Elliott (fl 1854–61) with offices at 9 Albany Court Yard and 48 Piccadilly.
59, 77

W England, photographer – William England (1816–96), the head photographer of the London Stereoscopic & Photographic Co.
189

The Fine Art Photographers' Publishing Co, 46 Rydevale Road, London, S.
103, 104, 170

G R & Co published the series *London and Neighbourhood*.
35, 92, 161, 210

S A Gracely, 27 Warwick Street (but see next entry).
73

Julius Graife, 27 Warwick Street, c/o Crystal Palace Collection.
144

Griffith & Griffith of Philadelphia, Pa, USA, published the series *Foreign and American Views*, which was sold exclusively through its offices in Philadelphia; Chicago, Il, USA; London; Hamburg; and Milan.
55, 128, 129, 130

Houses of Parliament (see also *The British Houses of Parliament*).
82, 84

Instantaneous Views of London. Several series with similar titles are recorded by various photographers, including Fredk Jones (*below*).
29, 31, 56, 62, 105, 147

J F Jarvis, Publisher, Washington, DC, USA, was connected with Underwood & Underwood (*below*).
38, 171

Fredk Jones of 146 Oxford Street published the series *Instantaneous*, *London Views* and *Views of London*. He was bankrupt by 1868.
31, 66, 80, 87, 106, 114, 179

E W Kelley, Publisher, Studio and Home Office, Chicago, Il, USA. It appears to have sold exclusively through its own offices in Chicago; Dallas, Tx; and Augusta, Ga, and presumably also a London agent.
37

London School of Photography – 78 Newgate Street; 174 Regent Street; Myddleton Hall, Islington; 46 Church Street, Liverpool; and 1 Market Place, Exchange, Manchester. Sold as *Views in London*. Proprietor: Samuel Prout Newcombe (1854–70).
186

The London Stereoscopic Company was founded in 1854 by George Nottage. It became The London Stereoscopic & Photographic Co in 1864 and had offices at 110 & 108 Regent Street and 54 Cheapside. It published the series *Views of London and its Vicinity* and was also the official photographer to the 1862 International Exhibition advertising about 350 stereo views.
45, 47, 73, 91, 94, 97, 139, 148, 149, 150, 151, 153, 154, 155, 156, 157, 158, 159, 166, 187, 208

Negretti & Zambra, photographers to the Crystal Palace Company, were based in Hatton Garden, Cornhill, and at the Crystal Palace, Sydenham. In 1854 the firm acquired the franchise to supply photographs within the palace, producing over 300 stereo views. Some of their stereos were described as being 'executed for the Crystal Palace Art Union of 1859'. (*See also Crystal Palace*)
141

Orchadia, Goulton Road, Clapton, NE – possibly a retailer.
41

Samuel Poulton (fl 1859–64, 147 & 352 The Strand) published *Poulton's Stereoscopic Series of English Scenery and Buildings*.
57

Victor A Prout, photographer, published by James Elliott (fl 1854–61; *see* p 231).
77

B L Singley – possibly a photographer working for the Fine Art Photographers' Publishing Co.
104

Strohmeyer & Wyman, publishers, New York, NY, USA, sold exclusively through Underwood & Underwood Ltd with offices in New York; London; Toronto, Canada; and Ottawa, Ks, USA.
51

T E Tayler, St Paul's – possibly a retailer.
61

Andrew & George Taylor (fl 1866–1906) operated a large chain of studios across England including 70 Queen Victoria Street, London.
22

»INDEX (BY BOROUGH) TO PLACES ILLUSTRATED IN THE BOOK

OTHER BOOKS USING IMAGES FROM THE NMR COLLECTIONS:

Childhood: The way we were. 2005. Product code 51141, ISBN 978 1850749 653, £9.99

Delamotte's Crystal Palace: A Victorian pleasure dome revealed. Ian Leith, 2005.
Product code 51074, ISBN 978 1850749 493, £17.99

John Gay: England observed. 2009. Product code 51395, ISBN 978 1848020 030, £20

Leisure: The way we were. 2007. Product code 51160, ISBN 978 1850749 868, £9.99

Railways and Rural Life: S W A Newton and the Great Central Railway. Gary Boyd-Hope and Andrew Sargent, 2007.
Product code 51193, ISBN 978 1850749 592, £17.99

Seaside Holidays in the Past. Allan Brodie, Andrew Sargent and Gary Winter, 2005.
Product code 51060, ISBN 978 1850749 318, £17.99

Shot from Above: Aerial aspects of London. Steven Brindle with Damian Grady, 2007.
Product code 51219, ISBN 978 1905624 058, £25

Stonehenge: A history in photographs. Julian Richards, 2004. Product code 51275, ISBN 978 1905624 546, £17.99

Traditional Crafts and Industries in East Anglia: Hallam Ashley, photographer, 1900–87. Andrew Sargent, 2009.
Product code 51192, ISBN 978 1850749 684, £14.99

Work: The way we were. 2007. Product code 51161, ISBN 978 1850749 875, £9.99

To order
Tel: EH Sales 01761 452966
Email: ehsales@gillards.com
Online bookshop: www.english-heritage.org.uk